# REVEALING THE INNER CONTOURS

# OF HUMAN EMOTION

## PRESERVING THE BALLETS OF
## ANTONY TUDOR

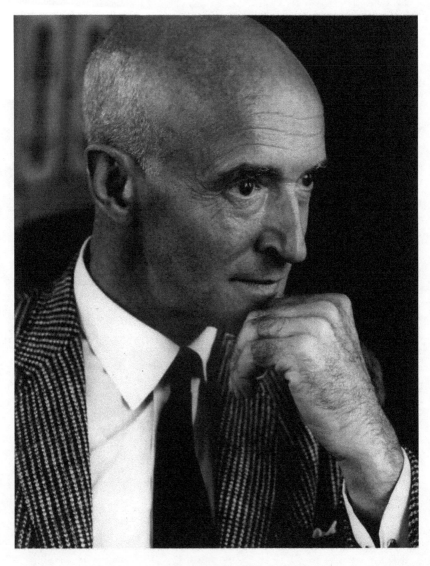

Antony Tudor
1908-1987

CHRISTINE KNOBLAUCH O'NEAL

# REVEALING THE INNER CONTOURS

# OF HUMAN EMOTION

## PRESERVING THE BALLETS OF
## ANTONY TUDOR

VITA HISTRIA

# Vita Histria
Las Vegas ◊ Oxford ◊ Palm Beach

Published in the United States of America by
Histria Books, a division of Histria LLC
7181 N. Hualapai Way
Las Vegas, NV 89166 USA
HistriaBooks.com

Vita Histria is an imprint of Histria Books. Titles published under the imprints of Histria Books are exclusively distributed worldwide through the Casemate Group.

Dust jacket and Cover photos: front cover photo of Antony Tudor courtesy of Elizabeth Sawyer, and the author as Hagar in *Pillar of Fire;* back cover photo of Antony Tudor by Cecil Beaton, courtesy of American Ballet Theatre.

Library of Congress Control Number: 2019950478

ISBN 978-1-59211-023-0 (hardcover)
ISBN 978-1-59211-035-3 (paperback)

# Table of Contents

# DEDICATION

To Grant and Kathleen Knoblauch,
they were the best parents.

# Prologue:
# Tudor and Me

I was auditioning for American Ballet Theater at the old studios on Broadway and Columbus Circle in New York City when suddenly a man I did not know walked in and sat on a chair in the far-right corner of the room against the mirrors lining the front wall. I was there to audition because I had recently lost my job as the principal dancer with the National Ballet Company in Washington, D.C., a company co-directed by Frederic Franklin and Ben Stevenson, because the company had recently folded due to financial concerns, and now I needed work. I recall he was a very dapper man, dressed in a white shirt and tie, with pressed trousers, and black shoes. At that time in my career, I had no idea that that man was Antony Tudor.

I honestly didn't even know who Tudor was, nor did I know anything about his ballets because his choreography had not been part of the National Ballet's repertoire. Furthermore, although I had seen performances of the American Ballet Theatre at the Kennedy Center in Washington, D.C., I had never actually seen a Tudor ballet. Looking back now, I realize how ironic this memory is, given that I later became a Tudor dancer in American Ballet Theatre and that I remain deeply involved with his work and with the preservation of his work.

My audition for American Ballet Theatre was focused on obtaining a role in the corps de ballet of La Bayadere,[1] along with numerous other female dancers all vying for this single position.

I really just needed a job, so it didn't bother me that, if selected, I would have to enter American Ballet Theatre as a corps dancer. Also, what I did not know was that the company was looking for a tall girl, someone at least five feet eight inches tall. In other words, the dancer who would be chosen would have to walk into the part at the same size and height as the dancer who had left the company. Despite all my physical attributes as a ballet dancer, I'm not tall and, as a result, I did not get hired that day.

Instead, I went to Houston, Texas to dance in a gala performance which included a reunion of the Americans who had competed in the International Ballet Competition in Varna, Bulgaria in 1972. The company management of the National Ballet Company sent three principal dancers and me to the Varna International Ballet Competition. My partner Kirk Peterson and I performed four pas deux (partnering duets): the pas for the *Sugar Plum Fairy* and *Cavalier* from the second act of Ben Stevenson's *The Nutcracker*, a *Romeo and Juliet*-styled pas choreographed by Ben Stevenson, the Peasant pas de deux from the first act of *Giselle*,[2] restaged by Frederic Franklin, and Ben Stevenson's *Harliquinad pas de deux*[3]. We all took home a medal; mine was a bronze. While at the competition in Bulgaria, I also had the opportunity to meet Kevin McKenzie whom, along with Suzanne Longley, represented Mary Day's Washington School of Ballet from Washington, D.C. They also won medals.

During the reunion in Houston, I performed with Kevin McKenzie, future director of American Ballet Theatre, two pas de deux: *Bluebird pas* from *Sleeping Beauty*,[4] choreographed by Ben Stevenson for the National Ballet, and Ben Stevenson's *Harliquinad pas*. After the last performance, while sitting in my hotel room, I received a phone call from my former National Ballet dance partner Kirk Peterson. He told me that the American Ballet Theatre management had asked him to call me and to tell me to

fly to New York as soon as possible. I asked why? Kirk explained that they were interested in having me work with Tudor. "Interesting," I thought, and next queried to myself: "Who is Tudor?"

I flew out to New York the next day, took the elevator up to the American Ballet Theatre studios, and walked out into the lobby. It was filled with dancers, most of whom seemed to be eyeing me with less than favorable feelings. I gave the receptionist my name: Christine Knoblauch. She greeted me in a friendly manner and directed me to the changing room and to the studio where I was to meet Tudor.

After changing into my dance clothes, I walked the hallways to find the studio, entered the doorway, put my dance bag down on the floor, and then looked across the room at three gentlemen. One of them was the same dapperly dressed man I remembered from my previous audition who I discovered to be Tudor; the second person was a quite charming, dark haired man who turned out to be dancer Hugh Laing; and the third man was the American Ballet Theatre accompanist, Howard Barr. I remember only the following about the next ten minutes: Tudor walked over to me and, without introducing himself or thanking me for coming to the rehearsal, said, "You will never dance in this company with that name." And then he asked me to sit on a chair, and we began the first moments of Hagar's role in Tudor's *Pillar of Fire* (1932, Appendix A).

I disliked Tudor immensely for asking me to change my name; I felt it erased my previous career accomplishments. However, I spent my first few weeks in American Ballet Theatre learning the role of Hagar and trying to find another stage name. It did not help me to realize that changing one's name was the norm for a generation of ballet dancers who had been asked to appear either more Russian during the years with Ballet Russe or later less Russian similar to George Balanchivadze who became simply

George Balanchine. After World War II in American Ballet Theatre, Russian names became less popular, with a more American sounding name preferred or a name with a more theatrical flair. For example, Tudor's American muse, Nora Kaye, had been born as Nora Koroff; Tudor was originally William Cooks; and the great English ballerina Dame Margot Fonteyn had been originally named Peggy Hookum.

After much trial and error, my name became O'Neal, with the change also sanctioned by my family. I remember the day I told Tudor my choice in last name as we stood together in the lobby area of the studios. I told him, with great reluctance, "It's going to be O'Neal." He immediately turned on his heel, walked over to the receptionist's desk, picked up the phone, called the American Ballet Theatre office, and perfunctorily stated: "It will be O'Neal." I almost cried. A whole career with the National Ballet was gone, wiped out in one stroke. And, I suspect, Tudor could claim that he discovered me. To make matters worse, Lucia Chase, director of American Ballet Theatre (ABT), offered me only a corps contract even though I was learning Tudor's leading role of Hagar in *Pillar of Fire*. According to Lucia Chase, everyone began in the corps. So, in a twist of fate, I learned the corps parts in ABT, while also learning a principal role with Tudor.

So began my relationship with Antony Tudor. He and I worked on *Pillar of Fire* while I was also learning and dancing in diverse ballets by other choreographers in American Ballet Theatre. When we worked together, he seemed extremely specific in his teaching and corrections; this type of specificity was not something I had experienced with choreographers I had worked with in the past. For hours, I found myself sitting on the chair learning the intricate details of the opening of *Pillar of Fire*, the famous Hagar gestural phrase that defines her character. There were endless hours of working together with Tudor learning the exact nature

of the gestures, the timing, and the exact angle of the arm and hand to the face. Tudor worked endlessly with me on developing the pace of the arm gesture which moved from Hagar's lap to the cameo she wore at her neck. The gesture needed to show how the cameo felt as if it would strangle Hagar, restricting her breathing, her very being. Next Tudor spent hours specifying how Hagar was to move from her seated position on the stoop to standing in front of the house, and only then finally making the decision to move into the house. This meticulous process was an unimagined way of rehearsing for me; it was not about concentrating on the performance of movement, as I had been taught, but how the movement emerged from the emotional intent of the character, the dancer.

All the while I rehearsed the ballet with Tudor, I also saw how the entire cast of characters in *Pillar of Fire* were created to move clearly and intricately through a set of gestures supporting the expression of the narrative. As Hagar, I met each of the characters by watching Tudor perform them. Here is a list of Tudor's characters as described in the program: Hagar's Eldest Sister, her Youngest Sister, the Friend (the man she loves), the Young Man from the House Opposite, and the Lovers-in-Innocence (the teenage children). All had specific gestures that were unique to the needs of that character's expression within the dramatic storyline of the ballet. This level of character development, driven by unique gestures not found within traditional ballet terminology, was new to me; I realized then that I had much to learn from Tudor.

The level of intensity with which Tudor directed each rehearsal made my days fraught with tension. There was so much to learn about the ballet, the character I was portraying, and the movements that would bring my portrayal to life for the audi-

ence. I had to pay attention to every gesture because each movement in its minutest detail was important: each reaction, turn of the head, and look had to have a specific performance directed by the expressive needs of the unfolding story. Every gesture furthered the Tudor narrative and had to be performed within the precise timing Tudor felt necessary to achieve the desired effect. This level of detail meant that I needed to repeat each movement endlessly, over and over, until I achieved the desired timing. There were moments during my rehearsals with Tudor when I felt like a mouse scampering to hide from a cobra. But there was never any place to hide; there was always just Tudor, me, and the accompanist.

Luckily, one of my strengths as a dancer was my musicality. I could listen to music and place each movement within the sound; it was as if the gestures became the lyrics expressing how the music felt. Tudor would demonstrate each of Hagar's actions while singing or humming the music; I don't remember him ever counting any phrase. Therefore, I learned Tudor's movements as lyrics interlaced through the music. In the end, I found phrases of movement riding through and around the musical phrases all supporting the story of Hagar. Although Tudor was difficult to work with, relentlessly focusing my attention on the smallest details, his musicality was incredibly logical and provided a way for me to learn how to embody the choreography while guiding me when to move and stop. Further, his musical logic gave each character a unique and defining expressivity which then helped the movements to become more easily remembered. For me, learning to dance in the music, not to react or respond to it, but to be *in* the music was my salvation during rehearsals. I determined then that Tudor's choreographic logic lived somewhere in the intersection of the movement and the music.

While learning the role of Hagar, I was also cast as the vendor in Tudor's *The Tragedy of Romeo and Juliet* (1943).[1] Of course, I was more than disappointed that I was not cast as Juliet. "So," I accepted the idea that, "I am to be the vendor." With a mix of emotions, in which I found myself glowering and muttering under by breath, "I'll show you," I decided to be the best vendor Tudor ever cast. To that end, I created a back story for my character, which I developed to justify each entrance and exit, each pattern and interaction with another character. When I got through my initial disappointment of not being cast as Juliet, I began to realize that using Tudor's movement technique for developing character gave me much material to play with, and that being a vendor could be quite rewarding.

I also experienced Tudor's humor for the first time during the rehearsals of *Romeo and Juliet*. I witnessed some of the dancers actually having fun with Tudor, laughing at his jokes in rehearsals, while also having moments of conversation with him about their roles. The conversations were real discussions about the work, not one-sided monologues. After this, I found myself relaxing during rehearsals, actually enjoying my work, enjoying the camaraderie, enjoying, may I say, Tudor. This isn't to say that Tudor didn't frequently pester the dancers or use a stern tone with them during the *Romeo and Juliet* rehearsals. However, the rehearsal environment was different. I was beginning to experience the many facets of Tudor's restaging process.

At a technical rehearsal for *Romeo and Juliet* onstage at the State Theatre at Lincoln Center in New York, I remember having my vendor exit the stage as if customers had called my name and I was in a hurry to attend to them and to make some good money. Once offstage, I turned around and, in one moment, I caught a

---

[1] see Appendix B

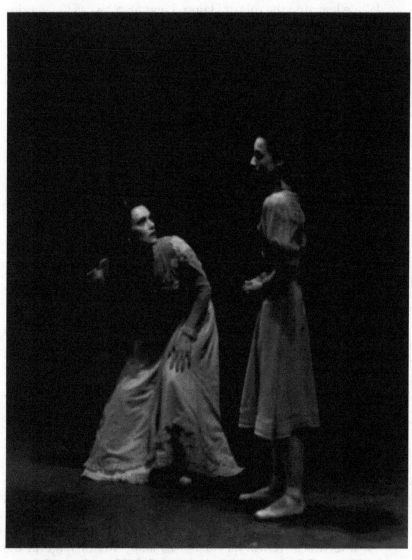

The author (right) as Hagar in Tudor's *Pillar of Fire,*
together with Marie Johansson (left)

glimpse of Tudor watching me with this curious little smirk on his face. "Finally," I thought. "I've done something right; I have made Tudor smile."

In performance, once the curtain went up, I always wanted to feel that I could rely on all of the rehearsals to let me ride the wave of being in the ballet, to let me simply be in the moment of experience. This feeling of allowing the ballet to pull you through was particularly important the night I performed Hagar in *Pillar of Fire* since I was unable not to feel terrified before going on stage. My name had appeared as Hagar in the cast list only after Lynn Seymour, guest artist from the Royal Ballet, had cancelled. I had twenty-four hours to learn all aspects of the ballet that had not been already taught to me in rehearsal. I simply kept in mind all of Tudor's instructions: spacing, interactions, timings for lifts, the size of the stoop designed in the set, negotiating the backstage steps after my first exit, and a host of other movement details about Hagar's life on stage. I found myself in costume as Hagar on the stage of State Theater waiting for the stage manager to call "places." I was walking around the stage thinking, "You're alone in the American Ballet Theatre and Hagar is alone – use that." I sat down on the stoop, looked out through the huge curtain into Hagar's future, and my mind went blank; the curtain went up. I was Hagar.

Hagar begins seated on the stoop of her house alone and lonely as she faces her future. From that opening moment when the curtain went up, I felt that Tudor gave me a gift: he presented me with one of the best sculpted characters that I had seen or experienced as a dancer. Hagar's gestural movements, when performed as Tudor wished, created for me a depth of human experience, passions, and unfulfilled desires. I discovered a new embodied sense of how hopes and dreams could be blocked, buried within a human being, as the weight of each limitation became

almost unbearable to carry. Hagar journeys through a series of human interactions which push her, force her into a final encounter, one that changes her life forever. The weight of dashed hopes is finally lifted through the warm embrace of the man she loves. I now thank Tudor for a ballet which is magnificent to dance.

I carried this new sense of appreciation of Tudor with me as I began a new role in his ballet *The Leaves are Fading* (1975).[2] Nanette Glusack and I were cast as the extra girls, not one of the main couples, and I also understudied one of the pas de deux with my partner Clark Tippett. *Leaves are Fading* seemed to me to be, in its choreographic structure and themes of movement, the culmination of Tudor's creative genius. In the duet for Nanette and me, Tudor used both pattern and gliding turns and jumps to create a playful, light, almost conversational companionship between us. Although not in the vein of his more dramatic duets, ours was joyous, almost a counter-balance to his earlier works. I felt the true diversity of his choreographic talent.

In *The Leaves are Fading*, Tudor's musicality again carried me as the pas de deux I danced with Clark Tippett naturally flowed through one choreographic phrase to another. There was an underlying dramatic tone in the music which supported an undulation of near and far, together and then apart. The only thing connecting Clark and me was our sense of movement, and move we did. He was a very strong dynamic performer and I was determined to keep up with him throughout our partnering. However, perhaps the most exciting experience for me when learning this duet was how I was swept into an ease of working with Tudor, as both Tudor and Clark were quick of wit, and an ease of interplay developed between Tudor's barbs and Clark's witty re-

---

[2]See Appendix C

sponses during rehearsals. I never ventured to enter their repar-
tee. Yet, I did feel I was developing an artistic relationship with
Tudor: my relationship had to do with connecting to and reveling
in his specific way of working, a relationship that continues today
as I try to bring his choreography alive to my own students.

However, even though I became more comfortable working
with Tudor, he still "kept me on my toes" during each and every
rehearsal. This consistent alertness became even more important
when, during the creation of *The Leaves Are Fading*, Tudor worked
with Labanotation specialist Airi Hynninen, who sat next to him
at every rehearsal. Tudor would call upon Airi to solve discus-
sions over the exact interpretation of a step he demonstrated. This
attention to the exactness of detail regularly taxed my abilities,
even though as a professional dancer learning quickly and accu-
rately was a skill I highly valued and practiced daily. To find how
the details flowed together, Tudor would demonstrate, always
wearing his trademark pressed trousers, shirt, tie, loafers and
socks, moving through phrases of movement while never count-
ing. He would simply move while often singing. Then he would
depend on Airi to make his musical demonstrations concrete.

During one of the rehearsals for *The Leaves are Fading*, Tudor's
sung phrase sounded like: *down, up, down, down, up, down up, up,
down up and up*. After hearing the sung phrase, we, the dancers,
would enter into a heated discussion about whether or not Tudor
had said: one down or two ups or a series of variations on the "up
down" theme. To answer this dilemma, Tudor would ask Airi to
read her notation. She then proceeded to read exactly what he
had demonstrated. Tudor would smile and look at us: at that mo-
ment, he had helped us see that perhaps we were not as skillful
at precisely learning his movement as we thought. In fact, this
clarity of the notated moment always made him smile since, in

that instant, Airi's interpretive decisions bested all of us and further demonstrated how much we still needed to learn.

Now, as I look back on my experience in *The Leaves are Fading,* I find it amazing that Tudor's insistence on following detail to the letter did not lead to a somewhat exasperating atmosphere, "killing" the spontaneity of the movement. Instead, the atmosphere in rehearsals for this new ballet was positive as we eagerly wanted to feel and to see how this new ballet would take shape and who our characters would become in the moment of that shaping. When the ballet finally came together, it seemed as if all the details we agonized over with Tudor and Airi became a wonderful stream of movement, slow and then fast, up and then down, danced with a delicate touch and then with a strong, urgent energy.

The last memory of Tudor that I have occurred during the opening night of *The Leaves are Fading* at the State Theater in Lincoln Center. The curtain fell and there was thunderous applause; we went through the ritual of our rehearsed bows, and then Tudor appeared onstage to my right. He joined the line of dancers. He bowed several times acknowledging the thunderous applause. He seemed pleased, really pleased. That is, if Tudor ever looked pleased.

# Introduction:
# The Tudor Aesthetic

Antony Tudor was one of a group of twentieth-century ballet choreographers working in the United States whose choreographic canon concentrated on the one-act narrative or the short story in movement.[3] The others in this group included American choreographers Jerome Robbins, Agnes De Mille, Eugene Loring, and Ruth Page, to name only a few. Tudor stands unique amongst the group in that he was British (Frederic Ashton was the other major British choreographer of the twentieth century, but he remained in England and created ballets for the Royal Ballet.). Tudor's one-act narratives were steeped in his curiosity of modern thought and artistic practice evolving in the mid-twentieth century, not only in America, but throughout Europe. Judith Chazin-Bennahum, author and former Tudor dancer, in writing on Tudor's *Dark Elegies*, juxtaposed his development as a dancer – he began late in life – against his non-dance interests. Chazin-Bennahum emphasized that Tudor brought to the choreographic process an *openness* to a new variety of ideas. She states how,

> *His passion for ballet [,] a knowledge of composers [,] and an interest in the writers-Freud, Bergson, Proust etc.-who influenced thought in the thirties. In addition, all of his life he had an abiding interest in Central European themes and music,*

---

[3]Jack Anderson, "With Movements, Tudor's Short Stories." New York Times, 30 Apr. 1992, p. 1.

*thus his choice of composers such as Dvorak, Janacek, Schoen-berg, and Mahler.*[4]

Most importantly, Tudor brought to the choreographic process first, his uncanny ability to observe his fellow man and woman and, second, his ability to structure his observations into the psychological interactions of his characters and their interrelationships within his plots, entangling his characters who also represented the average man and woman.

## Tudor's Backstory

Antony Tudor first appeared as a dancer and then as a choreographer in London, England through the Ballet Club (later Ballet Rambert) directed by Marie Rambert in 1931 after leaving his job as an accountant in a butcher's shop. Dance historian Muriel Topaz cites Tudor describing his experience with Rambert as learning dance in: "'a typical dance studio teaching a little bit of everything' in London."[5] When he joined Rambert's company, he studied ballet with her, concentrating on the Cecchetti syllabus.[6] Tudor noted that the Cecchetti method[1] established his idea of classical ballet training and later became the foundation for his unique choreographic motifs. A funny anecdote that sheds light on some of Tudor's work with Rambert happened when Tudor mentioned to her, almost from the beginning, that he had a desire

---

[4]Judith Chazin-Bennahum, "Shedding Light on Dark Elegies," in *Proceedings of the Eleventh Annual Meeting Society of the Dance History Scholars February 1988*, pp. 131-144, p. 132.

[5]Muriel Topaz, *Undimmed Lustre: The Life of Antony Tudor.* Lanham: The Scarecrow Press, Inc. 2002, p. 11.

[6]Enrico Cecchetti was an Italian dancer, performer, and master teacher who codified the ballet technique stabilizing the training within specific exercises for each day of the week and for specific levels of training.

to choreograph. Upon asking Rambert to allow him time to work with a few dancers on a new composition, she commented, "But Antony, you can't dance."[7]

Nevertheless, Tudor's early works, all of which premiered with Rambert's company at the Mercury Theatre in London, showed promise, at least to some of the British critics. Further, Muriel Topaz, an American biographer of Tudor and professional dance labanotator, offers in her biography, *Undimmed Lustre: The Life of Antony Tudor,* an entire chapter on some of the critical responses to the early Tudor ballets. Of most importance in these reviews is the acknowledgment that Tudor began immediately experimenting with how gesture created a story line. In her book, Topaz quotes Cyril Beaumont writing in London's December, 1931, issue of *Dance Journal,* concerning Tudor's early attempts at choreography and character development in his first ballet *Cross-Garter'd,* based on Shakespeare's play *Twelfth Night,* where he states:

> *Mr. Tudor has very wisely tried to work out his ideas in his own way. The result was a workmanlike little ballet which impressed by its obvious sincerity, while the dances and mime really did express the story. The steps were simple, the mime was simple, but it was all done in the lusty spirit of the text. The production would be improved by a little condensation....[8]*

In time, Tudor continued to work and explore within the genre of storytelling; he next began to weave his own tales rather than draw them from the stories of Shakespeare. As a result, on January 26, 1936, Tudor's *Jardin aux Lilas,* with music by Arnold

---

[7]*Antony Tudor.* Dirs. Viola Aberlé and Gerd Andersson. Stockholm and New York. 1985. DVD. Highstown, 2007.

[8]Topaz, *Undimmed Lustre: The Life of Antony Tudor,* p. 308.

Schoenberg, premiered. Here, Tudor's storytelling proved to be complex, historically contextualized, and driven by how human desire responds to the world around it. The story depicts the struggle of young Caroline who is about to marry a man she doesn't love. Set in a lilac garden, the cast of characters (Her Lover, The Man She Must Marry, and An Episode in His Past [this last character is a woman from the past of "the man she must marry"]) convene, intersect, and interact. The ballet's story mirrors the social etiquette and power struggles of the Edwardian period. [9]

Now considered by critics as a masterwork, the early reviews of the ballet were mixed. Biographer Muriel Topaz quotes critic Arnold Haskell writing in the 1936 British *Daily* where he states that, "Antony Tudor's choreography is not yet fully developed. Deeply interesting patches... it is too jerky as a whole...." [10] In 1937, Haskell further conceded that, "Mr. Tudor has ideas, but he has still some way to go before he acquires the certainty of touch.... His *Jardin aux [L]ilas* falls to the ground between the conflicting claims of choreographic, dramatic, and musical logic, though it has the merit of establishing and possessing a consistent atmosphere of the nineteenth century. He is apt to misinterpret the music." [11]

However, in the same year, critic Lionel Bradley is quoted by Topaz as noting that Tudor's craft as a storyteller and choreogra-

---

[9] Antony Tudor Ballet Trust.

[10] Topaz, *Undimmed Lustre: The Life of Antony Tudor*, p. 317.

[11] Topaz, *Undimmed Lustre: The Life of Antony Tudor*, p. 317.

pher for, "*Jardin aux Lilas* rouses all my romantic feelings. I continue to admire the apparently fortuitous but effective way in which the characters cross and recross."[12]

Tudor's *Dark Elegies* premiered on February 19, 1937. The story captures the rituals of grief men and women in a small fishing village practiced when their children were killed by a catastrophic event. The ballet is accompanied by Gustav Mahler's *Kindertotenlieder* and performed by a solo vocalist and orchestra. The vocalist in the attire of the villagers is seated onstage during the entire ballet. The story unfolds through a series of songs, each representing a form or level of grief. Although after its premiere, *Dark Elegies* was greeted with mixed reviews, subsequent reviews began to acknowledge Tudor's unique choreographic perspective. Lionel Bradley in his 1937 diaries reveals the following on February 19th: "Unvarying grief can hardly be represented dancing for half an hour on end...."[13] By October 23rd of the same year, however, Bradley wrote: "*Dark Elegies* is an astonishing and most successful combination of strictly academic movements and what might be called almost a primitive funeral ritual."[14]

In the 1937 Sunday edition of London's *Times*, biographer Muriel Topaz cites an anonymous critic (initials of A.B. only) as presenting a more lukewarm point of view. He or she states:

> ...but between times there were a good deal of processional movement of a not-too-purposeful order, and too little call

---

[12]Topaz, *Undimmed Lustre: The Life of Antony Tudor*, p. 318.

[13]Topaz, *Undimmed Lustre: The Life of Antony Tudor*, p. 325.

[14]Topaz, *Undimmed Lustre: The Life of Antony Tudor*, p. 325.

*upon the foot-techniques to hold the eyes' attention though the permutations were often ingenious.*[15]

During the 1930s, Tudor's work in the narrative genre became so prolific that Judith Chazin-Bennahum, a former Tudor dancer and author, writes that the "British critics came to call Tudor the 'Chekov of the ballet.'"[16] His masterworks, *Jardin aux Lilas* (1936),[17] *Judgment of Paris*, music by Kurt Weill (1938),[18] and *Dark Elegies* (1937),[19] survived from this period and later made the transition to the United States along with Tudor.

Tudor's move to America began with the support of Lucia Chase, an American heiress who created Ballet Theatre in 1939 (renamed later as the American Ballet Theatre). Under advisement from Agnes De Mille, American dancer and choreographer who had befriended Tudor in the Rambert Ballet and danced in the original cast of *Dark Elegies*, Ms. Chase wired Tudor to ask him to come to the United States and work with her burgeoning ballet company. Tudor accepted and, along with Hugh Laing, his lead dancer and companion, boarded the last boat to America just prior to the attacks on England by Germany in 1939.

Tudor's *Jardin aux Lilas* (Anglicized in the United States as *Lilac Garden*) opened on the American stage through a production by American Ballet Theatre in 1940. *Judgment of Paris* and *Dark Elegies* appeared later in the same season.[20] Tudor also performed

---

[15]Topaz, *Undimmed Lustre: The Life of Antony Tudor*, p. 325.

[16]Judith Chazin-Bennahum. *The Ballets of Antony Tudor: Studies in Psyche and Satire.* New York: Oxford University Press, 1994, p. 4.

[17]See Appendix D.

[18]See Appendix E.

[19]See Appendix F.

[20]Topaz, *Undimmed Lustre: The Life of Antony Tudor*, p. 372.

in Eugene Loring's *Great American Goof*,[6] music by Henry Brant, during the same 1940 season. As with the Ballet Rambert, Tudor soon focused his career primarily on choreography during his tenure with American Ballet Theatre. In regards to Tudor's *Dark Elegies* American premiere, dance critic Walter Terry is quoted by Topaz as revealing in the 1940 *New York Herald Tribune* that, "Sensitivity, ingenuity of movement and simplicity of pattern, qualities we have come to associate with Tudor works, were again in evidence, and *Dark Elegies* emerged as a work that was frequently telling."[21] Here, I believe Terry uses the word 'telling' to suggest the revealing nature of the work to inform, share, and/or speak to the audience of and about the nature of grief, 'telling' of its many layers and experiences to all who watch the narrative unfold.

Tudor continued to work with American Ballet Theatre after the first 1940 season. His American masterwork, *Pillar of Fire*, with music by Arnold Schoenberg,[22] premiered in April 8, 1942. This ballet seemed to secure Tudor's position as a master choreographer, a one-of-a-kind genius. In 1946, Lillian Moore writing from New York City for the British journal *Dancing Times* pronounces:

> *Perhaps once in a generation a work of art is created which completely realizes the aims towards which many other obscure and incomplete efforts have been directed. One work achieves what many have attempted, and becomes eventually the symbol of a school or a period. One time can reveal what ballet will emerge as representative of the present renaissance... It can only be said that in Pillar of Fire Antony Tudor*

---

[21]Topaz, *Undimmed Lustre: The Life of Antony Tudor*, p. 326.
[22]See Appendix A.

*appears to have created a masterpiece worthy of this distinction....*[23]

Once Tudor began receiving critical accolades, he was able to build his career within differing dance communities in the United States and in Europe to include his teaching and choreography work at Jacob's Pillow in Becket, Massachusetts, the Metropolitan Opera Ballet, and the Juilliard School in New York City, as well as the Royal Swedish Ballet.

Clearly, there are many research avenues to pursue concerning Tudor's life and work. However, our purpose is to analyze the restaging of the Tudor ballets, specifically those ballets that I previously mentioned, by interviewing those most closely associated with them. These ballets include those created for American Ballet Theatre: *The Tragedy of Romeo and Juliet*, music by Frederick Delius (1943),[24] *Dim Lustre*, music by Richard Strauss (1943),[25] *Undertow*, music by Richard Schuman (1944),[26] *The Leaves are Fading*, music by Antonin Dvorak (1975).[27] *Little Improvisations*, Robert Schumann (1953)[28] was created for Jacob's Pillow in Becket, Massachusetts with *Fandango*, music by Antonio Soler (1963)[29] choreographed for the Metropolitan Opera Ballet. The European productions included *Echoing of Trumpets*, music by Bohuslav Martinu (1963)[30] for the Royal Swedish Ballet; *Shadowplay*, music by

---

[23]Moore qtd. in Topaz *Undimmed Lustre*, pp. 337-338.

[24]See Appendix B.

[25]See Appendix G.

[26]See Appendix H.

[27]See Appendix C.

[28]See Appendix S.

[29]See Appendix I.

[30]See Appendix J.

Charles Koechlin (1967)[31] for England's Royal Ballet; and *Continuo*, music by Johann Pachelbel,[32] *Cereus*, music by Geoffrey Gray,[33] and, *Sunflowers*, music by Leos Janacek[34] for the Juilliard School in New York City in 1971.

Unfortunately, many of Tudor's early works were lost and only a few surviving photographs remaining. *The Planets* (1934)[35] was revised in 2002 at Duke University with additional choreography by Donald Mahler, a former Tudor dancer and then senior Répétiteur Emeritus of the Tudor Trust. The Duke production was supported by contributions from the Tudor Trust; Muriel Topaz, former Tudor dancer and author of *Undimmed Lustre: The Life of Antony Tudor*; and Celia Franca, former Tudor dancer and former director of the National Ballet Company of Canada. Fortunately, *Judgment of Paris* (1938),[36] set to the music of Kurt Weill, is often restaged, although the fee to use the Weill music, five hundred dollars a performance, often makes it prohibitive to some professional companies, let alone university dance departments. However, two of Tudor's ballets, *Jardin aux Lilas* (*Lilac Garden*, 1936)[37] and *Dark Elegies* (1937),[38] remain as masterworks, hallmarks of Tudor's craft, and are continually restaged by professional ballet companies around the world and by American university or college dance departments. The preservation of the

---

[31]See Appendix K.

[32]See Appendix L.

[33]See Appendix M.

[34]See Appendix N.

[35]See Appendix O.

[36]See Appendix E.

[37]See Appendix D.

[38]See Appendix F.

aforementioned ballets was secured through a continuation of performances by several companies throughout the years since Tudor's death; a number of archived videos which document these performances; and the first-hand experience of Donald Mahler, senior Répétiteur Emeritus of the Tudor Trust, having performed the ballet with the National Ballet of Canada.

## The Psychological Motivations of Tudor's Characters

Tudor's choreography is noted by some critics as signaling a Renaissance in ballet beginning in the 1930s (*Antony Tudor,* film). Setting the stage for Tudor's choreographic renaissance were the master choreographers of the Diaghilev Ballet Russe. Michel Fokine working with Ballet Russe (1909-1912) challenged the full-length, pyrotechnical ballet canon with his simple, flowing one-act work, *Les Sylphides* (1909)[7] with music by Frédéric Chopin (*Fokine*). Ballet Russe choreographer Vaslav Nijinsky (*Nijinsky*) turned classical ballet tradition on its head with the one-act story *Sacred du Printemps* (1913)[8] with music by Igor Stravinsky, in which the use of the turned-in leg, non-classical postures, and the uneven percussive meter of Igor Stravinsky's ballet score caused a public outcry in the theatre and brought the ballet world into the modern art movement. Leonide Massine (*Massine*), another Ballet Russe choreographer (1915-1921), created the one-act story ballet *Parade* (1917)[9] with music by Eric Satie, which also opened the ballet vocabulary to a more playful use of the body. All of these choreographers opened the doors for thinking about and practicing classical forms of ballet in a manner that reflected the coming modern age.

Building on how these early twentieth century ballet choreographers began to open ballet vocabulary to new ways of moving the body on stage and new ways of expressing life at the turn

of the century, Tudor began designing ballets around the psychological needs or desires of his characters. In other words, and according to Nora Kaye, Tudor's muse during his early years with American Ballet Theatre, Tudor's movements were so "biographical" that when the dancers actually experienced the choreography they found they "could move only as those characters would move."[39] Donna Perlmutter, author of *Shadowplay: The Life of Antony Tudor*, summarizes Tudor's contribution to the creation of a new twentieth century ballet by stating that:

> Guided by a deep knowledge of how [his characters] might react to each situation and inspired to create the kind of poetic equivalent—unique and economical—that could telegraph a state of mind, he reached out beyond ballet's limited realm. He found not just a whole new narrative form but a whole new body of material to narrate.[40]

Judith Chazin-Bennahum writes that Tudor "focused on the dramatic motivation of a dancer playing a character and looked for distinguishing and characteristic qualities [of each character]."[41] She offers that "Tudor's ballets are often called 'poetic,' evoking images and powerful personal feelings that resonate throughout his work."[42] Again, Chazin-Bennahum shares that "Tudor created poetic gestural moments without melodrama or

---

[39]Myron Howard Nadel and Constance Gwen Nadel, eds. *The Dance Experience: Readings in Dance Appreciation.* New York: Praeger Publisher, 1970, p. 249.

[40]Donna Perlmutter, *Shadowplay: The Life of Antony Tudor.* New York: Penguin Group, 1991, pp. 80-81.

[41]Chazin-Bennahum, *The Ballets of Antony Tudor*, p. 5.

[42]Chazin-Bennahum, *The Ballets of Antony Tudor*, p. 15.

histrionics."[43] Having performed or watched other dancers in rehearsal for several of the great female character roles of the full-length story ballets, I believe that Tudor's Hagar in *Pillar of Fire* joined the lineage of great female characters as unique and challenging to embody. For me, this includes Petipa's Odette/Odile;[10] however, unlike Odette/Odile, who appears caught in a web of sorcery and spells, Tudor's Hagar was just a woman dealing with everyday feelings of confinement, inner-family dynamics, and social expectations. For me, it seems that the plight of the female character in ballet was "updated" or made "everyday" through the Tudor narratives. Also, in Tudor's hands even the most difficult step signaled an emotional shift, a need or intention for Hagar. The virtuosic step was not the next technical feat or the pyrotechnical thirty-two fouettes (a series of repeated turns on one leg) during the Black Swan pas de deux.

Tudor's ballets as stories depicted experiences and interactions of the Tudor characters, the average man and woman, in a moment in time, not as mythic figures in an image of timeless fantasy. The Tudor *moment,* however, was fully explored, analyzed, and fraught with details. It could be considered Proustian; that is, epic in its proportion of information to movement, of movement to character, of characters to each other. Critic and dance expert P.W. Manchester affirms Tudor's propensity for complexity of detail by stating: "The audience could tell you what happened to these characters after the curtain came down. Where they went and what they did. That's how detailed and sure Tudor's concepts were."[44]

---

[43]Chazin-Bennahum, *The Ballets of Antony Tudor,* p. 4.

[44]Perlmutter, *Shadowplay,* p. 135.

To highlight Tudor's focus on detail in capturing the interrelationships of his characters, I offer the following two examples:

In *Jardin aux Lilas* or *Lilac Garden* (1936),[45] Caroline is the only character who is named. All the other characters are simply labeled: Her Lover, The Man She Must Marry, and An Episode in His Past (the past of the man she must marry). As the characters are introduced, their movements immediately establish their relationship to Caroline. The relationships are capsulated and the psychological tensions between characters revealed within seconds of the curtain rising.

In *Lilac Garden*, the audience is introduced to Caroline and The Man She Must Marry. They are standing together center stage; Caroline is standing slightly in front of the man, her right hand behind her back. The audience observes that the two characters are standing close to one another, but when they begin to move, they reveal no closeness, no feeling of two people about to marry. Instead, there is a tension between them. Caroline moves and gestures to him as if to plead with the him; he moves as if to possess her, yet unwilling to fully consider her presence.

In *Pillar of Fire* (1942),[46] Hagar is also the only character who is named. All the other characters are presented in relation to Hagar. There is her Eldest Sister, Youngest Sister, Friend, Young Man from the House Opposite, Lovers in Innocence, Lovers in Experience, and Maiden Ladies out walking. Immediately upon their introduction into the story, the movements of all the characters reveal some part of Hagar's personal history, some prior experience with Hagar and a suggestion of how future interactions

---

[45]See Appendix D.

[46]See Appendix A.

with her will play out. Tudor, through the design of uniquely biographical and specific movements for each character, sets the stage for the moment, the interplay of psychological tensions between the Tudor characters.

Earlier in this chapter, I described the opening moments and movements of Hagar sitting on the front stoop of her house in *Pillar of Fire*. When the audience is introduced to her younger sister and the friend, a man who Hagar is interested in, they can watch the developing narrative as the friend gestures toward Hagar as if to begin a conversation and Hagar's reciprocating attempts to move toward him. These attempts by both characters are dashed as the flirtatious younger sister repeatedly dances in between Hagar and the friend. Finally, the younger sister wins the moment and the friend seems to lose interest in Hagar. Within a minute of choreography, Tudor has intricately established Hagar's relationship to her younger sister and made complex the embodied and thwarted desire for a relationship.

Tudor began his narratives with an idea of how his characters moved or the private and social corporeality of his characters. During the hours I spent with Tudor, I felt the potential in each character's gesture; how their social status was defined in how they moved, or how, through the use of the spine and gesture, the characters revealed the context of their lives and relationships with each other. To illustrate Tudor's capacity to construct character through specific movement and gesture, Janet Reed, who was cast as the Younger Sister in *Pillar of Fire*, shares her following story:

> *Tudor used wonderful imagery to help the dancer create a role. For the kittenish younger sister in Pillar of Fire, he told me that she never looked at anyone directly; it was always from down and under. She never went straight to anything; her*

*movements were all curly... He never worked on character as a thing apart from dance; the character was in the movement.*[47]

One reviewer quoted by Judith Chazin-Bennahum also adds:

*Tudor's dancers become their roles. One comes onstage and you're certain that a life for Hagar or Caroline preceded this glimpse you're getting and will continue after she's gone from sight. Dancers act, not just through cleverly manipulated facial expressions, variations on theatre masks or traditional pantomime, but with their bodies.*[48]

Having worked with Tudor, I feel that the character of Hagar was brought to life in my body through the Tudor choreography. I had no desire or need to embellish what Tudor had so skillfully crafted. His movement was all I needed.

## Exploring the Depth and Detail of the Tudor Ballets

To accomplish Tudor's fully realized narrative, he would push the dancers into exploring new ways of moving. Tudor was only satisfied with the dancer's performance of his choreography after the exact movement was discovered supporting his narrative. The shape of a hand, the placement of the foot, the angle of the head all were important; therefore, they had to be tended to and repeated endlessly so that they became part of the dancers'/character's body. The movements were required and expected of the dancer. Judith Chazin-Bennahum, former Tudor dancer and author, offers a wonderful example of Tudor's process told to her by an anonymous notator for the ballet *Undertow:*

---

[47]Reed quoted in Chazin-Bennahum, *The Ballets of Antony Tudor*, p. 8.

[48]quoted in Chazin-Bennahum, *The Ballets of Antony Tudor*, p. 14.

*The notator for the ballet Undertow said, 'I remember sitting next to him while working on hour after hour rehearsing with him. We would review and labor over each character and then move on. Tudor's body, and especially his back and neck, would change shape and quality as he watched and rehearsed the various characters. He might not remember the exact steps. He kept fussing. He would do fourteen versions and then come back to the first version. He wasn't happy with what he did if it didn't match his mind's eye vision.'[49]*

In Donna Perlmutter's book on Tudor, *Shadowplay*, Cuban ballerina Alicia Alonso gives an account of working with Tudor while she was in American Ballet Theatre. Alonso remembers that Tudor walked over to her and asked: "How do you say hello to someone you like very much?" Perlmutter then notes how Alonso moves as she did that day in response to Tudor. She quotes Alonso:

*[I] made a movement with [my] upper torso and hands and then he told [me] to do the same thing demi-plié and arabesque, turning [my] head to the side. 'It was lovely… it was real. It meant something very special. It told [me] the difference between Tudor and other choreographers. They think of steps as primary. He thinks of feelings as primary.[50]*

Without the dancers' persistent vigilance during rehearsals, vitally important information conveyed by a look or a gesture could be lost. Furthermore, Tudor required a continued vigilance from the dancer even after he or she had performed a role. His casts had to continue to deepen their understanding of the roles they performed. During an interview with Jennifer Dunning of

---

[49]Chazin-Bennahum, *The Ballets of Antony Tudor*, p. 8.

[50]Perlmutter, *Shadowplay*, p. 124.

the *New York Times*, present director of American Ballet Theatre Kevin McKenzie recounts how Tudor wanted the dancers to sense that they were in a real setting, in this case walking through a garden filled with moss. Or was it leaves? For each choice, they would create a different sensation for the foot. In Kevin McKenzie's quote shared by Jennifer Dunning, he gives a glimpse of Tudor's sarcasm. He states:

> *I was pretty nervous because I hadn't worked with him that much. I did my entrance with great commitment, and he went on for a little bit, and then he had to stop for another correction. He glanced over in my direction and said, "You know of course why you're not supposed to make noise on the floor." And I said, "Well, I know that I wasn't in control of my weight." He said, "No, you fool, you know why you're not supposed to make noise on the floor. You're not employing your imagination. You obviously don't see the moss and the leaves." We did a run-through. He gave everybody corrections, and he didn't say a word to me. At the end of the rehearsal he said to me, "So, now you know why you don't make noise on the floor." And I said, "Of course, the garden, the moss." And he said, No, you fool, it was because you were in control of your weight." He had a little glimmer in his eye. There was this moment of tension, and silence. And then I just barked out a laugh that I couldn't hold back. And it was as if the truce had been found.*[51]

Tudor was at times caustic, critical, and notoriously rude with the dancers who had to withstand his Englishman's rapier

---

[51]Dunning, Jennifer. "Antony Tudor's Teaching Method: 'No, You Fool!" *New York Times*, 26 October 2003, p. 1.

wit. He constantly dug deep into their abilities, cutting away excess, mannerism, any gesture or personal movement affinity that did not serve his process. Tudor defended his process by arguing, "'You've got to get rid of the personal mannerisms to get to the character in the ballet and dancers don't want to let go.'"[52] However, for me, after working with Tudor I began to think about my dancing in ways I had not previously considered. I believe that through his creative process Tudor was also shaping my process in developing as an artist. Perhaps, it was Tudor's almost manic desire for specificity and detail as a way of dancing, a way of paying attention as a dancer, that I feel shaped my approach to all of my dancing thereafter. I can only imagine the impact of his work on the original casts of his early masterworks.

Nora Kaye, Tudor's muse during his early years with American Ballet Theatre, also discusses her own development as a dancer through Tudor's process and his ballets. She suggests that "as an American ballerina... I never take anything for granted. I question each tradition, each interpretation, each movement."[53] Along the same lines, Lucia Chase, former director of American Ballet Theatre, comments:

> *Tudor does not explain the feeling he wants; he shows emotion by motion, by demonstrating the movement. You have to sense the meaning from him, to find out what he is after, you have to keep doing the movement until you feel it. The movement phrases ride over the music. There are no steps in Tudor ballets, only phrases.*[54]

---

[52]Topaz, *Undimmed Lustre*, p. 111.

[53]Nadel, *The Dance Experience*, p. 249.

[54]Chase quoted in Topaz, *Undimmed Lustre*, p. 104.

During the American College Dance Festival at Washington University, Trinette Singleton, former dancer with the Joffrey Ballet, shared her story with me of working with Tudor in *Offenbach in the Underworld*. She recalls how during one of the first rehearsals, Tudor turned to her and asked her name. Quickly, sensing a lesson within the question, Trinette answered him using her character's name. Tudor smiled. Trinette had survived the test.

At other times, Tudor's vigilance turned more thoughtful. Bonnie Mathis who met Tudor when she was a student at Juilliard and also danced with him in American Ballet Theatre shares:

> *Feedback on performance I would equate to reading a Haiku poem-elusive and poetic comments conveying his impression of the performance. The life coaching he offered was supportive, non-manipulative, often an unclouded mirror to our lives. There was a great humor, many questions, and great curiosity about people.*[55]

## Concepts of Movement and Classical Ballet Training

For Tudor, "The performer should seek to achieve economy, but with perfection in purity of technique and manner."[56] Tudor wanted to work with good dancers; however, his movements, although at times difficult, were not considered virtuosic. There was for Tudor something in the Cecchetti syllabus that gave him a base from which to explore and which further supported his narratives beyond the reliance on mere technical feats. The Cecchetti

---

[55]Bonnie Mathis, "The Influence of Antony Tudor on a Dance Artist." Proceedings of the Thirty-first Annual Meeting of the Dance History Scholars, June 12-15, 2008; Roundtable on *Tudor Today: A Centennial Glance*, p. 105.

[56]Chazin-Bennahum, *The Ballets of Antony Tudor*, p. 5.

syllabus developed well-balanced dancers whose solid founda-
tion in aspects of alignment, carriage of the arms, and transfer-
ence of weight, enabled them to explore, along with Tudor, his
many variations and tangents of movement. In the beginning, the
Cecchetti technique was the language of Tudor's process.

The Cecchetti language often baffled dancers who came to
the Tudor ballets with a reliance on their virtuosic capacities as
defining their artistry. Tudor, however, encouraged all dancers,
but especially the virtuosic dancer, to look more deeply into his
or her artistry to find a point of entry into the choreography. In
effect, Tudor had to get to the dancers' humanity, their souls. And
the dancers had to remain open to this new way of working and
dancing.

The Cecchetti technique might be the foundation of Tudor's
process, but he created variations or tangents away from the es-
tablished movement system that defined his characters and pro-
pelled his narratives. Learning how to discover the physical ex-
cursions that could take the dancer deeply into and away from
the Cecchetti rules was the challenge for dancers when working
with Tudor. Again, Bonnie Mathis, former Tudor dancer from
American Ballet Theatre, recounts how Tudor might vary and ex-
pand upon the Cecchetti syllabus. She remembers:

> One of the important ideas was the use of épaulement to moti-
> vate movement into space by thinking of moving the back, ra-
> ther than the front of the body. Often very difficult weight
> shifts emphasized this concept. Of course, the timing of the
> plie, leading up to the following movement was important. He
> was asked, "Is the plie the beginning or the ending of the move-
> ment?" Of course, the answer was... both.[57]

---

[57]Mathis, "The Influence of Antony Tudor on a Dance Artist," p. 104.

An example of Tudor's unique use of plié (a bend of the supporting knee), is in his preparation prior to pirouettes (turns on one leg either moving outward or inward). Contrary to the Cecchetti syllabus, Tudor preferred and choreographed no visible preparation for his pirouettes. Sometimes, he only allowed for a deepening of the plié within the previous step. Well, for the classically-schooled ballet dancer, this no preparation strategy appeared beyond difficult, just plain awkward, and, further, awkward to the sense of being laborious and ugly. However, for Tudor, no phrase of movement was broken or no narrative compromised by a visible, out of context step or preparation. The well-schooled dancer when working with Tudor learned to adapt. The dancer had to find not the beauty, but the logic of the movement to the Tudor choreography. That logic was always rooted in the interrelationships of his characters, the backbone of his narratives. Hugh Laing, Tudor's lead dancer and life partner, is quoted by former Tudor dancer and author Judith Chazin-Bennahum, as explaining the logic behind the lack of plié. Laing states:

> *Tudor may expect the dancer to do four pirouettes, but one cannot let the preparation show. If the turns are part of a phrase that may be saying, "I love you Juliet," you must not interrupt that phrase to take a fourth position preparation because then you are paying attention to yourself as a dancer, not Juliet.*[58]

Diane Adams, former Tudor dancer with ABT and leading interpreter of Tudor's choreography, also found it very difficult to embody Tudor's ideas. She remembers:

> *To work with Tudor, you had to be a brilliant dancer. Academically his movements were not strenuous, but they were often*

---

[58]Chazin-Bennahum, *The Ballets of Antony Tudor*, p. 11.

*uncomfortable....* For *Medusa* in *Undertow,* he wanted a *purely classical line, yet the effect had to be hideous. 'Too neat' he would say.*[59]

Muriel Topaz, speaking as the labanotator of the score of *Pillar of Fire* score reports:

[T]*he very verticality of the body, the non-involvement, is a stylistic statement. The arms are more in focus than the feet, and have gestures that are character specific. The progression is of a start and stop nature; the sequence rather progresses smoothly nor travels very far. It is quite literally inhibited, controlled movement, reflecting the inhibited, controlled nature of the characters. The fingers are tightly pressed together, tight as the old maids who exhibit them. And the skirt is twisted in the embodiment of snobbism.*[60]

Topaz further discusses how movements in Tudor's *Sunflowers* reflect, "a typical Tudorism, taking classical material and manipulating it in such a way that it loses its recognizable reference to the classroom."[61]

In my experience as a Tudor dancer, I found that his choreography forced the dancer to move through a *grounded sensibility,* through a sense of the floor, while still retaining classical ballet vocabulary. The combination of weighted and character-driven movement projected the appropriate *human* quality of his characters. Jack Anderson of the *New York Times* in reviewing American

---

[59]Adams quoted in Topaz, *Undimmed Lustre,* p. 116.

[60]Muriel Topaz, "Specifics of Style in the Works of Balanchine and Tudor." *Choreography and Dance*: 1 (1988), p. 21.

[61]Topaz, "Specifics of Style," p. 28.

Ballet Theatre's production of *Dark Elegies* commented on the use of weight, the emotional weight of the Tudor's steps. He writes:

> No other ballet quite resembles "Dark Elegies." This fact as well as the use of weighted movement ally it to the emotionally motivated modern dance prized in the 30's. Believing in the slogan that "form follows function," many theorists of the time argued that each dance should possess its own unique form – a form that would be the outward manifestation of the emotional experiences that inspired it. In "Dark Elegies" Mr. Tudor choreographed a masterpiece in accordance with these precepts.[62]

## Tudor's Musicality

Tudor thought about music and dance as interconnected forces moving together in an interplay of phrases, a conjoined expression foundational to his narratives. His dancers had to be musical. However, this musicality was not about having the ability to count music, not in the ability to respond to specific landmarks, but in the ability to be *in* the music, to move in an intuitive *felt sense* with the musical phrase. During the Kennedy Center Honors for Tudor, Agnes De Mille referred to his choreography as "paraphrases... writ on the wind."[63] I remember Tudor singing his movements almost as lyrics. That said, he is also captured on film counting part of the fifth song of *Dark Elegies*. Muriel Topaz, again writing as a labanotator, affirms:

---

[62]Jack Anderson Jack. "Tudor's 'Dark Elegies,' by Ballet Theatre." New York Times, 6 June 1987, p. 2.

[63]*Antony Tudor*. Dirs. Viola Aberlé and Gerd Andersson. Stockholm and New York. 1985. DVD. Highstown, 2007.

*A common understanding among Tudor dancers is that there
is a note for every movement; he sometimes asks the dancer to
sing the musical line in rehearsals. Metric rhythm versus
breath rhythm might be one approximate way to characterize
the difference between the two approaches*[64].

Additionally, in reference to Tudor's *Sunflowers*, Topaz re-
lates:

*Tudor leads us to listen to the music in a different way. His
phrases ride over the bar line. He leads our ear to the melody,
to the expressive part of the musical sound.... Or Tudor might
engage in a dialogue with the music, purposely constructing
the dance phrase so that it produces cross accents with the mu-
sic...."*[65]

Ultimately, the Tudor dancers discovered the path to a suc-
cessful performance was to listen to the music.

## The Tudor Qualities

My work with Tudor, especially the time I spent in the re-
hearsal with him, confirmed for me that Tudor educated me, and
potentially the dancers around me. He taught me about the pos-
sibilities of movement through psychological motivations, about
being present in the process of collaboration, about being at one
with the musical phrasing which was so interconnected and wo-
ven throughout his choreographic phrases, and about remaining
connected to my humanity as I pursued my dance career. I don't
believe I was alone in thinking Tudor was different from other
choreographers I had worked with; nor do I think I corralled his

---

[64]Topaz, "Specifics of Style," p. 32.

[65]Topaz, "Specifics of Style," p. 32.

influence or the knowledge he shared; and I certainly don't feel Tudor's influence on dancers began and ended with me. After all, there were too many casts of dancers and too many rehearsal hours in which he could and would have taught countless burgeoning artists to dance through their humanity. What is truly important is how dancers working with Tudor could become aware and open to new ways of moving and dancing within musical phrases if they accepted his artistry and his artistic practice.

In just American Ballet Theatre alone, multiple casts of dancers had the opportunity of working with Tudor and dancing in his ballets in multiple performances. As a result, the dancers' skills for dancing the Tudor ballets increased. And, as with Nora Kaye, my process of learning choreography was changed in a way that influenced how I learned other choreographer's dances. I questioned, I dug deeper into the character or the choreography. And, if I became a better dancer by dancing the Tudor ballets, then, I believe that dancing a Tudor ballet produces better ballet dancers. To what extent my belief is accurate will be discussed later on in Chapter Four.

Tudor's influence did not stop in rehearsal. The ballet audiences were also learning about the power of Tudor to tell a story. I believe that through the multiple performances of the Tudor ballets by American Ballet Theatre and other companies, the audiences were given the time to review and reconsider these masterworks. During Tudor's prolific years of creating and restaging his works, the audiences were given the opportunity to watch ballet history in the making. This was a new kind of ballet storytelling; it highlights a moment, a period of time, or the life of the everyday man or woman. Again, former Tudor dancer Diane Adams perhaps says it best when she shares:

*To me, Tudor's greatest contribution lies in his revelation of intense emotional relationships among the characters on stage. With him, for the first time, ballet became concerned with what happened to people.*[66]

## The Tudor Trust and The Répétiteurs

Before the twentieth century, the masterworks of great ballet choreographers were typically housed and sustained by major ballet companies. The masterworks lived in a perpetual *afterlife* through the efforts of the assigned ballet master who had been given the responsibility of restaging the works once the choreographers had passed. The afterlife only continued through the auspices of the director of the major ballet company. Unfortunately, under this system, some masterworks have been lost. Beginning in the twentieth century, master choreographers began to create their own *Trusts* as repositories for their works. Such is how the Antony Tudor Ballet Trust was set up through the guidance of Tony Bliss, former general manager of the Metropolitan Opera, and Sally Bliss, Tudor dancer and past director of The Joffrey II Dancers. Tudor's first choice of executor of his will and trustee of his ballets was Jiri Kylian. Thoughtfully, and luckily, Kylian declined. Kylian was convinced that being a master choreographer himself would not be in the best service of the Tudor ballets. Sally Bliss having worked with Tudor at the Metropolitan Opera was a better choice. Tony Bliss, partner of the law firm of Milbank, Tweed, Hadley, and McLoy, asked if any of the lawyers would help create a trust for an internationally known choreographer[67]. Jay Swanson offered to work pro bono for the burgeoning Tudor

---

[66]Adams quoted in Topaz, *Undimmed Lustre*, p. 28.

[67]Sally Bliss, Personal Interview 13 December 2011.

Trust.[68] Prior to his death, Tudor put the details of creating the Antony Tudor Ballet Trust into the hands of Sally Bliss and Jay Swanson, also co-executors of the Tudor will. With these plans in place, after his death in 1987, the Antony Tudor Ballet Trust was established and is today responsible for the preservation and on-going performances of the Tudor ballets.

Sally Bliss became both executor of the Tudor will and Trustee of the Tudor Trust. Jay Swanson, the original handler of all the legal work for the Trust and part of the law firm of Milbank, Tweed, Hadley, and McLoy, was replaced by George Maguire of Deveboise and Plimpton.[69] Also, since the beginning of the Tudor Trust, any new staff members added to the Trust were all active professionals in their prospective fields who had contacted Sally Bliss to express a desire to work with the Trust. Furthermore, each new position was added to fulfill the growing responsibilities of the Trust and to expand the exposure of Tudor and his ballets. Over the years, these new staff members of the Trust included: Tara McBride, administrator; Adria Rolnik, web coordinator; and Bill Soleau, videographer.[70]

The newly established Trust also gave rise to a need for a new category of practitioner within the ballet field. For Sally Bliss, the available terms of "restager," "reconstructor," or "recreater" were insufficient in capturing the nature of the responsibility entrusted to the group by the Tudor Trust. Drawing from a term found in ballet history, Sally Bliss named this new group the Répétiteurs.

---

[68]Sally Bliss, Personal Interview 13 December 2011.

[69]Sally Bliss, Personal Interview 13 December 2011.

[70]Sally Bliss, Personal Interview 13 December 2011.

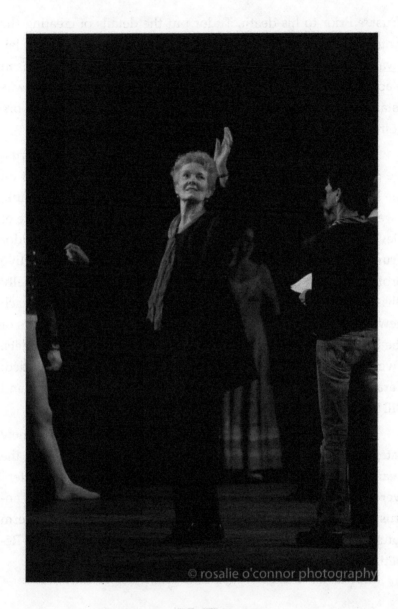

Sally Bliss
Trustee Emeritus of the Anthony Tudor Ballet Trust

Photo courtesy Rosalie O'Connor Photography

The term Répétiteur was chosen by the Tudor Trust to signify the particular person responsible for restaging the Tudor ballets and maintaining the qualities of those ballets. Typically, the Répétiteurs do not reconstruct or recreate an historic or lost work; however, some methods of reconstruction are used to recreate parts of a ballet where few resources exist within the Trust. To clarify, reconstruction or recreation signals a process which begins from limited resources (e.g. pieced together statements from texts; interviews with original cast members; and/or archived historical documents, programs, photographs, music, costumes, or sets). This process of reconstruction is not specifically the case with the restaging of the Tudor works where the majority have been captured on video and where the first generation Répétiteurs have directly worked with Tudor. And, through Sally Bliss's skillful selection process, future Répétiteurs are chosen from dancers who have performed the Tudor ballets, but who are too young to have worked with Tudor. This process ensures that there is an emerging second generation of Répétiteurs.

The Répétiteurs, as agents of the Tudor Trust, act in accordance with the Trust's rights and licensing procedures to create the most authentic productions of the Tudor ballets. Tudor created multiple versions of his ballets providing, potentially, differing performance experiences for each of the Répétiteurs dancing in those ballets. Therefore, the Trust, through their collection of videos of past productions along with the memories of the Répétiteurs and other performers dancing in the Tudor ballets, is able to maintain access to the numerous versions of the Tudor ballets. The versions were created during different periods of Tudor's career when he rethought sections of his ballets, allowed for artistic variance by particular dancers, or when the ballets were restaged for the camera. According to Sally Bliss, the collection and verifi-

cation of each version of a Tudor ballet captured on video or remembered by one of the Répétiteurs is not an easy process. Chapter Three discusses the unique position of the Trust in authenticating the collected versions of the Tudor ballets.

What has not altered in any of the Tudor versions is the recognizable Tudor aesthetic and unique choreographic perspective. The responsibility of retaining and sustaining this specific aesthetic and choreographic perspective as evidenced in his masterworks is directly in the hands of the Répétiteurs; as such, they are the stewards of the Tudor ballets. The Répétiteurs' productions of the Antony Tudor ballets keep Tudor alive and his ballets relevant for generations of future dancers and audiences. The work of the Répétiteurs in restaging the ballets of Antony Tudor for the Tudor Trust is the focus of this book.

During my months of research, it became clear that Sally was anticipating a change in leadership. She spoke of it several times and was in the process of considering the exact timeline of stepping aside for a new leader and, equally important, who she would choose to handle this great responsibility.

That decision has been finalized and the changes are detailed in the conclusion.

# Chapter I
# The Framework

## The Répétiteurs' Story

This book explores the work of the Répétiteurs of the Antony Tudor Ballet Trust in restaging the ballets of Antony Tudor. The contribution of these Répétiteurs within the Tudor Trust, under the direction of Sally Bliss, is a valuable, yet little researched area. By way of introduction, it is necessary to present an overview of the inter-linking issues involved in restaging the master works of twentieth-century ballet choreographers. These issues are:

1) the restaging of ballets not housed in the repertoire of a major ballet company,

2) the restaging of ballets where the lineage of teaching the choreography (choreographer to dancers, ballet master to dancers, former dancer to new cast member), is broken through a lack of scheduled performances of the work, or

3) the lack of experience with the ballet by any director or chair of a dance department, thereby preventing any connection or interest in producing the ballet.

The role of Labanotation in the restaging process becomes another variable when discussing the reconstruction process. Labanotation is a form of notating dances created by Rudolf Laban to ensure a permanent "score" of the dance much like a musical score. For this research, Sally Bliss of the Tudor Trust acknowledges the importance of notating any of the Tudor ballets

that are not presently notated. She prefers Labanotation over the alternative format of Benesch notation, citing its accuracy in capturing Tudor's unique musicality.[71] On the other hand, she also prefers to engage Répétiteurs for the restaging process because of the unique experiential nature of their process which closely relates to working with Tudor, and cannot be captured by any notation.

## How My Research Began

My interest in the restaging of the ballets of Antony Tudor arose from having danced for Mr. Tudor during my years at American Ballet Theatre. To help matters, I was already familiar with the work of Sally Bliss, executor of the Tudor will and Trustee of the Antony Tudor Ballet Trust, in restaging Mr. Tudor's ballets. I met Sally Bliss when she was director of Dance St. Louis, a non-profit dance presenter in St. Louis. While dancing with the National Ballet of Canada in Toronto, Ms. Bliss frequently traveled to New York City on weekends to study with Tudor. Meanwhile, while dancing in the company, she performed in *Offenbach in the Underworld*, music by Jacques Offenbach (1959)[72] and *Gala Performance*, music by Sergei Prokofiev (1938).[73] Later, she performed in *Echoing of Trumpets*,[74] and *Concerning Oracles*, music by Jacques Ibert (1996)[75] under Tudor's direction while in the Metropolitan Opera Ballet in New York City. As director of the Joffrey II dancers, she produced several of Tudor's restagings including

---

[71]Sally Bliss, Personal Interview 18 April 2012.

[72]see Appendix P

[73]see Appendix Q

[74]see Appendix J

[75]see Appendix R

*Continuo* and *Little Improvisations,* with music by Robert Schumann (1953).[76]

The work of the Répétiteurs in restaging the Tudor ballets was first the subject for a project for my doctoral work with Dr. Penelope Hanstein of Texas Woman's University. For that project, I first approached Ms. Bliss about being interviewed. I also asked for her permission to interview two Répétiteurs and to have access to their rehearsals. My choices for participants were Donald Mahler, then senior Répétiteur; and James Jordan, then Répétiteur in-training and ballet master of the Kansas City Ballet. Sally Bliss graciously opened the Antony Tudor Ballet Trust to my research and supported my choice of participants.

Donald Mahler danced in several Tudor ballets including *Dark Elegies,*[77] *Jardin aux Lilas,*[78] and *Offenbach in the Underworld*[79] while performing with the National Ballet of Canada. He also performed in *Echoing of Trumpets*[80] and *Concerning Oracles*[81] under Tudor's direction while dancing with the Metropolitan Opera Ballet. Mr. Mahler further worked with Sallie Wilson, who followed Nora Kaye as American Ballet Theatre's main interpreter of Tudor's roles. Ms. Wilson later helped to restage Tudor's works in American Ballet Theatre after his death.

---

[76]see Appendix S

[77]see Appendix F

[78]see Appendix D

[79]see Appendix P

[80]see Appendix J

[81]see Appendix R

James Jordan performed in Tudor's *Jardin aux Lilas*[82] and *Gala Performance*[83] with the Kansas City Ballet before becoming a Répétiteur with the Tudor Trust. The following year his expertise in restaging the repertoire of the Kansas City Ballet was immediately called into play when he was asked to restage *Gala Performance* for the company when all of the Répétiteurs were already working. Since then, he has begun in-depth training with Donald Mahler to continue to learn several of the Tudor ballets. Most recently he restaged *Dark Elegies*[84] for the Performing Arts Department of Washington University in St. Louis and the Dance program at the University of Missouri-Kansas City as part of his training. I met both Donald Mahler and James Jordan during two separate Tudor residencies of restaging Tudor's *Dark Elegies* for the Performing Arts Department at Washington University in St. Louis.

For this book, I again solicited the assistance of Sally Bliss and further expanded my participants from the original three to five by inviting then Répétiteurs Kirk Peterson and Amanda McKerrow to join the research process. I danced with Kirk Peterson, former principal dancer with the National Ballet and American Ballet Theater as well as being an independent choreographer, during my years at the National Ballet. Mr. Peterson learned many of the Tudor roles directly from Tudor and then studied the restaging process for the Tudor ballets with Sallie Wilson, Tudor's muse after Nora Kaye, during her years with American Ballet Theatre.

---

[82]see Appendix D

[83]see Appendix Q

[84]see Appendix F

I met Amanda McKerrow, former principal dancer with American Ballet Theatre and last ballerina to have worked with Tudor, during the meetings of the Antony Tudor Dance Studies Committee in June 2010. Ms. McKerrow brings an extensive background to the restaging process having danced in several of the Tudor ballets including *Pillar of Fire*[85] and *The Leaves are Fading*[86] and also having studied the restaging process with Sallie Wilson.

In addition, I interviewed three dancers who had worked in one or more of the restagings of a Tudor ballet with at least one of the participants. The student/participations were Appie Peterson from the University of Missouri-Kansas City in Kansas City, Missouri; Matt Schmitz from Webster University in St. Louis, Missouri; and Joshua Hasam from Washington University in St. Louis, St. Louis, Missouri. These foundational procedures provided a strong framework for my book and made me realize that the more I researched the work of the Répétiteurs, the more fascinated I became with this valuable and little-known process.

The importance of this study resides in the larger issue of why it is important to maintain our ballet heritage. Pertinent to considering the preservation of ballet heritage is the preservation of the individual master works of the twentieth-century ballet choreographers. The issues of legacy and authenticity in regards to the preservation of ballet master works have been interwoven throughout my research. In other words, my research on the work of the Répétiteurs of the Tudor Trust in restaging the Tudor ballets crosses over and intersects with issues of preserving the

[85]see Appendix A

[86]see Appendix C

original choreographic intention, and thereby sustaining the authenticity of a ballet within each subsequent production when the choreographer is no longer available to restage it.

To clarify the terminology, throughout this book I will be classifying certain ballets as masterworks. I have chosen to use the following criteria employed by dance historians and critics to make this determination:

1. Critics from major news organizations (the *New York Times*, the *London Times*, or the *Village Voice* in New York City) credit the choreographer for creating something new that will alter the direction of ballet choreography.

2. Well-respected dance artists in the field of classical ballet credit the work for its impact on ballet choreography and deem it seminal to ballet history.

3. Ballet historians knowledgeable of ballet history credit the work for its innovation and unique use of the ballet vocabulary and employ the choreographer and/or the work as an example of a seminal moment in ballet history.

This terminology is important since it places the Tudor ballets as not only important within their own time periods, but also as being seen by professionals in the field to create moments of change for the future of ballet.

My research also raised the following questions: 1) Who will do the work of restaging the ballets?; 2) What do the restagers do to preserve, sustain, and, ultimately, share the choreographer's craft and style with the next generation of ballet dancers?; 3) Who will produce the work in order for the restagers to have an opportunity to restage the ballets?; 4) How marketable are restaged twentieth-century master works to twenty-first century audiences? In the following chapters, I will explore the complicated issues within these questions in order to better describe the role

that the Répétiteurs of the Antony Tudor Ballet Trust play, especially as they relate to the larger issues concerning the preservation of Tudor's place in ballet history and his choreographic legacy. Further, I hope to open new insights into how Tudor's ballets might be appreciated and kept alive for future generations of Tudor dancers and audience members.

A major challenge to the preservation of any ballet master work is how to develop an interest in producing the work by a ballet company. Maintaining this interest is important since the active repertoire of the ballet choreographer, (the ballets restaged for production by ballets companies, at least the ones that are preserved), are saved through the continued interest of directors, ballet masters, and dancers, and, to some extent, the audiences. Clearly, ballets that are restaged, recreated, reproduced, revived, reconstructed, or re-performed on a continual basis have a better chance of survival than those that are lost to generational disinterest. Even more advantageous to a ballet's future survival is when the directors have some experiential knowledge of the ballet, probably having seen it or even, better yet, having danced in it. This familiarity of the preserved ballet by the director allows her or him to more passionately submit the importance of restaging the ballet to the ballet company's board of directors.

Marcia Siegel calls the continued performance of a ballet following the opening night its *afterlife*. Without a continued afterlife, the master work may not exist beyond the life of its creator. For example, there are many works of Leonide Massine, twentieth-century ballet choreographer with Ballet Russe de Monte Carlo, that received acclaim when first performed, but weren't recorded or presented enough times in enough diverse geographical locations to have an impact on the directors of ballet companies. The only Massine ballets reproduced recently are *Les Presage*, music by Pytor Tchaikovsky, produced in 1992 by the Joffrey

Ballet of Chicago, Illinois (Joffrey) and *Choreatium*, music by Jo-
hannes Brahms, produced in 2012 by the Bayerisches Staatsballet
(Bavarian State Ballet) in Munich, Germany (Bavaria). The Dance
Notation Bureau in New York City had no record of any company
requesting the notation of a Massine ballet for production.[87] The
remnants of many of the Massine ballets currently only live in a
few black and white photographs, as entries in ballet history
texts, or in Labanotation scores. Seeing the black and white pho-
tographs or reading a dance history entry, or even reading a past
review of the ballet, does not often generate enough interest by a
director or motivate a board of directors to commit large sums of
money to the restaging efforts.

To further complicate the restaging efforts, dancers who
were in the first production of the ballet, those who experienced
the creation and represent the embodied knowledge of the ballet,
are now retired or deceased. Even the ballet masters who were
present during the creative process from which the ballet
emerged are also more than likely retired or deceased. The ques-
tion then becomes: If there was an interest, who would restage
the work and how would that process take place? This question
underlied the direction of my research, a process that continued
to raise more questions the deeper I explored it.

The loss of an acknowledged master work represents, in
some cases, the loss of a work that made a significant contribution
to ballet history. Furthermore, the ballet may even represent the
contribution of a particular choreographer who injected a unique
artistic vision into the course of ballet history, thereby affecting
the evolution of ballet choreography. Without any means of
preservation, future generations of dancers will be unable to ex-
perience the ballet that was noted as affecting the development of

---

[87]Dance Notation Bureau. Phone Interview. 17 Aug. 2012.

ballet choreography. Finally, ballet dancers of the twenty-first century may unknowingly move through a cadre of choreographic practices initiated by twentieth century choreographers challenging traditional norms; these ballet dancers may be unaware that what they now consider the norm was actually a revolutionary act by the earlier choreographers. The skill sets exhibited by current ballet dancers result from the amalgamation of differing paradigm shifts created by individual choreographers throughout history. Understanding that history, that lineage, is important for ballet dancers to see their art form as living through time and to sense how this living artistry now shapes their own practice.

## Nijinsky's *Sacre du Printemps* – Robert Joffrey as a Motivating Force

Our focus is on the problems faced by the person charged with resuscitating a ballet long after its final performance. In addition, let me clarify the term reconstruction in regards to ballet productions. Angela Kane, drawing on the ideas of dance historian Susan Manning, brings to light the importance of clearly defining how you are using terms to describe the act of renewing a dance. In a conference emphasizing aspects of the reconstruction and revival of dance, Kane quotes Manning as defining reconstruction as having a "primary reliance on non-oral, non-kinesthetic sources, either a notated score or visual documentation." Kane then continues Manning's ideas by emphasizing how a different meaning can be applied to the act of revival in dance: to Manning, revival relies on an "oral kinesthetic transmission" of steps and ideas.[88] The term restaging then would be applied to

---

[88]Manning quoted in Angela Kane, "Issues of Authenticity and Identity in the Restaging of Paul Taylor's *Airs*." Jordan, *Proceedings* 72-78.

those dances that are in continual performance with little time between the original production and the following productions; these dances do not need to be reconstructed or revived, they are still actively alive in performance. These three definitions are important when describing the work of the Tudor Trust. The Tudor Trust assures that a collection of Tudor ballets are always in the process of being restaged. However, to do this they rely on and are open to both oral and kinesthetic transmission (revival), along with supporting documentation (reconstruction). I will undertake a more in-depth discussion of these ideas in chapters three, four, and five.

To highlight and provide an example outside of the Tudor Trust for how these definitions have been used in the past when saving the afterlife of a ballet, let us examine the reconstruction and revival of Vaslav Nijinsky's *Sacre du Printemps* (Sacre), titled after the music composed by Igor Stravinsky. This particular process of reconstruction and revival has been written about at great length in numerous texts and documented on video. The background of this process began when dancer Marie Rambert was requested by ballet producer Sergei Diaghilev to aid Nijinsky with the original choreography, premiering in 1913. However, there were only four performances after that first production, so restaging was not possible after the dance was no longer in performance.

In 1955, Marie Rambert asked Robert Joffrey, director of the Joffrey Ballet, to visit her ballet company as a guest teacher and choreographer. During that visit, Joffrey asked Rambert about her participation in Nijinsky's *Sacre*. In response, Rambert danced a few phrases from memory for Joffrey and he excitedly expressed a desire to see the work performed again. After much work, the reconstructed *Sacre du Printemps* was performed by the Joffrey Ballet in 1987.

Robert Joffrey and the Joffrey Ballet hired Millicent Hodson, dance historian and choreographer, to reconstruct Nijinksy's *Sacre du Printemps*. Her work is an illustration of how much research must be conducted over time, similar to that of archeologists excavating to uncover hidden artifacts. Hodson had to find and then dig through archives, old photographs, and documents, as well as interview the last of the remaining original cast to reveal the almost lost master work. The ballet was not documented on video and the notation, as well as any remaining costumes, were scattered among libraries in five different countries. Black and white photographs and archived drawings helped in depicting particular moments or positions of the body, but they certainly did not reveal whole choreographed phrases. Furthermore, even though eighty percent of the costumes and some of the props were discovered, fabrics and dyes had changed over the years since *Sacre's* first performances, creating even more complications for the reconstruction. All Hodson could do was to purchase new fabrics and dyes to approximate the lost costumes as closely as possible.

Hodson interviewed Marie Rambert at the very start of the project; unfortunately, Rambert died in 1982 before the project was finished. Luckily, a copy of Rambert's notes written on an original score was found in her house after her death. As the film documentary on the reconstruction reveals, some sections of the choreography were not remembered or notated by Rambert thereby preventing a full revival of the movement; clearly, Hodson needed to create additional choreography to complete the reconstruction. The question that arose for critics evaluating the performance of the Joffrey Ballet's *Sacre* was: If indeed a portion of the costumes, sets, and choreography were brand new, were we now looking at Nijinsky's *Sacre* or the reconstructed *Sacre* created by Hodson?

In this case, the film documentary presents the Hodson reconstruction for the Joffrey Ballet as being as close to the original production as possible. Therefore, one can hope that not only was a master work saved, but a key example of Nijinsky's genius, his aesthetic, and his vision for classical ballet was also saved. Even if not exact, even if not the original, the Hodson reconstruction was considered to be as authentic as possible. Therefore, the Joffrey Ballet had done its part in saving the ballet and continuing Nijinsky's legacy. The question then arises: How long after the last restaging takes place before the reconstruction and revival process needs to begin again? Will there be a future afterlife for *Sacre du Printemps* and who will step up to undertake this process? These are the type of questions that the Tudor Trust must consider when looking at the *afterlife* of the Tudor ballets.

### Introduction to the Antony Tudor Ballet Trust

Such is the nature of the *afterlife* of the nearly lost master work. It is this transitory afterlife of lost choreography that spurred Muriel Topaz, author of *Undimmed Lustre: the Life of Antony Tudor*, dance notator, and dance educator, to urge Antony Tudor to create the Antony Tudor Ballet Trust. The Trust was conceived as an institution designed to prevent the loss of as many of the Tudor ballets as possible. The exact form and substance of the Trust was the purview of Sally Bliss, executor of the Tudor will and Trustee of the Trust. She and Trust lawyer George Maguire and Trust administrator Tara McBride have organized a system of licensing fees and royalty fees for each ballet according to the size of the ballet company or dance department negotiating to produce a Tudor ballet. The ballet company or dance department interested in producing a Tudor ballet contacts the Trust and then negotiates a contract. The contract details all the respon-

sibilities of the producing agency toward the ballet, the Répétiteur, and the Trust, including the choice of Répétiteur, costumes, sets, lighting, music, and program notes.[89]

Ms. Bliss often suggests the appropriate Répétiteur according to the specific ballet being restaged, or the producing ballet company or dance department may request a specific Répétiteur. Once the contract is signed and the Répétiteur chosen, the schedule for the restaging and all casting is turned over to the Répétiteurs. Ms. Bliss will re-enter the restaging process toward the end of the studio rehearsals and for much of the technical rehearsals onstage, and attend performances when possible.

Sally Bliss is also involved in the preservation of every version of each ballet that Tudor created along with the costumes and sets of the ballets. She is further involved with the updating of the fabrics and sets of the ballets, without altering the relevant elements that support Tudor's narratives. The Répétiteurs of the Antony Tudor Ballet Trust are also committed to authentic restagings of his ballets. The Répétiteurs are the unheralded intermediaries between Tudor's initial impact on the ballet world and Tudor's relevance for future generations of dancers and audiences. The restagings by the Répétiteurs, in concert with the Tudor Trust, are what generate continued interest in the Tudor ballets; the work of the Répétiteurs is the preservation of the legacy of Antony Tudor.

## Theoretical Conversations about *Worldmaking*, Practice, and Knowledge

Nelson Goodman's theory of *worldmaking* serves as a basis for understanding not only the world of Antony Tudor, but also

---

the worlds of his ballets and the worlds of the Répétiteurs who recreate the ballets. Goodman, an American philosopher, offers that the worlds "consist of taking apart and putting together... dividing wholes into parts, and partitioning... analyzing complexes" as a way of knowing.[90] The process of worldmaking "always starts from worlds already on hand; the making of remaking."[91] For the choreographer and the restager, it's the worldmaking of craft and creativity. For restaging the narrative ballet, it's the craft and creativity of making the world of human interactions, relationships, and situations.

The intersections of these worlds: choreographer, ballet, and restager are further explored by author Gail Minor-Smith in her research on restaging Eugene Loring's *Billy the Kid*.[92] Minor-Smith posits that there are essential elements of Loring's ballets that must be retained in each restaging; without these elements, the ballet can no longer be considered Loring's *Billy the Kid*. I would go even further than Minor-Smith, to posit that it is important to not only find the essential elements of a specific ballet, but also one needs to have a sense of how Tudor himself and the aspects of his choreographic process are still alive within the ballets.

These connections between Tudor and his ballets in a sense create a world of Tudor. In other words, I'm looking at what supports the act of worldmaking for Tudor. Questions underlying my search include: 1) What of Tudor's creative moorings live in

---

[90]Nelson Goodman, *Ways of Worldmaking*. Indianapolis: Hackett Publishing Company, 1978, p. 7.

[91]Ibid., p. 6.

[92]Gail Minor-Smith, *The Life and Times of Eugene Loring's "Billy the Kid"*: *A Study of the Restaging Process*. Diss. Texas Women's University, 2004, pp. 60-77.

each ballet?; 2) How did Tudor create his characters as specific to the action needed for each ballet?; 3) How is Tudor's creation of character relevant to the Répétiteurs' process *informing* and in *forming* the worlds of a Tudor ballet?; and 4) What was the *dailiness*[93] of his practice which resulted in a collected oral narrative recounted and retold by the Répétiteurs as part of their restaging process? Also, how do the Répétiteurs create worlds in their practice and how do these worlds further connect with the world of Tudor? Questions underlying the Répétiteur's worldmaking might include: 1) How do they know Tudor and how did that "knowing" shape their restaging process?; 2) What skills do they bring to the restaging process that intersect with Tudor's practice?; and 3) What is the *dailiness* of their process?

Pierre Bourdieu's theorized *habitus*[94] offers another potential basis for understanding the world of Tudor, the world of his ballets, and the world of the Répétiteurs. According to Bourdieu, a French philosopher, each world or *habitus* could be considered a commonsense homogenizing of "the durably installed generative principle of regulated improvisations... history turned into nature... which accomplishes practically the relating of two systems of relations, in and through the production of practice" Bourdieu

---

[93]Leila Fernandez, Transforming Feminist Practice: Non-Violence, Social Justice and the Possibilities of a Spiritualized Feminism. San Francisco: Aunt Lute Books, 2003, p. 52.

[94]Pierre Bourdieu. *Logic of Practice.* Trans. Richard Nice. Stanford: Stanford University Press, 1990, p. 53; Pierre Bourdieu and Loïc J. D. Wacquant. *An Invitation to Reflexive Sociology.* Chicago: The University of Chicago Press, 1992, pp. 22-23; 129-130; Judith Butler. "Performativitiy's Social Magic." Shusterman ed. *Bourdieu,* p. 117; and Stephan Wainwright. *Bourdieusian Ethnography of the Balletic Body.* Diss. University of London. 2004, pp. 20-25.

continues to discuss how, "The habitus is the outcome of the sedimentation of past experiences. In other words, *habitus* shapes the agents' perceptions and action of the present and future and thereby molds their social practices."[95] In effect, the Répétiteurs are attempting to understand and convey the world or *habitus* of Tudor by cultivating intersections with their world of experience and knowledge or "sedimentation of past experiences."[96] Sally Bliss of the Tudor Trust insured a commonality of understanding or past *sedimentation* by choosing the Répétiteurs who have had an experience with Tudor or his ballets. As the new trustee, Amanda McKerrow may follow Sally's lead, but sooner or later she may not have any dancers available who danced with Tudor. She will then draw from dancers interested in doing this kind of work or who have worked with her or another Repetiteur.

Also, Bourdieu's theory of the *logic of practice* allows for an understanding of how Tudor worked in creating his ballets.[97] The *logic of practice* is often defined as a "feel of the game" where each player knows how to play the game and reacts accordingly as the game progresses; it is "the sense of the imminent future of the game, the sense of the direction of the history of the game that gives the game its sense."[98] Bourdieu continues to explain that within a given player, "the logic of practice... understand[s] only to act, not to just analyze or to interrogate."[99] The game, for our

[95]Bourdieu quoted in Wainwright, *Bourdieusian Ethnography of the Balletic Body*. Diss. University of London. 2004, p. 23.

[96]Ibid.

[97]Bourdieu. *Logic of Practice*, pp. 81-99; Bourdieu and Wacquant. *An Invitation to Reflexive Sociology*, pp. 22-23; and Stephan Wainwright. *Bourdieusian Ethnography of the Balletic Body*, pp. 28-29.

[98]Bourdieu. *Logic of Practice*, p. 81.

[99]Ibid., p. 91.

purposes, is the practice of the Répétiteurs in restaging the Tudor ballets: Tudor's practice is mirrored in the embedded, embodied daily *logic of practice* of the Répétiteurs. Further, that heritage of practice becomes part of the dancers' practice during and after the restaging process. So, the world of Tudor and his ballets, and the world of the Répétiteurs intersect with the worlds of the dancers' through the inherited, experiential logic of Tudor's practice, embedded in the practice of the Répétiteurs in restaging his ballets.

Sandra Noll Hammond, author of *Ballet Basics*, and her husband Phillip E. Hammond present a similar concept of *the internal logic of dance* using the world of classical ballet as an example. They argue that the development of classical ballet technique contains necessary elements. The first necessary element is a sense of "dissatisfaction with prevailing ballet practice [which] leads to innovation." However, this dissatisfaction can only be innovative if it also serves the needs of the dancers to become part of "the new prevailing practice."[100] It is the act of accumulating practices that constitutes technical development in ballet.

The Hammonds continue to support their ideas by quoting Agnes De Mille when she states: "'Individuals are continuously trying to break away from inherited classical patterns and originate something new. When what they do is valid [it] may change the direction of the classic course.'"[101] In addition, the Hammonds further pinpoint their discussion by asserting:

---

[100]Sandra Noll Hammond, and Phillip E. Hammond. "The Internal Logic of Dance: A Weberian Perspective on the History of Ballet," pp. 591-608 in *Journal of Social History*, 12:4 (1979), p. 593.

[101]Ibid.

*In addition to a series of shifting artistic styles, then, the development of ballet also reveals the "internal logic" Max Weber called rationalization. At the technical level, changes have been accumulative. This process is not merely the idea that one technical development can occur only after the occurrence of developments preceding it. On occasion, Weber stated matters this simply... he meant that because one development occurred, the next development was more likely to occur. The first not only allows but encourages the next.*[102]

In Tudor's case, he pushed against the precepts of classical ballet by creating ballets about the average man and woman. He did not use the classic characters of nobility or fairy queens. He altered the precepts of classical ballet vocabulary by using the classical steps in non-traditional ways, while also referencing his Cecchetti training. The challenge for the Répétiteurs, therefore, is to instill in the dancers Tudor's way of thinking about moving as ballet dancers living in a different century than Tudor. Further, the Répétiteurs, according to the logic of the Hammonds, must also find a way for the dancers to sense how Tudor's innovations, how the embodiment of these innovations, can still speak to their needs today.

Dance theorist Maxine Sheets-Johnstone also writes concerning how knowledge is gained through experience. She explains that, "human knowledge is securely tethered to its experiential moorings"[103] and "the tactile-kinesthetic body is a body that is al-

---

[102]Ibid., p. 603.

[103]Maxine Sheets-Johnstone. *The Roots of Thinking*. Philadelphia: Temple University Press, 1990, p. 13.

ways in touch, always resounding with an intimate and immediate knowledge of the world about it."[104] For a ballet dancer, this means that his or her *practice* becomes the path through which he or she experiences the world of ballet. The logic of that practice resides in the dancer's body; it's an embodied knowledge of practice and of ballet. In other words, how the ballet dancer moves has been formed through his or her experience with the technique and the artistry required of the world of ballet, past, present, and future. The ballet dancers' training coalesces into a constellation of unique movement knowledge; for each dancer it is his or her knowledge of how to move in ballet. Therefore, upon confronting the Tudor choreography, the dancers' embodied knowledge of how to move as a ballet dancer is challenged, stretched, and increased through the experience of Tudor's logic of practice.

The morphing of the dancers' embodied knowledge of how to move as a ballet dancer takes place through the experience of learning, dancing, and performing the Tudor ballets. The experiential nature of the restaging process reinforces the change in the dancer's *thinking* about moving and, thereby, the dancer moves differently. Thus, the cognitive process of learning, dancing, and performing guided by the Répétiteurs is inspired by Tudor's logic of practice. At this point, the world of Tudor and the world of the contemporary ballet dancer become connected and enhanced.

When transformed by the process, the dancer in a Tudor ballet fulfills what Sheets-Johnstone refers to as a "kinetic destiny."[105] Sheets-Johnstone states: "The dancer is not moving

---

[104]Ibid., p. 16.

[105]Maxine Sheets-Johnstone. "On Movement and Objects in Motion: The Phenomenology of the Visible in Dance," pp. 33-46 in *Journal of Aesthetic Education* 13.2 (1979), p. 43.

through a form; a form is moving through him."[106] The form, with all of the technical and artistic elements, becomes part of the dancers' constellation of movement affinities. As dancers of the Tudor ballets, the Répétiteurs strive to instill that heritage of embedded, embodied knowledge into each new cast member. This embodied knowledge is a vital part of the Tudor legacy and ballet heritage. According to philosopher Nelson Goodman:

> *An increase in acuity of insight or in range of comprehension, rather than a change in belief, occurs when we find in a pictured forest a face we already knew was there, or learn to distinguish stylistic differences along works already classified by artist or composer or writer, or study a picture or a concerto or a treatise [or a dance] until we see or hear or grasp features and structures we could not discern before. Such growth in knowledge is not by formation or fixation or belief, but by the advancement of understanding.*[107]

The sense of understanding that Goodman discusses above is what I carried with me when structuring my research process and analysis. I brought it with me when developing my methodology (to be discussed in the following chapter) and I certainly searched for how my interviewees, the Répétiteurs and student dancers, described their experience with the Tudor ballets. The information gathered in these interviews comprise the data presented in chapters three, four, and five.

---

[106]Ibid.

[107]Nelson Goodman. *Ways of Worldmaking*. Indianapolis: Hackett Publishing Company, 1978, pp. 21-22.

## Data Chapters

The three data chapters present the findings of my analysis regarding the work and the main contribution of the Répétiteurs to restaging the Tudor ballets for the Tudor Trust. Chapter Three develops the concept of *authenticity* relative to the restagings of the work of the Répétiteurs. The *authenticity* of the recent restagings is secured through the Répétiteurs' experience with Tudor and/or their continued research about Tudor and Tudor's choreographic process, as well as the ballets he crafted.

Chapter Four describes the Répétiteurs' restaging process in retaining and sharing Tudor's original choreography. This process requires the dancers to persist through phases of difficulty and feeling awkward; to engage with Tudor's search for Truth within the simplicity of movement; and to hear Tudor's particular musicality. Chapter Five examines how the Répétiteurs become the *tellers of stories* within the restaging process.

In the concluding chapter, I review the work of Sally Bliss, the Trust, and the changes that have taken place. The process of my research, data gathering, and data analysis was one of observation, interview, and experience. The voice of the study is at times that of a researcher, or at times that of a former Tudor dancer, or at other times that of a former professional ballet dancer. What holds together every observation, response, and reference is the genius of Antony Tudor and the work of the Répétiteurs of the Tudor Trust in restaging his ballets.

# Chapter II
# Methodology

## And so, it began

My choice of methodology was based on the underlying premise of qualitative research which seeks to understand how a particular group of people "interpret their experiences, how they construct that world and what meaning they attribute to their experience"[108] or as Pierre Bourdieu, the French sociologist, suggests, the *habitus* of their experience.[109] According to Bourdieu, habitus constitutes the "common-sense world" or the "structure" containing "principles which generate and organize practices" of the world of the individual.[110] Qualitative research, therefore, looks to understand how a particular group experiences their world, their *habitus,* and for this research, how the Répétiteurs understand their world of restaging the ballets of Antony Tudor.

As suggested by research theorist Janice M. Morse, qualitative research has three characteristics: [A]n *emic* perspective; a holistic attitude; and an inductive and interactive process of inquiry. The *emic* perspective involves eliciting the participant's point of view, rather than imposing the researcher's perspective.... The

---

[108]Sharan B. Merriam, *Qualitative Research: A Guide to Design and Implementation.* San Francisco: Jossey-Bass, 2009, p. 5.

[109]Bourdieu, *Logic of Practice,* p. 53.

[110]Ibid.

holistic attitude emphasizes the inclusion of the beliefs of the informant to enrich the contextual interpretation of research findings.... Moreover, the process of inquiry is interactive as the objectives of such research may change as the researcher gains insight and understanding about the researcher topic.[111]

Combined, the three characteristics serve as an opportunity for researchers to engage with their participants in the participants' natural surroundings where they live or work, as they are, in their *dailiness*,[112] or in their *state-of-being*[113] as the source of the data.

Qualitative researchers also value hearing how the participants talk about and describe their world while in their world. That is, many qualitative researchers plan interviews and observations with their participants within the environment of the participants' work rather than outside or away from their environment. In fact, the qualitative researcher allows the participants to choose the place of the interviews to allow for the most "in context" potentials of the interview process. In addition, as suggested by the naturalistic research approach,[114] the context of experiences [of the participants] is the multi-realities of a particular experience or "entity-in-context."[115] Furthermore, it is important to understand "the context [which] is crucial in deciding whether or

---

[111]Morse quoted by Wainwright, *Bourdieusian Ethnography of the Balletic Body*. Diss., p. 59.

[112]Fernandez, *Transforming Feminist Practice*, p. 52.

[113]John W. Creswell, *Qualitative Inquiry and Research Design: Choosing Among Five Traditions*. Thousand Oaks: SAGE Publications, 1998, p. 53.

[114]Yvonne S. Lincoln and Egon G. Guba. *Naturalistic Inquiry*. Beverly Hills: Sage Publications. 1985, p. 37.

[115]Ibid., p. 39.

not a finding may have meaning in some other context as well; because of the belief in complex mutual shaping rather than linear causation..."[116] of an individual's understanding of his or her world.

For my research, the focus was always the world conceptualized and actualized by each Répétiteur as manifested in the context of rehearsals during each restaging of an Antony Tudor ballet within the preservation of the legacy of Antony Tudor. Then, returning to Lincoln and Guba's sense of naturalistic inquiry as opening the relationship between contexts, I was further interested in how the meanings described by the Répétiteurs emerging in their rehearsals provide insights into how the practice of restaging "mutual shapes" might influence continuing discussions of dance restagings in the future.

## A nod to grounded theory

Although I did not conduct a formal grounded theory methodology, I did work within the foundational concepts of grounded theory: I wanted any ideas or theoretical concepts discussed in my research to emerge clearly from my data or the voices of my research participants. I did not want to enter my research site with any preconceived ideas of what I was hoping to find; instead, I was constantly creating memos that put my own assumptions aside so I could listen to and hear what my research participants were telling me about their individual processes. Since my research did not solely rest on understanding the world of the Répétiteurs or how they conceptualized these worlds, I was also searching for a method by which I could explore how the

---

[116]Ibid.

Répétiteurs actually worked within the restaging process, the actual "nuts and bolts" of their work. I wanted to interview the Répétiteurs and, equally important, I wanted to attend their restaging rehearsals. I wanted to see for myself the efforts of their work, their process as it unfolded. This attention to process as a way to gather and analyze data is supported by qualitative researcher Sharan B. Merriam when she suggests that grounded theory is also "particularly useful for addressing questions about process..."[117]

I initially began exploring how data collection might occur within a grounded theory framework with Dr. Penelope Hanstein at Texas Woman's University. Working with her, I discovered how new ideas and unimagined insights might emerge from my data. By acknowledging how grounded theory methods of data gathering and data analysis delve deeply into the study of each participant's process, I could establish the groundwork for developing a more in-depth analysis while also providing my original participants time for reflection through additional interviews. From this process of qualitative research based in the fundamental belief of grounded theory in which the theory is grounded in and emerges from the data, I was able to create a research process in which the Répétiteurs could discuss and demonstrate their knowledge of as well as the actual doing of the restaging process. I was then able to find links within these data and discover how they became integral to the *gestalt* of the restaging process. In the end, I listened to how the Repetiteurs understood themselves to be preserving Tudor's legacy while also preserving ballet history under the auspices of the Antony Tudor Ballet Trust.

---

[117]Merriam, *Qualitative Research: A Guide to Design and Implementation*, p. 30.

## Research Questions

My questions were based in listening to how insights were shared concerning the world of the Répétiteurs and their process in the restaging of the Tudor ballets. My initial questions included:

What do the Répétiteurs do? Why do they choose to do it, and how do they choose to do it?

How are the elements of a ballet retained, sustained, and performed in every restaging? Or how are the elements lost in the restaging?

The research was then further guided by the following questions:

How do the Répétiteurs negotiate the daily restaging process against the requirements of the Tudor Trust and the obligations to the dance department or the ballet company who hired them?

How much agency and ownership of the production do the Répétiteurs feel at the end of the process?

What, in their own words, do the Répétiteurs consider as essential elements to the production? In their own words, what makes *Dark Elegies, Dark Elegies*?

How do the Répétiteurs begin to agree on and retain a sense of authenticity of each of the separate restagings of each Tudor ballet?

What issues are facing the Répétiteurs in documenting their work for future second generation Répétiteurs who will not have worked with Tudor?

## Participants with the Trust

In order to really step into the world of the Répétiteurs and be able to understand their individual and collective process of

restaging the Tudor ballets, I planned interviews with five Répétiteurs of the Tudor Trust:

Sally Bliss, executor of the Tudor will and Trustee of the Antony Tudor Trust, and former Tudor dancer

Donald Mahler, senior Répétiteur of the Tudor Trust and former Tudor dancer

Kirk Peterson, former principle dancer with American Ballet Theatre, and former Tudor dancer

Amanda McKerrow, former principle dancer with American Ballet Theatre, and former Tudor dancer

James Jordan, ballet master with the Kansas City Ballet, Trustee of the Antony Tudor Trust, and Répétiteur in-training

## Listening to and for the Key Language of the Participants

Although I was an insider to the process of restaging ballets, having been a professional ballet dancer and having worked with Tudor on his restaging of *Pillar of Fire*[118] and *The Tragedy of Romeo and Juliet*,[119] during the interviews for my research I purposely focused on listening to the particular language of these Répétiteurs in describing their world and process of restaging the Tudor ballets. I also listened for specific descriptions of the Répétiteurs' process of restaging the Tudor ballets from the student/dancers I interviewed. Their *insider* perspective was important to completing my understanding of the work of the Répétiteurs. This *listening* for key language by the Répétiteurs continued during my observations of their rehearsals.

---

[118]see Appendix A

[119]see Appendix B

Initially, I listened for phrases and the use of imagery particular to the Tudor Répétiteurs in describing their process in restaging the Tudor ballets. In addition, I listened for phrases that might reveal how the Répétiteurs defined their world, experienced their world, their *habitus*,[120] and understood their world within the context of the restaging process. Further, I listened to the student/dancers' use of imagery or descriptions as insiders to the process to aid in my understanding of the important factors of the restaging process. During all of the interviews and observations, I listened[12] for a key that would unlock the story to the new knowledge of this particular restaging process.

## The Point of the Research: Qualities and Situation

I wanted not only to understand what the Répétiteurs do, but also to understand the qualities of their experience in restaging the ballets of Antony Tudor. In other words, I believed that the world of the restaging process, as created and experienced by each Répétiteur, more than likely came with its own qualities, qualities that had to be understood within the context of the restaging process as sanctioned by the Tudor Trust. I also looked and listened for the *particulars* of their restaging processes: how they constructed their schedules, how they interacted with the students, and how they managed to remain faithful to their own process while fulfilling the expectations of the Tudor Trust and the company or dance department producing the work. I questioned whether or not the qualities might transcend the boundaries of personal preferences or affinities in teaching, coaching, or mentoring, and appear unified, or, perhaps, codified in some fashion. In addition, I also looked for the qualities that might

---

[120]Bourdieu, *The Logic of Practice*, p. 53.

change due to a different constituency of dancers, that is, whether or not the dancers were professional or students.

When looking at my research from numerous contexts and relationships, or multiple realities, as previously suggested by Lincoln and Guba, I found the work of a theorist on qualitative research, Margaret Myers, of particular value. She summarizes that, "experience is both situational and interactive within the social and historical context and represents multiple realities."[121] To that end, I made every effort to ensure that my research process preserved and gave context to the information emerging from each Répétiteur's situation to include interactions during the observed rehearsals and the interviews they shared with me. To create spaces for these interactions and differing contexts to happen, I relied on my detailed field notes, transcriptions of interviews, and data analysis. I found the interviews with the Trustee of the Tudor Trust, Sally Bliss, the Répétiteurs, and the student/dancers unveiled, revealed, and allowed me to discover the key(s) to the worlds of the Répétiteurs in restaging the ballets of Antony Tudor.

## Role as Researcher

As a former Tudor dancer, I made every effort to retain my position as an *outsider* during the rehearsals. In particular, I sustained a respectful distance during the restaging process between the Répétiteurs, the dancers, and me. I found myself constantly checking my body language and squelching desires to perform the choreography as demonstrated by each Répétiteur. At times, I found myself really wanting to join the dancers in the restaging

---

[121]Margaret Myers, "Qualitative Research and the Generalizability Question: Standing Firm with Proteus." *The Qualitative Report* 4.3/4 (2000) 1-9, p. 2.

process. Fortunately, I kept reminding myself of my role as researcher, observer, and scholar. Thankfully, the desire to move was greatly reduced by having already spent time with my students in the restaging process conducted by Répétiteurs Donald Mahler and James Jordan, and having already learned some of the choreography for *Dark Elegies*.

To make sure that I was seen by the student participants in my role as researcher, I made sure I was always introduced to the dancers, by either the head of each dance department or the Répétiteur, as a researcher first, as a dance faculty member of Washington University in St. Louis second, and as a former Tudor dancer third. I was determined to sustain my role as researcher, observer, and scholar throughout my data gathering, interviews, and observations and not engage with developing in any way the research situation. Qualitative researchers Egon G. Guba and Yvonna S. Lincoln refer to the distancing of the researcher as "unflagging courtesy" and "value-neutral behavior."[122] Even though I never forgot my background or my *backstory* with Tudor, I actively put these experiences in the background by acknowledging them in my memos. Instead, I purposely focused on my important role as a researcher; in that role, I listened and watched.

Even though I determinedly established distance from my Tudor experience, I also never lost sight of the value of my previous professional ballet dancer/former Tudor dancer experience. In the following chapters, I make an effort to keep my own perceptions as only another aspect of research data in order to form even more contexts and relationships as I create insights into the complex world of the restaging process of the Tudor Répétiteurs.

---

[122]Guba, Egon G., and Yvonne S. Lincoln. *Effective Evaluation*. San Francisco: Jossey Bass Publishers, 1981, p. 175.

## Field Work Observation

I immersed myself in the data gathering process by attending rehearsals and viewing archival videos of restagings in rehearsals from the Tudor Trust. These archival videos include residencies at Webster University in St. Louis, Missouri; Texas Christian University in Fort Worth, Texas; and the University of Missouri-Kansas City, Kansas City, Missouri. In addition, Judith Chazin-Bennahum, author of *The Ballets of Antony Tudor: Studies in Psyche and Satire*, former Tudor dancer, and distinguished professor emeriti of the University of New Mexico, sent me a series of videos of Donald Mahler's restaging of *Dark Elegies* for the University of New Mexico from 1998.

I combined all these observations and research with my previous observations of Sally Bliss, Donald Mahler, and James Jordan at Washington University in St. Louis. This plethora of data gathered from differing points of view and in differing research sites provided an effective assemblage of data from which I could feel confident about creating connections and relationships from which ideas could emerge. Indeed, as educator Eliot Eisner states, "We seek a confluence of evidence that breeds credibility[,] that allows us to feel confident about our observations, interpretations, and conclusions."[123]

## Process of interviews: Questions

To begin each interview with the Repetiteurs, I reiterated the nature of the study and reviewed each person's participation and

---

[123]Elliot W. Eisner, *The Enlightened Eye: Qualitative Inquiry and the Enhancement of Educational Practice.* Columbus: Prentice-Hall. 1998, p. 110.

his or her responsibility to the project. The interview process remained flexible with continued cross-referencing of questions as ideas and concepts emerged which secured the accuracy and breadth of the interviews and the resultant data.

As an example of the flexibility of the questions, I wanted to hear from Sally Bliss and the Répétiteurs their responses and reactions to two recent publications. The first was a short section on Antony Tudor written by Jennifer Homans in her recent offering *Apollo's Angels*. In the section read, Homans was quite negative about Tudor's relevancy for the future of ballet. Homans statement flies in the face of everything the Tudor Trust is doing to bring the Tudor ballets forward for the next generation of dancers and, therefore, I felt I could gather interesting insights into how each Répétiteur reacted to this conflicting point of view.

The second selection was Margaret Fuhrer's article in *Pointe* magazine entitled "Where are the Narrative Ballets?" In my opinion, Fuhrer suggested to the reader that the recent resurgence of full-length ballets signals a Renaissance of storytelling by classical ballet choreographers. She described the historical mapping of full-length narratives from Marius Petipa to John Neumeire. Granted, even though her thesis focused on the full-length ballets, there still seemed to me to be an obvious oversight of the contribution of the twentieth century ballet choreographers, Tudor, De Mille, Loring, or Robbins who worked in the one-act ballet narrative canon. Furthermore, what seemed to emerge from my reading of the article, which also prompted my interest in showing the article to my participants, was an underlying question of why the twenty-first century ballet choreographers weren't attempting the one-act narratives.

I wanted to hear what my participants thought about Fuhrer's opinion. I wanted to initiate a discussion on the development of the one-act narrative and, further, Tudor's role in the

development of the one-act narrative as a choreographer who only created within this canon. The participants responded suggesting in various forms of analysis that perhaps the one-act ballets are just harder to choreograph requiring a different skill set or simply a different choreographic or aesthetic interest on the part of the young twenty-first century choreographer. In direct response to the readings, the participants' analyses turned quite intensely into diverse descriptions of the multiple dimensions of Tudor's craft as a choreographer, and the difficulties of learning, dancing, and performing the Tudor ballets.

I had hoped that by introducing these two readings into my interviews I would be able to delve into some of the surrounding terrain of my research such as: 1) the continued relevancy of art from one generation to another, 2) cultural differences from one generation to another which affect the art being produced, 3) critics who have trained in another syllabus – Homans worked in New York City Ballet through the Balanchine technique and choreography – when evaluating a choreographer's style or aesthetic, 4) one act ballets versus the full-length ballets as reflective of the cyclical nature of ballet productions, and 5) finding an audience for the Tudor one-act narratives when the cultural diet of the ballet repertoire of today is the contemporary, abstract, fast-paced choreography or the full-length ballet. So although the interviews were formal, in that they were scheduled and began through a series of structured questions, they also proceeded through a more flexible and responsive format.

The interviews with the student/dancers progressed in much the same manner as with the Répétiteurs. I prepared a separate set of questions for them, and yet, was open to pursuing ideas and concepts as they emerged. Moreover, I made even more of an effort to approach each dancer in a professional manner

while retaining my position as researcher, as someone who listened rather than prompted them for specific answers. I knew Joshua Hasam fairly well since I had spent several years as Josh's ballet teacher when he was a student at Washington University in St. Louis. Also, I had coached him during the second *Dark Elegies*[124] residency with James Jordan. I stepped into that coaching process only during the weeks in-between James's visits. Additionally, I knew Mathew Schmitz fairly well having met and re-met him during the Webster residencies with Kirk Peterson re-staging *Dark Elegies*, and with Amanda McKerrow's and John Gardner's residency restaging of *Jardin aux lilas*[125] at Principia College, December 2010, and the Kansas City Ballet summer program during the summer of 2011. I met Appie Peterson years earlier during her training in St. Louis, but I was not as familiar with her individual work in *Dark Elegies*, restaged by James Jordan, or *Continuo*,[126] restaged by Donald Mahler.

Due to the large amount of data surfacing from the transcriptions, I constantly returned to my memoing[127] and journal entries for additional guidance and reminders about how my own thoughts might connect to or disconnect from the issues raised by the participants. Kathy Charmaz, sociologist working in grounded theory suggests "memo-writing frees you to explore your ideas and your categories."[128] According to Barney G. Glaser and Anselm Strauss, theorists on grounded theory, the cyclical

---

[124]see Appendix F

[125]see Appendix D

[126]see Appendix L

[127]Kathy Charmaz, *Constructing Grounded Theory: A Practical Guide Through Qualitative Analysis*. Los Angeles: Sage Publications, 2006, pp. 83-85.

[128]Ibid., p. 84.

nature of grounded theory data analysis and data gathering also allows for "concurrent and ongoing analysis"[129] and "scrutiny as the discovery of concepts, their properties and dimensions, the linkages between concepts, and the eventual integration of these concepts into a theoretical framework are all made overt."[130] Indeed, I found that memoing was extremely important for the continuity of the research. Due to my full-time work and responsibility to the Performing Arts Department at Washington University in St. Louis, I often had to schedule the interviews weeks apart. Upon my return to the process, a quick read through of my memos brought me right back into my research. For me, the memos were important markers of ideas and concepts throughout the process as well as providing me a place to situate my own experiences with Tudor and to keep these sites in the forefront of my analysis. This process of writing down my own reactions as memos assured that I was continually aware of when I was forming opinions from my experience rather than that of my interviewees. I returned to these markers in order to confirm the ground I had covered or as concepts to re-consider against recent discoveries.

## Additional Data Gathering

The Tudor Trust allowed me access to film and video footage of previously recorded rehearsals and productions. The assemblage of documented footage extended my understanding of the Répétiteurs in practice as well as supporting how they discussed and developed issues of authenticity within the many versions of the original Tudor. My awareness of the differences within the

---

[129]Quoted in Wainwright, *Bourdieusian Ethnography*, p. 69.
[130]Ibid.

*authentic* Tudor productions fostered my interest in how the Répétiteurs handled authenticating their restagings. I began each initial interview by listening for any reference to the issue. If none appeared, I pursued the issue through specific questions around the topic attempting to never lead the interviewee to respond in a manner that I thought or assumed was appropriate to my needs.

In their interviews, the Répétiteur's also discussed how authenticity of a Tudor production was often determined by the analysis of the dancers' accuracy in performing the choreography as set by Tudor or another Répétiteur. To determine this accuracy, film/videos of productions restaged prior to the Trust's creation of the position of Répétiteur and subsequent productions restaged by the current Répétiteurs are analyzed in detail. However, questions concerning whether the films/videos are authentic to Tudor's original intent still remain. These questions for the Repetiteurs include the following: Do the film/videos even capture dancers' or the students' mistakes? Or, were the mistakes really mistakes in the restaging process? Or, were the errors not errors at all but simply the differences between one Répétiteur's experiences with Tudor? Or, were the differences discovered in the various filmed versions of the choreography actually differences created when the choreography moved from the stage to the smaller film studio? Fortunately, these questions were addressed by the Répétiteurs in my interviews with their responses interwoven through the following chapters of the dissertation.

The film footage of the Tudor ballets also drew me into further questions about how the productions were being analyzed. The Tudor ballets are a collaboration of choreography, lighting, set, and costume design. Consistency of production value then relies on rallying independent designers to replicate the nature and values of the Tudor ballets. The obvious consistency of previous production values, as evidenced in the archival footage, led

me to believe that there must also be an overarching artistic and collaborative sensibility inherent in the restaging process. Clearly, I needed to include interview questions about how this overarching artistic sensibility was understood by each Répétiteur in order to understand the process of sustaining the Tudor production values within the most recent restaging. Therefore, questions about how each Repetiteur addressed issues of production collaboration were often included in my interviews if not addressed by the Repetiteurs in the initial interviews. The responses were then interwoven throughout the following data chapters.

## Data Analysis

The process of analyzing the data included my combing through the transcriptions for repeated words, phrases, and/or ideas. An initial *Focused* coding revealed the repeated use of the active verbs: understanding, experiencing, and storytelling. My analysis of the data continued by triangulating the data and data coupling as initial theories emerged. According to qualitative theorist Sharan Merriam, "triangulation remains a principal strategy to ensure for validity and reliability"[131] in grounded theory data analysis. In my analyses, however, I used triangulation not to confirm existing data, but to "assure validity and reliability"[132] of my inquiry in the hopes of "offering a deeper and more comprehensive picture."[133] I further designed various mappings in order to define particular relationships between the data, con-

---

[131]Merriam, *Qualitative Research*, p. 216.

[132]Ibid., p. 216

[133]Gerard A. Tobin and Cecily M. Begley. "Methodological Rigour within a Qualitative Framework." Journal of Advanced Nursing 48.4 (2004), p. 393

cepts, and the emergent theories. Through my "constant comparative"[134] strategy categories and additional questions emerged. As my analysis unfolded, I continued to name and frame the data toward the goal of finding categories of like concepts, while other data and concepts began to fall away from the analysis. I knew I had turned a point in the analysis when I found the ideas emerging from the data consistently repeating, therefore, leading me to feel I had gathered enough data to finalize my analysis.

## Data Chapters

The important issues of authenticity and their connection to developing a Tudor legacy emerged as soon as I began my research and are, therefore, interwoven throughout my data chapters. After conducting the research, I re-fashioned my initial thinking about the issue of authenticity in regards to the restagings of the Tudor ballets (Chapter Three). Initially, I thought the Trust, alone as the established repository of the Tudor repertoire, gave weight to the authenticity of each new restaging. Actually, for the Tudor Trust, authenticity resides directly in the abilities of the Répétiteurs as historians, eyewitnesses, curators, and pedagogues. In addition, the process of authenticating each restaging is complicated when considering that Tudor restaged different versions of his ballets. As Chapter Three enumerates, the multiple layers of authenticity which truly define each new restaging are deeply rooted in and through the experiences of the Répétiteurs with Tudor and his ballets.

To assist my understanding of what something means to be *authentic*, I turned to theorists writing in theatre and dance regarding authenticity in theatrical productions and the restaging,

---

[134]Merriam, *Qualitative Research*, p. 30.

reconstruction, and revival of master dance works. Further, I also included theorists in the subject of the preservation of master theatre and dance works specifically focused on retaining and sustaining the essential elements of each work. I was focused on understanding exactly what elements are deemed necessary to be taught and preserved within a master dance work in order for it to be considered authentic. I also focused on who decides what those elements are and how they are preserved, sustained, and recreated.

When analyzing the data, I also found that the Répétiteurs note that each Tudor ballet contains essential elements for a ballet to be considered an authentic Tudor ballet. After synthesizing the data, I summarized these elements to include Tudor's kinetic innovations, truthfulness in performance, and unique musicality. The Répétiteurs' descriptions throughout the following chapters capture the difficulties and creativity of the challenges facing them in teaching the complexities of the Tudor elements and also the dancers/students' difficulties when attempting to embody the complexities of these elements. In Chapter Four, therefore, I bring out the interview data in which the journey into the world of the Tudor narrative and the embodiment of the essential elements are noted as transformative for the dancers who are pushed to re-think the *hows* and *whys* of their dancing. This discovery of a pedagogical practice by the Repetiteurs was then related further to theorists and practitioners exploring issues within the pedagogy of movement creativity within the learning process.

The unexpected fourth element of the Tudor restagings emerging from the data concerned the Répétiteurs' recounting and telling of stories about Tudor in which his presence is purposefully recreated within the rehearsal process. These stories, archived and maintained through the Trust as a collective narrative,

shifted my sense of the restaging process from a means to attain production accuracy to one that develops a deeper connection to Tudor. The stories now keep Tudor in the process; the stories keep Tudor in the rehearsal; the stories keep Tudor, relevant to the restaging of his ballets (Chapter Five).

## Writing

Placing my research within the art of Antony Tudor had a profound effect on the writing of the book. Indeed, I discovered several similarities between writing my book and my understanding of Tudor's craft. Similar to qualitative research, the Tudor ballets were clear examples of multi-layered perspectives: no one character spoke for the ballet and all the voices were imperative to his narrative. When writing these chapters, I tried to bring these multiple perspectives into clear relief by including nuanced descriptions of each Répétiteur and each site of the restaging.

Amanda McKerrow
Trustee of the Anthony Tudor Ballet Trust

# Chapter III
# Authenticity within
# the Restaging Process

Ballets need to be performed to be appreciated by dancers and audiences. They are not like paintings or sculptures that can be accessed during museum hours and, therefore, appreciated over time by other painters, sculptors, or followers of great art. Ballets are much more like operas, musical compositions, or plays; the ballets live only again in performance. However, unlike operas, musical compositions, and plays which have a tangible document denoting their existence, the ballets too often live only in the memories and the embodied knowledge of the dancers who performed them.

Fortunately, some ballets have been preserved through one of the dance notation systems: Benesch, Labanotation, or other movement notational systems. Some ballets have been filmed or have been photographed in order to preserve them in more tangible formats. Even though the "score" of a notated ballet or the two-dimensional video does capture the structure of the work and secures the general format of the ephemeral performance in a more permanent form; ultimately, the ballets must be performed to be experienced as a living, danced art form.

An appropriate restaging of a ballet master work should address the original choreographic intent and preserve the theatrical elements of the *lived* ballet in the costume, set, and lighting

designs. Jane Sherman, writing on what she terms the "Den-ishawn revivals," advocates for accuracy because, "revivals can become a vital part of dance history material for research schol-ars" while also establishing a certain "truth" in the subsequent production. These "truths" should not be affected by advances in dance technique.[135] Sherman also voices her concerns for the "glaring misrepresentations... [of] the original intentions of mood, costume, and lighting in some present-day productions" which she finds unforgivable and a, "cruelty not only to the memory of great artists but to present-day dance researchers who seek validity."[136] She cites dance critic Walter Terry's rebuke of one production when he states that it, "could be compared with a reconstructed Indian village in which the tepees were made of plastic and secured with aluminum poles instead of being built with the hides and boughs of real life."[137]

Clare Lidbury, having researched what she terms the restag-ings of early twentieth-century choreographer Kurt Jooss's works, writes that some of the changes in the costumes, "reflect minor revisions in the concepts of the works" and the lighting designs show "perhaps an awareness of the developments in technology."[138] Lidbury also comments, "These changes to light-ing and costume are relatively minor and may be seen to reflect a desire to keep the ballets alive without obvious alteration."[139]

---

[135]Jane Sherman, "Denishawn Revivals: One Method in the Madness." *Dance Chronicle* 6.1 (1983), pp. 37-53, p. 38.

[136]Ibid., p. 41.

[137] Ibid.

[138]Claire Lidbury, "The Preservation of the Ballets of Kurt Jooss." *Jordan Proceedings,* pp. 89-96, p. 90.

[139]Ibid, p. 91.

Jooss's daughter, Anna Markard, who was interviewed by Lidbury for the article, also appears less worried about the theatrical elements and the minor revisions of her father's works than how Jooss's original choreography was retained. Much like Tudor's choreographic vocabulary, Jooss's choreography reflected particular meanings and, according to Markard, "These aspects are essential in the performance of his ballet."[140]

The two arguments offered by Anna Markard and Walter Terry create a substantial gap in the idea of and concern for the restaging of ballet master works. On one hand, Markard sees no problem in the minor changes of costume, lighting, and set materials. Terry had a differing opinion whereby the altered materials of the teepees, now made of plastics, of the Denishawn work fell dramatically short of representing the work in its most advantageous way. The importance of these conversations can be related to how the student of ballet history might perceive these restagings, reconstructions, or revivals of dance as authentic. Do the students perceive Terry's aluminum poles as part of the original set? If so, how does this affect their sense of history, truth within history, and their place within that history?

Helen Thomas, theorist on dance and dance history, suggests that the restager or the reconstructor of the ballet master work will need to search for enough of a "usable past" for knowledge of ballet history to be enhanced.[141] The *usable* past of the ballet master work exists not as a foreign country one merely visits in order to understand the intricacy or history of style or design; instead, the "usable past" of the ballet master work remains as an

---

[140]Ibid., p. 95.

[141]Helen Thomas, "Reconstruction and Dance as Embodied Textual Practice" pp. 32-45 in Alexander Carter ed. *Rethinking Dance History: A Reader*. Routledge: London, 2004, pp. 33-36.

understandable, recognizable, and danceable part of ballet history experienced viscerally by the dancers and audiences in live performances. The performed ballet master work, in its most authentic form, therefore, should remain as a vital part of dance or ballet history. The ballets' existence needs to be more than just an imaged past which "exists continuously in the minds of thinkers and men [and women] of imagination."[142] The ballet master work, ultimately through continued performances of authentic restagings, is instead physically re-enacted as living history.

Within this conception of performed authenticity, the ballet remains and continues as something part of the past, present, and future. The ballet should continue to be known and appreciated by dancers and audiences as part of the past, experienced in the present, and sustained and preserved for its place in the future. This is the goal of the Antony Tudor Ballet Trust for all of the ballets of twentieth century ballet choreographer Antony Tudor: the need to bring the past alive in the present for future audiences to appreciate as their human histories. The following section discusses how the Tudor Trust has dealt with the issues presented in this section.

## Authenticity as defined by
## the Antony Tudor Ballet Trust

The Antony Tudor Ballet Trust's responsibility and obligation is to keep alive the ballets of Antony Tudor through continuous performances of the most authentic restagings of his ballets. By continuous performances I mean adequate restagings so that

---

[142]Highet quoted in David Lowenthal, *The Past is a Foreign Country*. Cambridge: Cambridge University Press, 1985, p. 186.

a generation of dancers or audience members has had the opportunity to have danced or to have seen a Tudor ballet in their lifetimes. To that end, the Tudor Trust oversees three areas of responsibility to insure the authenticity of each subsequent restaging: 1) creating the legal foundation from which to negotiate future restagings of the Tudor ballets; 2) archiving all videos and films of previous performances of the Tudor ballets prior to the Trust and all subsequent restagings since the Trust's formation; and 3) the hand-selection of the Répétiteurs of the Tudor Trust, the group of professionals who have had first-hand experience with the Tudor ballets and who are charged with the responsibility of restaging the Tudor ballets.

By definition, in order to be authentic, therefore, each subsequent restaging of the Tudor ballets by the Trust must conform as closely as possible to the structure, style, and quality of the original production.[143] As I will review in Chapters Four and Chapter Five, there are four essential Tudor elements that must be present in each restaging and production of a Tudor ballet. These elements are: Tudor's kinetic innovations, truthfulness of performance, unique musicality, and the presence of Tudor. Beyond these four elements, the restaging must also conform to the accepted Tudor detail and theatricality as defined by the Trust. This includes the infusion of costumes, sets, lighting design, and, when available, the appropriate live musical accompaniment. In particular, with *Dark Elegies*, this would be a vocalist onstage dressed in a costume fitting the ballet accompanied by a pianist, playing from offstage or a full orchestra playing from the pit.

---

[143]Philip Babcock Gove, ed. *Webster's 3rd New International Dictionary of the English Language Unabridged.* Springfield: Merriam-Webster, Inc., 2002, p. 146.

Furthermore, Sally Bliss, as executive of the Tudor will and Trustee of the Tudor Trust and a dancer who had first-hand experience working with the ballets and Tudor, must *feel* and *see* that the essential elements are present in each restaging before giving her official "nod" to the production.[144] In effect, Sally Bliss was therefore the *common denominator*[145] of the restaging process, shouldering the final responsibility of accepting the newest production of the Tudor ballets as authentic. For her, there must be no doubt that each restaging is as close as possible to the original, that is, as authentic to one or more of the versions Tudor choreographed (as often there were more than one version), and, that as a whole, the restaging has at its core the essential Tudor elements. Sally's successor, Amanda, as a répétiteur and former Tudor dancer, will continue this direction.

The authenticity of the restaging process is also supported through research by the Trust and the Répétiteurs into the cultural context of the ballet, the time and place of the original production, and the social and cultural influences that framed Tudor's process.[146] This research not only informs the work of the Trust, but also informs the restaging process and the day-to-day presentation of the ballet to the new cast members. For the Tudor Trust, the "usable past" may contain some hidden "gems" about Tudor or his process, information that can aid the Répétiteurs in their quest to understand Tudor and, therefore, their ability to restage the most authentic productions. For example, during my first interview with Sally Bliss, she mentioned that Tudor received one of the first National Endowment of the Arts grants in

---

[144]Bliss, Sally. Personal Interview 13 Dec. 2011.

[145]Jordan, James. Personal Interview. 01 Apr. 2012.

[146]Muriel Topaz, "Reconstructing: Living or Dead? Authentic or Phony?" Jordan *Proceedings* 1997, pp. 98-99.

the early 1960s. Tudor didn't use all of the funding and promptly returned the remainder.[147] Now, the story of Tudor's frugal nature is in the permanent Trust record, the *usable past*, of Tudor.

Sally Bliss and the Répétiteurs also research the background of each version of the Tudor ballets which were filmed, remembering that Tudor not only worked with ballet companies in theatres, but also in film. As an example, the ballets restaged for the film productions were often altered, at times due to changes made going from the stage to the filming studio, either by Tudor or the director of the film in order to facilitate the frame of the camera. The ballets documented on film, therefore, even though authentic versions of the original, are not necessarily usable as a reference for another *staged*, restaging. As a result, each film recording validates, as such, a part of the filmic history of that particular Tudor ballet. The film indeed only validates that there are authentic and different Tudor versions of the same Tudor ballet.

For the historian, the photographic or filmic evidence is very relevant to the story of the dance. Perhaps, historians could, as Dutch historian Gustaaf Renier suggests, "replace the idea of sources with that of 'traces' of the past in the present...."[148] Following Renier's ideas then, paintings, statues, engravings can still be considered authentic in that within them we find traces of the original. In the same line of thinking, the Tudor ballets also exist as traces in the photographs and the videos taken of them. Fortunately, the traces left in the photographs and the videos do suggest Tudor's use of the ballet vocabulary, his use of the spine, and the relational *shapings* of his characters' individual movements reflecting the emotional complexities of the characters within his

---

[147]Bliss, Sally. Personal Interview 25 Jan. 2010.

[148]Renier quoted in PeterBurke, *Eyewitnessing: The Uses of Images as Historical Evidence*. Ithaca: Cornell University Press, 2001, p. 13.

narratives. These traces help support the sense of authenticity when the Répétiteurs restage a Tudor ballet.

The videos also capture every mistake by the dancers. Or, the videos lose parts of the ballets during close-ups of the principal dancers. Here, indeed, "the form is surely part of the message."[149] That is, whatever is captured on the video, errors made by the dancers or altered staging due to the shape of the film studio space, is forever part of the history of that ballet. On the other hand, and perhaps best of all, the films document the performances of many of the original Tudor dancers. We see Tudor, Nora Kaye, and Hugh Laing dancing as first generation interpreters of the Tudor roles; further, we see subsequent first and second generations of dancers tackling the difficulties of the Tudor choreography. Even in black and white, in the minimized camera frames, the performances of Tudor's ballets as part of the ballet's history and, more broadly ballet history, are captivating and informative as well as giving diverse insights into authentic possibilities.

For the Tudor Trust, and similar to the triangulation of data in qualitative research methodology whereby data is supported by three differing sources, Sally Bliss and the Répétiteurs analyze the films and videos of past productions by comparing and contrasting the versions against that of their own experience of dancing the ballets on the stage. The discussions between the restagers are, therefore, three-sided and proceed with the following in mind: the recording, what I know (experienced), and what you know (experienced). Included in the discussions of archiving the film/videos is the important consideration of when Tudor restaged the work. In some respects, the videos represent a timeline of how a particular Tudor ballet evolved and Tudor's path as a

---

[149]Ibid., p. 41.

choreographer. The Répétiteurs then analyze differences between the videos and their knowledge of the live ballet performances.

In general, Sally Bliss and the Répétiteurs are not forced to "retrieve"[150] information as Hodson did in her work on Nijinsky's *Sacre du Printemps* for the Joffrey Ballet (*Introduction*) due to the Répétiteurs' lived experience with the Tudor choreography and the Trust's archives. The exceptions are the reconstruction of Tudor's *The Planets* (Prologue)[151] and the proposed future reconstruction of Tudor's *The Tragedy of Romeo and Juliet* (Prologue).[152] Over the years I have known Sally Bliss, I have heard her comment several times that there is very little of Tudor's *The Tragedy of Romeo and Juliet* left on film, and that very few dancers are alive who remember the choreography.[153] This future reconstruction process will provide further opportunities for the Trust to add to the literature of restaging, reconstructing, and reviving dance.

Fortunately for Tudor's other ballets, the Répétiteurs continue to receive videos from former Tudor dancers and institutions to review. And, they continue to review formerly archived film/videos in order to discover additional information about the individual Tudor versions. Ms. Bliss mentioned during our final interview that Donald Mahler had recently uncovered a particular gesture of the hand in *Dark Elegies* by watching films of past productions. Mahler told her that the hand gesture was not a part of any of his experiences[154] of having performed the work many

---

[150]Siegel, Marcia B. "Retrievals." *The Hudson Review*. 54:3 (2006): 437-444.

[151]see Appendix O

[152]see Appendix B

[153]Bliss, Sally. Personal Interview 18 Apr. 2012.

[154]Bliss, Sally. Personal Interview 18 Apr. 2012.

times with the National Ballet of Canada. Now, this *discovered* gesture is part of the permanent *usable past* of *Dark Elegies*.

Indeed, the complexities of *truth* of the Tudor ballets require the perpetual vigilant scrutiny of all versions of any archived videos by the Répétiteurs while they are preparing to restage one of the Tudor ballets. The preparation by the Répétiteurs honors Tudor's versions. Nevertheless, the version taught, ultimately, may be the version the Répétiteurs experienced or are most familiar with, or the version that they know, having watched Tudor create or recreate the ballet. The versions, after all, are all Tudor's.[155]

## The Place for Existence – Making History

Stuart Hodes, former Graham dancer and dance educator, suggests the importance of the rehearsal as the place of making dance history when he states:

> *Choreographers have notebooks too, but their paper trail necessarily ends at the studio door. Only in dance do we lack all records of how the creative process leads to the work of art. This is true even though dance, of all the arts, is closest to its history because it has only one means of passing physical knowledge down the generations—from one human being to the next. Dancers absorb history by learning to dance; when they extend their bodies in arabesque, they share sensation and demeanor with the courtly elite of eighteenth-century Europe....[156]*

---

[155]Bliss, Sally. Personal Interview 13 December 2011; Mahler, Donald. Phone Interview. 27 Jan. 2012; and McKerrow, Amanda. Personal Interview 19 Dec. 2011.

[156]Hodes, Stuart. "Transforming Dance History: The Lost History of Rehearsals" *Design for Arts in Education*. 91.2 (1989): 10-17, p. 10.

He adds, "The blindness of historians to living dance–what happens in the studio – fetters the art, much as lack of virtually any scholarship fettered it fifty years ago."[157] The rehearsal space continues to be the place of making another chapter in the history of each Tudor ballet.

In this place of working and sharing, the Répétiteurs begin the task of revealing the mastery of the Tudor choreographic craft and theatricality, as well as his insights into human interaction. In classical ballet, as well as in theatre, the rehearsal is the place for "transmission of behavior from master to novice."[158] Performance art theorist Richard Schechner also observes, "It is the function of rehearsal in aesthetic theater to narrow the choices or at least to make clear the rules of improvisation."[159] The Répétiteurs do not work improvisationally, but do choose between versions of the ballets. The choice may reflect the technical abilities of the dancers standing before them or the evaluation by the Répétiteurs as to how fast the dancers are learning and retaining the choreography.

In addition, during the restaging process, the way a professional dancer acts in rehearsals during the restaging process is also part of the shared knowledge. In other words, the tradition of being a dancer in a Tudor rehearsal is shared from one generation to another through the restaging process. The process of being a professional dancer working within the restaging process while experiencing Tudor's choreography is another permanent,

---

[157]Ibid.

[158]Richard Schechner, *Between Theatre & Anthropology*. Philadelphia: University of Pennsylvania Press, 1985 p. 36.

[159]Ibid., p. 37.

embodied link to Tudor. By conforming to the tradition of work-ing in a Tudor ballet, the dancers become part of the Tudor leg-acy. In this regard, the restaging process is aligned with experi-ential pragmatists who approach learning as thinking through experience or "thinking experience."[160] Within the space of learn-ing, the rehearsal space, the transmission of knowledge, experi-ence, and history of Tudor continues through the restaging pro-cess of the Répétiteurs of the Tudor Trust. Paraphrasing D.W. Winnicott, psychoanalyst and author of *Playing and Reality*, the rehearsal space is the transitional space, "the time and place out of which experience of the learning emerge"[161]

The role of the Répétiteurs of the Tudor Trust is not only to transmit knowledge but to transmit history. The intermingling of knowledge and history in rehearsal also enriches the experience of the dancers in learning, dancing, and performing the Tudor ballets. The Répétiteurs use the space of rehearsal to continue the historical legacy of Antony Tudor: a legacy of sharing and learn-ing in the space of the rehearsal.

## Eyewitnessing

Historian Jacqueline Shea Murphy, on writing about the his-tories of Native Americans' dances, shares:

Gradually, an understanding of dance as not just recounting history or expressing emotion, but as itself a form of knowledge and history – as capable of enacting effect – emerged through these letters, performances, and conversations. Some dancers and

---

[160]Elizabeth Ellsworth, *Places of Learning: Media, Architecture, Peda-gogy*. New York: Routledge, 2005, p. 17.

[161]Winnicott quoted in *Ibid*.

choreographers talked about the transformations they experience on stage when dancing as animals or other beings..."[162]

The communications, the letters, and the performances document a history of an embodied epistemology, the history of the experience and performance of the Native American dances as relayed by those who have danced the dances. This experiential, embodied, performative history is also fundamental to how the Tudor Trust creates an "authentic" restaging of the Tudor ballets.

The stories and the photographs of Sally Bliss and Donald Mahler performing in Tudor's ballets are part of the recounted history of these ballets and the man who created them. Their embodied, experiential, performative history lends support to the Antony Tudor Ballet Trust's claim of producing the most authentic restagings of the Tudor ballets since the Trust's definition of authentic is steeped in dance as a living practice. Répétiteur Amanda McKerrow's performance in American Ballet Theatre's video of *The Leaves are Fading* anchors her experiential, embodied, performative knowledge of Tudor, and also reinforces the Trust's claim of authenticity within its restaging process. It also confirms the Répétiteurs' position as eyewitnesses, often one-on-one with Tudor, to the making of Tudor history. During our interviews, the recounted hours of watching both rehearsals and performances of the Tudor ballets by Sally Bliss, Donald Mahler, Kirk Peterson, and Amanda McKerrow also re-affirm their position as *eyewitnesses* of Tudor history.

---

[162]Jacqueline Shea Murphy, *The People Have Never Stopped Dancing*. Minneapolis: University of Minnesota Press, 2007, p. 9

In addition, when considering the issue of authenticity, there are also the Répétiteurs' eyewitness, and experiential, links to the first generation of Tudor dancers. In particular, the links are to Nora Kaye and Sallie Wilson. Both women worked with Tudor in American Ballet Theatre. As an example, according to Donald Mahler, Sallie Wilson's performance of Hagar in *Pillar of Fire* was, to some degree, influenced by Nora Kaye's interpretation, even though Sallie Wilson was her own artist and brought to the role of Hagar her own interpretation.[163] The influences from Nora Kaye's performances were transferred through Sallie Wilson to Répétiteurs Donald Mahler, Kirk Peterson, and Amanda McKerrow who were coached by Wilson. Also, James Jordan worked with Ari Hynninen, Laban dance notator for many of the Tudor ballets and a student of Tudor's at The Juilliard School, when she restaged *Gala Performance* for the Kansas City Ballet. Jordan shared with me that he still has his notebooks from that experience.[164] So, the traces of experiential, embodied history with Tudor and/or his ballets by the Répétiteurs reinforce the Trust's claim of authenticity with each of its restagings.

By privileging the past of their peers, the Répétiteurs give substance to that past. Their view is not value-free, however. That said, as I learned through the interview process, their experiences with Tudor and/or their experiences learning, dancing, and performing his ballets were more than could be defined by any one statement. Their experiences with Tudor, in particular, were complex ventures into the workings of Tudor. The rehearsals were teeming with in-depth issues of learning, artistry, theater, performing, technique, honesty, being real in the face of tremendously difficult choreography, finding oneself through the Tudor

---

[163]Mahler, Donald. Personal Interview. 05 Dec. 2011.

[164]Jordan, James. Personal Interview. 06 Feb. 2010.

process of character analysis, surviving Tudor's wicked humor, to name only a few. No one experience defined the Tudor experience; no one example caught the whole story. The recollections and memories and documents of the former Tudor dancers fill the texts of Judith Chazin-Bennahum, Donna Perlmutter and Muriel Topaz concerning Tudor's work and life. The recent publication of the *Antony Tudor Centennial* book, created after the Tudor centennial celebration at Julliard 2008, also contains multiple remembrances and mementos of Tudor by former Tudor dancers.

Every Répétiteur draws on his or her story of working with Tudor during each restaging. Their stories and the stories of other Tudor dancers combine as an amalgamation of narratives. I found that the Répétiteurs' use of narrative, the recounting and telling of stories about working with Tudor, was one of the most unique elements of the restaging process. Chapter Five further discusses the Répétiteurs as the tellers of stories.

## Curating the Tudor Legacy

By definition, a curator is a guardian or person who has the care or superintendence of something—an artist's work, a collection of art works for example—through a particular legal system.[165] As an overseer, manager, or steward of the work of art, the curator is therefore in charge of any exhibits of the work of art, any research supporting the exhibits, or any personnel connected to the place of the exhibits. The depth of the analysis supporting the message of the exhibit and how the exhibit appears to the public are all the purview of the curator. In other words, the

---

[165]Gove, Ed. *Webster's 3rd New International Dictionary of the English Language*, p. 555.

world sees, appreciates, and/or observes the work of art through the efforts of the curator.

The Répétiteurs are the curators of the Tudor ballets. Once Sally Bliss of the Tudor Trust determines who will perform the ballet and which of the Répétiteurs will restage the ballet, the Répétiteur is contacted by the producing company or dance department and a schedule between the two constituencies is agreed upon. Then, the Répétiteur proceeds through exhaustive and rigorous analysis of the ballet, reviewing each step prior to the restaging process. James Jordan refers to the process as "tunnel vision for all of the weeks of preparation going into that staging process."[166] He, in particular, also researches the company producing the restaging in order to "get a sense of where they've been in the past five years before I walked through the door."[167] The schedule of rehearsals, the casting, and the acceptance of all costume, lighting, and set designs all fall under the purview of the Répétiteurs.

As a result, the Répétiteur will meet with all of the designers of costumes, sets, and lighting along with accompanists and vocalists, when necessary, to ensure the authenticity of the total performance. The resultant performances, including deviations from the restaged form based on the dancers' missteps, nerves, or just errors, will be videoed and archived for future reference. The lessons learned and the experiences shared with the dancers will be documented in order to further the collective knowledge of the Répétiteurs and the Trust. Any new insights or *gems* that are discovered in the process are documented in the collective knowledge of the Répétiteurs and the Trust. Each performance,

---

[166]Jordan, James. Personal Interview. 01 Apr. 2012.

[167]Jordan, James. Personal Interview. 27 Dec. 2011.

like an exhibit, becomes an important part of the ballet's history and *afterlife*.[168]

The Répétiteurs' collective knowledge of the ballets is a flexible, working entity. As an example, the Tudor Trust was invited to be a part of the *Reperformance* Symposium through the Performing Arts Department at Washington University, September 13-15, 2012. The Trust was offered an opportunity to share the work of the Trust and the Répétiteurs' in restaging the Tudor ballets. James Jordan was the Répétiteur charged with the project. He was aided by Jennifer Owen, former Kansas City Ballet dancer and dancer with the Owen/Cox Dance Company and Joshua Hasam, dancer with the Missouri Contemporary Dance Company. The presentation included a performance of Mr. Jordan and Ms. Owen from *Offenbach in the Underworld* and Joshua Hasam's performance of the fifth song from *Dark Elegies*.

Jordan drew from the extensive Tudor Trust archived documents and videos along with using some of the Kansas City Ballet's costumes from their productions of *Offenbach in the Underworld* and *Dark Elegies*. With very little lead time, James Jordan organized, restaged, and crafted a presentation that covered all areas of the symposium: the re-performance of a work of art, the preservation of a master work, and the preservation of legacy. He became, in a sense, a curator for Tudor's work.

## Pedagogical Authenticity

The authenticity of the restagings of the Tudor ballets also rests in the pedagogical skills of the Répétiteurs. The pedagogical

---

[168]Marcia B. Siegel, *Mirrors & Scrims: The Life and Afterlife of Ballet*. Middleton Wesleyan University Press, 2010.

authenticity of the restagings comes from the balanced, multi-layered, transactional methodology developed through each Répétiteur's unique relationship to Tudor and his ballets, and his or her individual development as a teacher. Collectively, their approach replicates their interpretation of Tudor's rehearsal environment of exploration and discovery. Their approach begins with each Répétiteur's preparation prior to arriving at the place of the restaging. Each Répétiteur prepares in order to have every skill at his or her disposal in order to engage the dancers in the restaging process. This includes a review of every aspect of the ballet being restaged and how best to present those aspects, along with any supporting or supplementary information.

On the subject of shared knowledge, dance educator Elizabeth Gibbons suggests a balance between a visual and verbal pattern of learning in the presentation of knowledge. The visual pattern of learning is described by Gibbons as "knowledge by direct contact or doing, such as technique...." with the verbal pattern of knowledge being "knowledge by description or interpretation...."[169] For the Répétiteurs, Gibbons's ideas come into play when they are demonstrating (direct contact as dancers watch) the de-constructed Tudor choreography through understandable, accessible, and teachable parts or sections. The verbal pattern of learning is then provided to the dancers through appropriate and timely descriptions and interpretations from the Répétiteurs. Although the day-to-day restaging process remains specific to each Répétiteur, I observed that they all appear to balance their physical demonstrations with their explanations of the choreography throughout the restaging process.

---

[169]Elizabeth Gibbons, *Teaching Dance: The Spectrum of Styles.* Bloomington: Author House: 2007, p. 13.

The pedagogical balance in the restaging process also resides in the Répétiteurs' seeming alignment with Dewey's teachings in education. Dewey's writings challenge teachers to reconsider the traditional schema to teachings as:

> "*not imposition from above but rather expression and cultivation of individuality; as not learning from texts and teachers but rather learning from experience;*
>
> *[moving] from acquisition of isolated skills and techniques by drill to acquisition as means of attaining ends which make direct vital appeal;*
>
> *not preparation for a more or less remote future to making the most of the opportunities of present life;*
>
> *[moving] from static aims and materials to acquaintance with a changing world.*"[170]

After reading Dewey's texts, I was interested to find many connections to the work the Répétiteurs were doing with the dancers. Following is how the restaging pedagogical schema for the Répétiteurs emerged from my data. They practiced enhancing:

the full cultivation of the individual's technique and artistry through the experience of learning, dancing, and performing a Tudor ballet;

the acquisition of skills and techniques directed at the motivations of character and supportive of narrative;

the raising of the dancers' understanding and experience of the *whys* and *hows* of dancing as a professional ballet dancer;

---

[170]Dewey, *Experience and Education*, pp. 5-6.

the aims of the restaging process as transitive, active, embodied, and performative supporting the dancers' efforts in experiencing the world of Tudor.

Furthermore, the Répétiteurs' process aligns with educators discussing and writing about the pedagogy of creativity. In particular, the writings of Mark A. Runco and Ivonne Chand[171] in their work evaluating the creative education of children through problem-finding, evaluative thinking, and creativity, offer a template in which to analyze the Répétiteurs' methodology. Similar to Runco's and Chand's work, the Répétiteurs must make in-the-moment decisions based on their evaluations and calculations of the dancers' immediate responses to learning the Tudor choreography. From these responses, the Répétiteurs must then make immediate decisions about the path of the restaging during the initial moments of the rehearsals. They have to weigh how much to teach at each rehearsal dependent on how fast the dancers learn and retain the choreography. Of course, their choices are estimated against the daily schedule and the overall schedule of the residency. Rarely are the Tudor residencies the only project on the dancers' schedule. The dancers are often learning several new works while bringing other ballets back into the repertoire. For the students in dance departments, the rehearsals are often in the evening, after the students' academic classes. The Répétiteurs' process is very democratic in engaging and supporting all constituencies. In other words, no matter the dancer's ranking in the company—corps member or ballerina—or ranking as a dance major/minor or non-dance major/minor, each receives the same instruction. All of these factors playing into the pedagogical space of rehearsal must be creatively dealt with by each Répétiteur.

---

[171]Mark A. Runco, ed., *Problem Finding, Problem Solving, and Creativity.* Norwood: Ablex Publishing Corporation, 1994, pp. 40-62.

The process of sharing knowledge as well as demonstrating and explaining the choreography proceeds through more than just trial-and-error. The process is more a re-fashioning of the dancers' abilities. It's a process reliant on a transactional relationship between Répétiteur and dancers in order to achieve the scheduled goals of the rehearsal. The Répétiteurs benefit from the cast dancing and performing the Tudor ballet through an improved awareness of *why* and *how* to move which further benefits the telling of the Tudor narrative. The dancers, on the other hand, benefit from an opportunity to transform into better dancers who are more aware of both *why* and *how* they dance. Altogether, the Répétiteurs receive strong, highly informed performances from the dancers. The dancers, then, receive skills which, when applied, service their understanding of their roles and enhances a performance displaying their newly acquired understanding. In the end, the entire pedagogical process underlying the final production fulfills the goals of the Tudor Trust and the institution producing the restaging.

In order to achieve being-in-the-world of Tudor, the Répétiteurs foster a rehearsal praxis that is corporeal, embodied, and experiential affecting the psychomotor cognition of the dancers' performance. Dewey, as quoted in Mullis, reports:

> *The motor coordinations that are ready because of prior experience at once render [the] perception of the situation more acute and intense and incorporate into it meanings that give it depth, while they also cause what is seen to fall into fitting rhythms.*[172]

---

[172]Eric C. Mullis, "Performative Somaesthetics: Principles and Scope." *Journal of Aesthetic Education* 40.4 (2006), pp. 88-118, p. 107.

To achieve the appropriate psychomotor cognition, the Répétiteurs pursue a process that allows for multiple starting points of learning and understanding. The process is not exclusive of demonstration and explanation, but includes even more aural, verbal, and visual cueing which supports the dancers' various learning processes. In this particular case, the Répétiteurs' process addresses what Howard Gardner, psychologist and neuroscientist, refers to as "multiple intelligences"[173] and the variant paths of learning suggested by each.[174] So, the dancer who is less familiar with dancing through phrases of music rather than counting is allowed to count the music. The dancer who is less aural and more visual is given plenty of demonstrations of the exact movements by the Répétiteurs. By contrast however, the Répétiteurs are also always challenging the dancers to expand their individual comfort zones of learning by exploring alternatives to their natural inclinations.

Again, the Répétiteurs' process also takes into consideration the dancers' previous ballet training and performance experience as a base for their corrections, comments, and/or cueing. Their comments are specific and detailed. Their comments often contain both narrative and biographical contexts which both enrich and expand the dancers' knowledge of the ballet and how to dance the ballet. "This process of creating a context for action also shows how the performer can solve the difficulty of creating a believable role—one that is 'truthful' and yet avoid the restrictions imposed by daily technique."[175] The Répétiteurs' balanced, multi-

---

[173]Smith, Kevin. 'Howard Gardner and Multiple Intelligences,' the encyclopedia of informal education, http://www.infed.org/thinkers/gardner.htm 11 Aug. 2012.

[174]Gibbons, *Teaching Dance: The Spectrum of Styles.*

[175]Mullis, "Performative Somaesthetics" p. 113.

layered, transactional approach to teaching the choreography is considerate of all learning strategies through a transactional relationship with the dancers.

## Deconstructing the Pedagogical Methodology

By further de-constructing the Répétiteurs' balanced, multi-layered, transactional, pedagogical approach, I discovered an additional balanced, binary approach which affords the students an opportunity for transforming their own process as artists. The binary approach is shaped by the formality of learning the de-constructed parts and sections of the Tudor choreography and, alternatively, the informality of negotiating with the needs of the dancers learning the choreography and giving these dancers space and time to question. Then the process proceeds from the first de-constructed steps of the ballet and progresses through a sequential, developmentally structured process. The de-constructed complexities of the Tudor choreography are presented to the dancers by the Répétiteurs against a high level of expectation for the outcome of the dancers' process.

The Répétiteurs' balanced, binary approach also addresses both the technical and the artistic requirements of the Tudor ballets. The Répétiteurs teach the integration of the technique and artistry whereby the technical aspects actually service the development of character. Within the balanced, binary approach lies the harmony between technique and artistry within each individual's performances, that is, the correct balance of technical acuity with the gestalt of Tudor's character. The collective harmony of individual performances conjoined within the Tudor narrative unifies the production.

The pedagogical approach also speaks to the Répétiteurs' daily emphasis on integrating the dancer's knowledge of moving

as a ballet dancer with Tudor's own understanding. In other words, for the dancers, the shift in cognitive awareness by dancing the Tudor ballets becomes an integration of pure classical training and Tudor's unique creative innovations. For the dancers, the transformative process contextualizes the Tudor characters' unique movement motifs within the complexities of the Tudor narrative. As a result, the dancers not only learn to explore the technical components of moving, but also learn to explore the motivations and reasons driving the movement – they move beyond the performance of steps.

Ultimately, the Répétiteurs' balanced, binary, transformative approach to restaging the Tudor ballets is analogous to educator Eliot Eisner's pedagogical praxis, a praxis aiming to be both implicit and explicit within the dimensions of schooling.[176] For my research, the schooling takes place in the rehearsal space during the restaging process. The aims of the restaging process, therefore, implicitly support the dancer's journey through the exploration and discovery of the Tudor choreography. Explicitly, the restaging process encourages the vital negotiating and questioning between the Répétiteurs and the dancers in order to encourage the dancer's participation in the process. However, the overall aim of the restaging process is to link the dancer's ability with Tudor's choreography and to then link this process to the subtleties of the Tudor characters, a pedagogical *gestalt*.

The Répétiteurs' process also aligns with Dewey's progressive education schema in that the overall educational experience of the dancers is one of quality. The elements of the Répétiteurs' pedagogical process unites a deep understanding of Tudor's process with the dancer's own understanding of dance to ensure a quality experience. Although the process of learning, dancing,

---

[176]Eisner, *The Enlightened Eye*, pp. 72-81.

and performing the Tudor choreography can be arduous, at times trying, and often off-putting, the quality of the experience guarantees that the dancers will have the best chance to achieve an understanding of the work. This quality of experience will also ensure that the dancers will want to continue to use the skills they have learned through the restaging process and, hopefully, as they continue their careers. Dewey refers to this process of caring forward experiences as a "central problem for education based upon experience."[177] The Répétiteurs' restaging process ensures Dewey's idea that quality experiences "live fruitfully and creatively in subsequent experiences."[178]

The outcome of the Répétiteur's pedagogical process is to create *better* dancers. Better because the dancers think about the choreography they are learning; they are more aware of *why* they move, and *how* they move. The transformation, therefore, is not just in one performance of one ballet, but rather in the dancers' approach to dancing, which even goes beyond their Tudor experience. Naturally, the Répétiteurs' vision is directed toward the restagings of the Tudor ballets; however, after interviewing them, I found that their vision encompasses the effect of their work in influencing ballet dancers to become more empowered artists. In addition, the Répétiteurs envision dancers as life-long learners who continue to be interested in their craft and who are also interesting to work with.

---

[177]Dewey, John. *Experience and Education.* The Macmillan Company: New York, 1950, p. 17.

[178] Ibid.

## Creative, Theatrical, Physically
## and Mentally Demanding

By de-constructing the Répétiteurs' restaging process, I observed that it is a creative, theatrical experience. All of the collaborative elements are made to align with the performed work (the costumes, the lighting, the sets, and the music), but each collaboration is adapted to fit the needs of the particular setting or residency. The process is physically and mentally demanding as well: it pulls together all the expectations of the producing company and the Trust while remaining mindful of the schedule, the time it takes for dancers to really understand the Tudor choreography, and the need for the ballet to be performance ready by opening night. All of the forces of production, collaboration, and choreography do not cohere when the curtain rises without the constant readjustments and carefully, calibrated decision-making skills of the Répétiteurs. From my observations, the Répétiteurs, throughout the entire process, remain professional, friendly, calm, and Tudoresque in their concern for detail, specificity, and musicality. They lend their great knowledge of Tudor and their skills as teachers to the restaging process because of their love of his ballets and their devotion to the ballets remaining vital for the continued authenticity of each new restaging.

## Summary

The Répétiteurs' pedagogical methodology described as balanced, binary, transactional, transformative, experiential-knowledge supports the Antony Tudor Ballet Trusts' authenticity of the restagings of the Tudor ballets. Within the parameters of the Tudor style and the ballets themselves, the Répétiteurs empower the dancers through an environment of exploration and discovery, negotiation and questioning, emphasizing a learning

that is experiential and, ultimately, embodied. Within the pro-cess, the Répétiteurs delve into the complexities of the Tudor characters and narratives with the dancers. The dancers are em-boldened and embodied to create an understanding of Tudor. In the end, for those dancers who truly embrace the process, they become a type of *connoisseur*, as coined by Eisner, of ballet tech-nique and of artistry, a Tudor connoisseur.[179] Based on the quality of the experience, the transformation of the dancers transcends both the rehearsal and the performance of the ballets.

The basis for the Antony Tudor Ballet Trust's claim for re-staging authentic productions of the Tudor ballets is Sally Bliss's and the Répétiteurs' experience as being former Tudor dancers and/or having had performed his ballets. Their often one-on-one relationship with Tudor during his creative years, and then being students of the Tudor choreographic process, also secure the au-thenticity of their restagings of the Tudor ballets. Further, the au-thenticity of the Répétiteurs' restagings of the Tudor ballets is en-livened through their skills as restagers, historians, curators, and as pedagogues of the Tudor Trust.

---

[179]Eisner, *The Enlightened Eye*, p. 63.

Répétiteur Donald Mahler

# Chapter IV
# The Work of the Répétiteurs

The curtain rises on a performance of a ballet and the audience is made aware of three elements: the choreography, the dancers, and the music. I would argue that classical ballets are structured out of these three integral elements. The input of costumes, sets, and lighting design combine to highlight the three integral elements and may appear very complex, as in the ballets of Frederic Ashton, English choreographer with the Royal Ballet in London, or minimalistic as in the ballets of George Balanchine, ballet master of New York City Ballet. The integral elements – the choreography, the dancers, and the music–also may appear very complex or very minimalistic. The Tudor ballets weigh the scale toward complexity in all three integral elements. My work with, and my interviews with others, working with Antony Tudor's ballets highlight how these overall integral elements in a ballet production can be deconstructed further when specifically discussing Tudor's choreographic process. When analyzing a Tudor ballet, one must also be aware of the following integral elements: his kinetic innovations, his truthfulness in performance, and his unique musicality.

## Deconstructing the Tudor Integral Elements

As much as each Tudor ballet is a unique work of art, the ballets are also connected by the elements integral to Tudor's aesthetic. The elements are what make a Tudor ballet a Tudor ballet. The elements must be present in each new production to support

the authenticity of that production. The presence of the elements is dependent on the performances of the dancers in the cast. The success of the dancers' performances is also dependent on their understanding of the elements. In other words, there is a causal relationship between the elements and the dancers' performance. Minor-Smith, writing about the restagings of Loring's *Billy the Kid*, characterizes the required properties of the Loring ballet as essential elements. For this research, the work of the Répétiteurs is, at its essence, to give the dancers an understanding of the essential Tudor elements integral to the ballet; thereby insuring the success of their performances and the authenticity of the newest production of the Tudor ballet.

I would argue that the essential Tudor elements are the DNA of Tudor's creativity. The elements are what Tudor knew, what he understood, and what he shared with his dancers about moving, dancing, and performing. The elements are what he taught, the lens through which he analyzed his characters, and how he challenged his casts. So, key to the authenticity of the present-day productions of his ballets is the dancers' understanding of the elements and their link to Tudor's artistic DNA.

It is even better for the production if the dancers have in their lexicon of qualities and potentials, in their artistic or creative DNA, an affinity for these elements. The success of the present-day productions relies on the dancers' understanding of the essential Tudor elements, but more importantly on their applying the elements in their performance of the ballet. Again, the essential Tudor elements of his ballets are his kinetic innovations, his truthfulness in performance, and his unique musicality.

In my analysis, the Répétiteurs, when preparing for the restaging process, deconstruct the very complex Tudor ballets into these recognizable elements and then develop individual methods for making them accessible to the dancers they are working

with in a specific rehearsal. To make the essential Tudor elements of kinetic innovations, truthfulness in performance, and unique musicality accessible to the dancers, the elements are again subdivided into: steps, gestures, and lifts; character motivations, costumes, sets, and lighting; and musical notes, phrases, and counts. The Répétiteurs are prepared to teach the Tudor choreography in sections of steps, gestures, and lifts; to provide a skilled analysis of the emotional motivations of the dancers' characters including, when necessary, what the dancers are wearing, a description of the set and, when required by the ballet, some information about the lighting; and, to challenge the dancers to hear Tudor's unique interpretations of the music, either through phrases or counts, which underscore the ballet.

The Répétiteurs are confident about their well-researched and experiential-based understanding of the Tudor ballets and in their individual processes of restaging his works supported by their well-structured pedagogical methodology. They are willing to share their accumulated knowledge and experience with dancers who remain open to something new, something the dancers have not danced before. Further, they will strive to create a rehearsal environment that fosters the kind of exploration and discovery experienced by the original casts. But first, they must cast dancers who are most compatible with the essential Tudor elements.

## The Dancers

Faced with the responsibility of casting the next Tudor ballet, the Répétiteurs have to their collective advantage the knowledge of specific unifying qualities of former Tudor dancers. The qualities of the Tudor dancers are directly linked to Tudor's qualities as a choreographer. He was intelligent, open, and musical. Tudor generally collaborated with dancers who were also intelligent

and open to the explorations and discoveries at the heart of his choreographic process, and who were musical. Tudor's openness to influences both inside and outside of ballet proved to be most advantageous to his development as a choreographer.

Tudor took advantage of every opportunity presented to him to study a variety of dance styles which he called upon later on in his choreographic process. He remained open to the early twentieth-century choreographic innovations of Michel Fokine who pushed the direction of ballet choreography toward the creation of narratives within the one-act ballet. Furthermore, he was open to the influences of modern dance choreographers Kurt Jooss and his contemporaries coming out of the twentieth century modern dance expressionistic movement in Germany.

Once in the United States, Tudor opened his rehearsals to the influences of Constantin Stanislavsky, early twentieth-century Russian theater director who began a method of acting called "The System" founded on emotional memory and the physical action emerging from this memory.[180] Stanislavsky moved the actor's skill sets to one of a more natural form, less obvious or exaggerated in its physical manifestations than the acting styles coming out of the nineteenth century. Twentieth-century American actor and teacher Lee Strasbourg of the Actor's Studio in New York City, was greatly influenced by the tenets of Stanislavsky. He developed the "Method" acting technique of "non-acting acting" which influenced a whole generation of actors, to include: Shelley Winters, Eli Wallach, Geraldine Page, and on occasion

---

[180]Janet Brown, Personal Conversation, 4 August 2012.

Marilyn Monroe and Marlon Brando[181] Further, Nora Kaye, Tudor's first American Ballet Theatre muse, also spoke of her "fascination with Tudor's Stanislavskian procedures [her father was a Stanislavsky actor]."[182] Stanislavsky's psychophysical approach to acting and Strasbourg's non-acting methodology aligned with Tudor's development of his characters within his psychological narratives.

Tudor also created a course called Production Class during his years with the Juilliard School in New York City. According to Topaz, "He would give the students problems to solve, a scenario to experience."[183] Also, "He tried to entice the performer beyond 'acting' the part. He wanted the dancer to abandon stopping him or herself, whether consciously or unconsciously, and 'become' the part."[184] When Tudor taught ballet class he explored different qualities of movement with his casts, and together they discovered a new way of moving that was truthful, straightforward, and balanced giving the dancers the best possible physical base as connected to psychological motivation from which to move. As quoted by author and former Tudor dancer Judith Chazin-Bennahum, Répétiteur Donald Mahler remembers that "Tudor cared about spontaneity, an almost improvisational approach, not the studied, dry, academic outlook. A certain amount of risk-taking and daring as well as exposing one's inner self brought excitement and life to one's dancing."[185] Mahler, quoted

---

[181]Topaz, Undimmed Lustre: The Life of Antony Tudor, p. 177; Lee Strasbourg, Actor's Studio http://en.wikipedia.org/wiki/Lee_Strasberg 3 Aug. 2012

[182]Topaz, *Undimmed Lustre: The Life of Antony Tudor*, pp. 274-275.

[183]Ibid., p. 177.

[184]Ibid., p. 178.

[185]Chazin-Bennahum, *The Ballets of Antony Tudor*, p. 11.

in Muriel Topaz's text, expresses another example of Tudor's exploration and spontaneity:

> *He wanted the men to act out a young girl in love. Of course,*
> *nobody could do it. Everybody was mortified. He finally threw*
> *up his hands and said, "All right, I'll do it." And he did. He*
> *became a young girl in love; it was unbelievable.*[186]

This risk-taking and exploration ultimately leads the dancers to the truthfulness of the Tudor characters. That is, the dancers discover the truthfulness of performance through the direct performance of the choreography, nothing else. The characters were not to be elaborated on; they were to be danced truthfully; this movement then reciprocally informed the dancers' truthful performance of the character. The implied truthfulness in all levels of the dancers' performances was required and developed as the following pages will construct for the reader.

## Casting

In order to cast dancers who are capable of "dancing with soul" (Répétiteurs' term), the Répétiteurs look for dancers who they feel dance through their humanity. For example, James Jordan admits that he would look into the dancer's eyes and ask himself, "Is someone there?" Jordan also suggests that the dancers should have a "sense of themselves, with a sense of maturity, with an imagination," then adding that, "we are looking for those who are curious, who are still open to exploring something they've never explored before."[187] Répétiteur Amanda McKerrow offers that like Tudor, she looks for "someone who is questioning

---

[186]Topaz, *Undimmed Lustre: The Life of Antony Tudor*, p. 178.

[187]Jordan, James. Personal Interview. 06 Feb. 2010.

and exploring."[188] Executor of the Tudor will and Trustee of the Tudor Trust Sally Bliss describes the Tudor dancer as "instinctual... honest and real."[189] Also, Répétiteur Kirk Peterson adds that he immediately,

*"...look[s] for someone who has a theatrical sense without putting on a sort [of] artificial theatrical modeling quality. Someone who understands that dance can be more about the theatre than just steps. If someone has that innately, one can often see it and I tend to look for that kind of dancer. The other side is [to look for] someone who technically has a really good simple foundation in traditional classical ballet."[190]*

## Virtuosic vs. Artistic

Some of the Tudor roles do require a certain technical ability; however, the Répétiteurs are not looking for the virtuosic dancer. Consequently, for those dancers who have built their careers on displaying their virtuosic abilities onstage, the change into the Tudor simple, realistic, truthful choreography is a major challenge. Also, there are Tudor roles that require a particular physicality, a look. Tudor did not use the dancers as a traditional corps de ballet where all the women were required to fit into a particular size or look. Here again, Tudor is drawing from the Stanislavsky basis of acting whereby the actors cast had some physical compatibility with their characters.

Répétiteur Donald Mahler offers that for some of Tudor's ballets, he begins by physically typecasting the dancers. In other

---

[188]McKerrow, Amanda. Personal Interview 19 Dec. 2011.

[189]Bliss, Sally. Personal Interview 13 Dec. 2011.

[190]Peterson, Kirk. Personal Interview. 5 Dec. 2011.

words, he feels that the dancer needs to have some physical features of the character.[191] He goes on to describe the younger sister in *Pillar of Fire* as needing to be a smaller dancer whereas Hagar, in *Pillar of Fire*, is a taller, womanlier dancer. He went on to explain that this process is a bit different when casting *Leaves are Fading* which does not necessarily rely on a physical type for a particular role.[192]

All the Répétiteurs agree that Tudor's choreography is difficult to dance, particularly, because of its uncommon use of pointe work,[193] gesture,[194] and musical phrasing.[195] Consequently, the successful dancer must not only bring his or her soul to the collaborative Tudor rehearsal, but also a basic understanding of the ballet vocabulary. This combination of truthfulness in moving and understanding of specific technical principles creates a fertile and open space for new ways of moving.

## Concepts of Moving

The Tudor ballets are designed through Tudor's training in the Cecchetti syllabus and his exploration into the use of the classical vocabulary to support dramatic and comedic narratives. At

---

[191]Mahler, Donald. Personal Interview. 13 Feb. 2010.

[192]Ibid.

[193]Bliss, Sally. Personal Interview 13 Dec. 2011; Jordan, James. Personal Interview. 06 Feb. 2010; Mahler, Donald. Personal Interview. 05 Dec. 2011.

[194]Jordan, James. Personal Interview. 01 Apr. 2012; Mahler, Donald. Personal Interview. 05 Dec. 2011; Peterson, Kirk. Personal Interview. 5 Dec. 2011.

[195]Mahler, Donald. Personal Interview. 05 Dec. 2011; McKerrow, Amanda. Personal Interview 19 Dec. 2011; Peterson, Kirk. Phone Interview. 18 Feb. 2012.

first, the Cecchetti training of Tudor and the other dancers was filtered through Marie Rambert, Tudor's first dance employer and teacher, who gave it a distinct English interpretation.[196] Later Tudor studied with Maragaret Craske who also kept to the original concepts of Cecchetti[197] Author Judith Chazin-Bennahum describes Tudor's interest in the technical method when she states: "From the Cecchetti technique, Tudor learned an evolutionary dance process that developed the gradual tuning of the body's movement in space."[198] Of the Répétiteurs, only Sally Bliss and Donald Mahler were trained in Cecchetti with the National Ballet of Canada, and then later with Tudor. Kirk Peterson credits his training to the French School and Amanda McKerrow began in the Balanchine training, then switched to the Royal Academy of Dance (RAD), later the Vaganova system, and then ended her formal training with some Cecchetti. James Jordan's training is a combination of those teachers with a background dancing with the Ballet Russes and several from the Balanchine style including Todd Bolender, Diana Adams, and Una Kai. That said, all the Répétiteurs can speak to the Cecchetti training as referenced in the Tudor choreography.

Donald Mahler gives an example of how his training in Cecchetti helped in coaching a struggling dancer. He was watching a choreologist, a restager versed in dance notation, restage part of *Echoing of Trumpets* (Appendix J) teaching the wrong steps. Mahler explains that he knew that Tudor would not have done what

---

[196]Perlmutter, Donna. *Shadowplay: The Life of Antony Tudor*, pp. 18, 116-117.

[197]Ibid., p. 43; *Antony Tudor*. Dirs. Viola Aberlé and Gerd Andersson. Stockholm and New York. 1985. DVD. Highstown, 2007.

[198]Chazin-Bennahum, *The Ballets of Antony Tudor*, p. 12.

the choreologist had given because the correct phrasing came directly from a Cecchetti combination which Mahler knew as a student. He now uses the corrected movement phrase as he knows Tudor would have wanted it whenever he restages the ballet.[199]

Today's professional ballet dancers often have an eclectic mix of training, some Cecchetti and/or the Royal Academy of Dance (RAD), or an Americanized version of one or both. These dancers seem to offer no distinct or unified challenge to the Répétiteurs. It is the dancers from either the Russian training or Vaganova training, codified in 1967[200] or the Balanchine training–postulated through the School of American Ballet, the training academy of the New York City Ballet – who seem to have the most difficulty with the Tudor choreography. According to the Répétiteurs, Tudor's affinities for movement lie in a simple, balanced and weighted approach. The lighter, lifted, higher carriage of the body through the Balanchine training means the dancers must re-adjust and lower their sense of center, and ground their movements in order to achieve the feeling of the Tudor choreography. As an example, both Donald Mahler and Kirk Peterson describe the use of the chassé – a connecting step which appears to be a sliding motion of the gesture leg almost as in skating along the floor – whereby Tudor put the weight forward over the gesture leg and foot and Vaganova and Balanchine keep the weight back on the supporting leg.

Donald Mahler shares a story about his ability to help a dancer by suggesting a shift in her weight during a particularly difficult, but basic, step for the advanced ballet dancer. He states: "And I said 'stay up and keep your weight to the side, and she

---

[199]Mahler, Donald. Phone Interview. 27 Jan. 2012.

[200]Peterson, Kirk. Phone Interview. 18 Feb. 2012.

did it..."'[201] He continues by explaining that his eye for coaching was trained through the basic precepts of the Cecchetti syllabus and his understanding of how Tudor choreographed movement. He went on to say, "You have to understand the mechanics of that [Cecchetti's] work"[202] to understand Tudor's movement choices.

Both Donald Mahler and Amanda McKerrow admit that instructing the dancers specifically through the Cecchetti vocabulary is not effective if the dancer is not already familiar with the training.[203] Ultimately, the Répétiteurs draw on their skills as teachers, coaches, and mentors to offset the dancers' lack of experience with the Cecchetti syllabus. Appie Peterson, dance major at the University of Missouri-Kansas City comments on Donald Mahler's coaching of *Continuo*. She relates:

> *I think we were not familiar with the Cecchetti syllabus. I mean, I've had a little bit of it but not enough to recognize it....* *He [Mahler] gave me a lot of corrections not just for the piece but for how I am as a dancer in general... there was a step with a partner where we would swing out into arabesque and we were supposed to look forward and I would look into the mirror.... I had no idea that I was doing it. And at one point he got out his I-phone and... recorded me doing it, and he said 'Look....' I couldn't believe it.... He would stop the music and say 'No, do it from the right angle, don't cheat yourself because you can do it. Just make yourself do it.'*[204]

---

[201]Mahler, Donald. Personal Interview. 05 Dec. 2011.

[202]Ibid.

[203]Mahler, Donald. Personal Interview 6 Dec. 2011; McKerrow, Amanda. Personal Interview 19 Dec. 2011.

[204]Peterson, Appie. Personal Interview 22 Apr. 2012.

Matt Schmitz, dance major at Webster University, St. Louis, Missouri shares his thoughts on Kirk Peterson restaging *Dark Elegies* when he reflects:

> *He [Peterson] was very specific about the way you did things... he worked on the girls' solo[s] and the contraction is very beautiful but very subtle and it's very important, and the hands, and the feel of the walks, or how you walk with your feet. It has to be more pedestrian and less ballet in that sense.*[205]

And again, speaking about Amanda McKerrow in learning *Jardin aux Lilas*, Matt Schmitz also offers:

> *Well first of all the energy [she] bring[s] into the classroom was very important to me and [she is] very expressive and very kind.... I can remember little glimpses in my head of moments... I think I was more inspired by her then her saying certain things... because of the way she acted, the way she took... a step or when she explained a step... she would feel it and do the step, right there.... That's what I took from her.*[206]

Joshua Hasam, dance major at Washington University in St. Louis, continues to share his thoughts when working with James Jordan in *Dark Elegies*. He narrates:

> *I never felt stressed out in the rehearsals. I thought he [James] was very patient with me trying to understand not only the meaning behind the movement but the movement itself, since I was very unfamiliar with a lot of it. I think what made it*

---

[205]Schmitz, Matt. Personal Interview. 15 Mar. 2012.

[206]McKerrow, Amanda. Personal Interview 19 Dec. 2011.

*easier for me to go into this role is because with the Tudor bal-*
*lets there is that emotional element so what I lacked in tech-*
*nique I could put an emotion into and fill the role.*[207]

The Tudor movements are the physical manifestations of the
psychological inner-workings of his characters. For the Tudor
movements, the spine initiates the movement. This explains why
the Tudor movements are not over-extended: the movements,
particularly of the leg to the side or in arabesque, are in concert
with the spine and the head to define an emotion. Tudor never
created steps as steps; the steps emerged from an exploration of
the emotion specific to the needs of each character and his or her
place within the narrative.

The Répétiteurs can and do work with the Russian and Bal-
anchine-trained dancers, as they do with all dancers who are new
to Tudor's way of moving. The beginning of their collaborations
with those dancers is an adjustment of the dancers' understand-
ing of why and how to move. Through the efforts of the Répéti-
teurs, all of the newly cast dancers slowly begin to understand
that their technique is an instrument through which to express
great emotions. To underscore the importance of using technique
as a pathway to artistic expression, dance historian Arnold
Haskell reminds us that it is a mistake to think that the dancer is
expressing "classicism instead of taking it as it really is, that clas-
sicism is helping the dancer to express herself."[208] Also, Somaes-
thetics scholar Eric Christopher Mullis, in his dissertation *Toward
an Embodied Aesthetic*, analyzes performative practices of experi-
ence relative to somatic practices. He posits:

---

[207]Hasam Joshua. Personal Interview. 3 Mar. 2012.

[208]Arnold Haskell, "The Dancer," in Caryl Brahms, ed. *Footnotes to the
Ballet*. New York: Henry Holt and Company. 1936, p. 13.

Répétiteur James Jordan

*Finally, performative practices consciously manipulate the body in order to develop its powers of aesthetic expression.... Artists, of course, are not mindless automatons who remain unaffected by their practices, for by developing the body's performative capacities they transform the self, a transformation that is an essential component of personal style.*[209]

According to the Tudor Répétiteurs, it is critical for the dancers to make the adjustment to the Tudor way of moving, and often, for those that succeed, to remain open to the possibilities of dancing. Répétiteur James Jordan observes:

*I mean, his [Tudor's] movement phrases have such detail about them that they can just be lost in someone else's bad habit of a flipped wrist or whatever, that can just ruin that visual idea that he had that could get an idea or a character across. It can just be totally obliterated by someone's habit of doing something weird that's distracting to the role. So, we often as stager[s] strip away habits... because his ballets are not... [about] selling it... his ballets are really internal experiences between characters and it's not about... selling that to the audiences whatsoever.*[210]

Jordan also adds that some dancers like to embellish Tudor's choreography. "Some are intentional and some are unintentional" says Jordan. "They think this would read so much better.... You try to be pleasant and say 'but Mr. Tudor wanted this gesture to come from the palm forward and just from that depth,

[209]Mullis, Eric C., *Towards an Embodied Aesthetic*. Diss. Winthrop University. Diss, pp. 100-101.

[210]Jordan, James. Personal Interview. 06 Feb. 2010.

and he didn't want a turn of the wrist and a spiral of fingers at the end.'"[211]

Again, Mullis who wrote on an embodied aesthetic suggests that "by becoming aware of ineffectual habits, the practitioner [dancer] consciously develops the body and consequently produces an increased sense of agency. An artist carves out a body by cultivating aesthetic habits that allow him or her [an opportunity] to create works of art."[212] As an example of the positive effects of working through the challenge of the Tudor choreography, Répétiteur Amanda McKerrow describes how, after a battle with repeatedly working in the choreography of the role of the Innocence from *Pillar of Fire* and failing to feel at ease with it, she discovered that the struggle actually helped her find herself in the Tudor movement. She relates:

> And I was a little puzzled at first; and he actually taught me. You know as a ballet dancer you're taught [to] make it look... smooth, make it look pretty. And from then on, I never tried to turn his movements into something familiar, to jump over that awkward phase. It was okay to look awkward... and that helped me tremendously because there is such a tendency to gloss things over, and make it look beautiful, clean, smooth, or something you're familiar with. And so, by going through that awkward phase it would elicit that feeling of angst, or struggle... abandonment that I like to think he was going for there.[213]

---

[211]Jordan, James. Personal Interview. 01 Apr. 2012.

[212]Mullis, Eric C., *Toward an Embodied Aesthetic*. Diss. Winthrop University, 1999, p. 102.

[213]McKerrow, Amanda. Personal Interview 19 Dec. 2011.

Later in the interview she expands the idea by reiterating: "Repetition is the key. Just keep trusting the movement, trust the movement and you'll understand. Repetition is the key; it really is."[214] Now, as a Répétiteur, Amanda McKerrow encourages the dancers to work through the awkwardness and the letting go of bad habits to find the truth of the character embedded in the Tudor choreography.

Maxine Sheets, aka Sheets-Johnstone, dance theorist, suggests dancing is about tapping into the "fund of lived experiences" beyond the dancers' training.[215] The Répétiteurs also tap their previous lived experiences after having spent many hours restaging Tudor ballets as well as their experiences working with Tudor. These experiences provide them with a fund of possibilities they can call upon for just the correct instruction or insight for a particular situation. Donald Mahler shares how, after observing several dancers struggle with the simple, naturalistic walk required of their characters, he suggested that they try walking "as if they were going to the super market" or "to go and do like you've just got your paycheck." Mahler emphasizes, "It's a whole way of relating to natural life, but that is very hard to do. They [the dancers] want to make it, they want to add to it [Tudor's gestures]."[216]

Amanda McKerrow often helps by suggesting to those dancers who have also studied modern dance that "it might help to pull some of your feeling out of your modern dance training or

---

[214]Ibid.

[215]Sheets, Maxine. *The Phenomenology of Dance*. Milwaukee: The University of Wisconsin Press, 1996, p. 117.

[216]Mahler, Donald. Personal Interview. 05 Dec. 2011.

modern dance ballet."[217] Alternatively, Kirk Peterson offers an insight into the masterful structure of the Tudor ballets and the logic of movement choices, the moment-to-moment choices that Tudor crafted in each ballet, as a form of kinetic logic. Peterson comments that he tries to teach the steps with the same kind of logic which he believes has a "cumulative effect whereas [what] you [the dancer] feel when you do a Tudor ballet, [makes] you become a Tudor dancer." [218] Both Répétiteurs' comments speak to their efforts toward understanding each dancer and then helping each one find pathways to Tudor's kinetic logic.

## Sensitivities - Building toward Character and Truthfulness in Performance

Shegenori Nagatomo writing on the body-scheme of body-mind oneness, pens that "those who excel in the performing arts have a well-developed "circuit of kinesthesis"; they can rapidly convey information about a condition of their limbs and coordinate this information skillfully with bodily movement."[219] The circuit of kinesthesis for the Tudor dancer comes from a sensitivity of the use of the spine which then initiates movements from the arms, and the legs, including the feet, all relating to the narrative which moves in, through, or under the musical phrase. For the Tudor dancer, the circuit translates multiple sensitivities through the body relative to the character being danced. Mahler's

---

[217]McKerrow, Amanda. Personal Interview 19 Dec. 2011.

[218]Peterson, Kirk. Personal Interview. 5 Dec. 2011.

[219]Nagatomo, Shegenori. "An Eastern Concept of the Body: Yuasa's Body-Scheme." ed. Maxine Sheets-Johnstone. *Giving the Body Its Due.* Albany: State University of New York Press, 1990, pp. 48-68, p. 50.

pedagogical cue about walking to the grocery store, therefore, becomes defined, structured, and informed by the character's emotions or motivations and how these play out physically in the spine and then through the arms, legs, feet in relationship to the musical phrasing.

Actually, according to Tudor, his dancers should be sensitive to every element connected to his ballets.[220] Tudor references this in the documentary Antony Tudor. In one scene, Tudor asks Hugh Laing to perform moments from three Tudor solos. Tudor acquaints the viewers with the reason why Laing changes his dancing shoes from jazz shoes to ballet slippers in between two of the solos. Tudor explains that the different shoes activate a different use of the foot and the carriage of the spine. Judith Chazin-Bennahum, former Tudor dancer and author, describes how Tudor gave exercises in his ballet classes to make his dancers think about the beginnings of movement. She describes:

> *Dancers were always aware that what they worked on in class was part of a search for values that would and should affect the performance on the stage. Tudor sought to arrive at principles that explained where movements initiated. He stated many times, 'Center-of-the-body consciousness is a primary necessity that far outweighs the mechanics of high kicks, etc... an unmalleable spine, with automated legs and flappy wrists can only produce the non-genuine'.... He encouraged dancers to move from the torso, naturally taking the hips along. The arms as well had to have a fluidity and prior motivation. This awareness tended to relax the limbs.[221]*

---

[220]*Antony Tudor*. Dirs. Viola Aberlé and Gerd Andersson. Stockholm and New York. 1985. DVD. Highstown, 2007.

[221]Chazin-Bennahum, *The Ballets of Antony Tudor*, p. 11.

The Répétiteurs are constantly vigilant to the dancer who becomes less diligent about his or her performance, where shortcuts are taken, or the real sensibilities of the movement are lost to easier or more comfortable alternatives. Often, the Répétiteurs stop the rehearsals to remind the dancers to just remain sensitive to their walking, to how the foot is placed before or after a particular movement, or to the position of the feet in standing. They layer the information with more details, refining and retuning each dancer's understanding and performance of the Tudor choreography. James Jordan, Répétiteur in-training, observes that it sometimes takes the dancer more time to have that mind/foot connection in learning a Tudor piece.[222] Indeed, the process, as holistic, mind-body connections, is not just time-on-task but allowing the information to seep into the dancers' muscles.

The Répétiteurs aid the dancers in their understanding of the importance of specificity and attention to detail by stressing the overall composition of the story. They remind the dancers that the Tudor choreography tells a story. There are no choreographed fillers; every moment of a Tudor ballet furthers the storyline. In explaining and demonstrating Tudor's use of the extension of the leg to the side as only hip height, the Répétiteurs remind the dancers that the movement is part of the character's opening up of the chest to the heavens. This opening includes reaching the arms to the side with the leg adding to the overall movement composition to support the character's yearning for some answer, some help in dealing with the circumstance in which she finds herself. The leg moving any higher would dwarf the composition of the movement and overpower the emotional content of the use of the spine, head, and arms.

---

[222]Jordan, James. Personal Interview. 27 Dec. 2011.

Appie Peterson, dance major at the University of Missouri-Kansas City, adds her thoughts on understanding the restaging process after working with James Jordan in *Dark Elegies*. She remembers:

He [James] just showed us the steps.... It was a really hard, a really difficult solo... it took me a while to maneuver around, there's like a penché from a crossed position, and that took me a real long time to figure out how to do, but once I got it, the movement felt really natural, felt really organic... once we had the story it gave us something to hold onto during the performance.[223]

The Tudor use of the arms is another area of concern for the Répétiteurs. His characters do not use the traditional ballet port de bras–the use of the arms through clearly defined positions relative to the shape of the feet and legs. "He [Tudor] spoke of the arms as extensions of the torso and as silent voices of the music rather than convenient, automatic shapes we learn as youngsters in ballet class," pens Judith Chazin-Bennahum.[224] During rehearsals, I observed the Répétiteurs continually explaining and demonstrating the proper use of the Tudor arms and hands. As Donald Mahler aptly states, there are "no fancy hands."[225] Kirk Peterson offers that he often goes around the cast, "taking the dancers' arms and hands and shaking them just to release the tension."[226] The dancers are constantly reminded that they are dancing real people, with real arms and hands that move only when necessary and that lend some insight into the character. As executor of the Tudor will and Trustee of the Tudor Trust, part of Sally

---

[223]Peterson, Appie. Personal Interview 22 Apr. 2012.

[224]Chazin-Bennahum, *The Ballets of Antony Tudor,* p. 13.

[225]Mahler, Donald. Personal Interview. 13 Feb. 2010.

[226]Peterson, Kirk. Personal Interview. 5 Dec. 2011.

Bliss's role in the restaging process is to alert the casts to the nuances of their performance and fine-tune the dancers' consistent approach to their roles during the last rehearsals in the studio, onstage just prior to the performances, and after each performance.

## Face-to-Face

The Tudor partnered moments represent another hurdle for the dancers and there are no manuals for instructing Tudor's partnered moments or lifts. They are unique to the traditions of ballet partnering. Many of Tudor's partnered steps and lifts are performed with the man and woman facing each other which is quite opposite than the traditional configuration of the man standing behind the woman during a partnered phrase or the man holding the woman by the waist as she faces out to the audiences. However, the face-to-face relationship appears logical when considering the relationship of the lift or partnered moment to the through-line of the story. Donald Mahler offers that the face-to-face positioning is more relational and more like ballroom dancing. To help the dancers during the restaging of *Lilac Garden* for the Kansas City Ballet, Mahler brought in films of Fred Astaire and Ginger Rodgers for the dancers to watch. He wanted the company dancers to observe the kind of dancing between a man and a woman in which there is a distinct relationship, where the dancers relate to one another as they dance.[227] For years, fans of Fred Astaire have watched as his choreography moved the story ahead: Astaire meets girl; Astaire dances with girl; girl falls in

---

[227]Mahler, Donald. Personal Interview. 13 Feb. 2010.

love with Astaire. Tudor's choreography is slightly more complex, but the depiction of relational interactions in face-to-face partnering is apparent in both.

The Répétiteurs are very hands-on while teaching each man and woman cast in the partnering sections. The Répétiteurs instruct the mechanics of the partnered moment or lift while constantly reminding the dancers of the motivations behind the movements. It was obvious to this observer that the safety of the dancers, especially in the lifts, is also paramount. There is a period of trial-and-error for the dancers, as with learning any of the Tudor choreography. The work is arduous and time consuming. The Répétiteurs, therefore, appear to bring their most careful instructions to the learning of the Tudor partnering moments.

I remember when Tudor taught Michael Owen and me a lift which seemed particularly difficult for Michael during the *Pillar of Fire*[228] rehearsals. It began with me standing on one leg on pointe in arabesque while being supported by Michael, then he flipped me toward him in one-count while I drew my standing leg into a bent knee position; I ended by being held in Michael's arms still in arabesque with the standing leg now pulled up in a parallel, bent knee position. Luckily for me, Michael was a great partner and the lift always went flawlessly. What I came to understand about that moment in the ballet was that, for Hagar, it was a breakthrough moment for her and her acceptance of the Friend (Michael's character). Prior to the lift, Hagar was full of hesitation, hiding her face in her hands as she looked away from the Friend, keeping one foot rooted in her past. Then, in one moment, she allowed him to help her, he was there for her, and she freed herself from her past. I thought it was a pivotal moment in

---

[228]See Appendix A

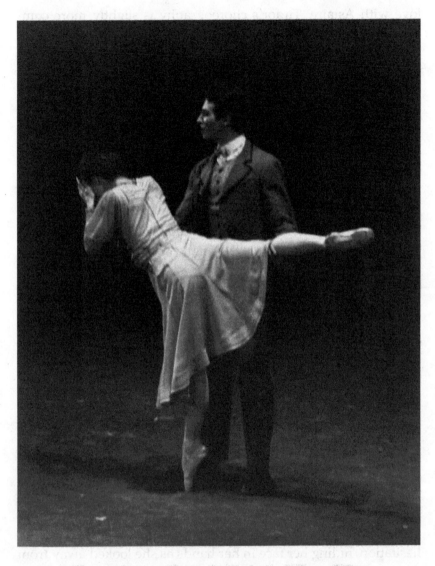

The author as Hagar in Tudor's *Pillar of Fire,*
together with Michael Owen

the ballet all made more apparent by Tudor's choreographic instinct for the metaphor held within this partnered moment. Discovering the metaphor behind the movement in the moment of doing the movement helped me as a dancer figure out the physicality needed to perform in the duet.

## Character Analysis

The performance of a Tudor character is a heightened awareness of every moment on stage relative to the emerging story. It also requires a consistency in performance whereby the dancer doesn't lurch into some favorite movement, add a flourish here and there, or slap a smile on her face.[229] The consistency of performance is reliant on the dancers' analysis and understanding of their characters. The dancer's body must be transformed; the dancer's personal movement affinities must now serve the movements of the Tudor character. The dancer's way of moving onstage must transform into moving through the character's personal affinities. Through the dancer's analysis of character, the corporal etchings of the character transfer into the dancer's embodied knowledge of the character. The repeated muscle patterns of the Tudor choreography become the muscle memory that the dancers will rely on to fulfill the task of performing the Tudor characters.

The Répétiteurs guide the dancers through a dialogic and experiential analysis of character. The dialogue between Répétiteur and dancers emphasizes the truthfulness of the characters. The dialogues progress through well-described instructions, ideas, or suggestion. The dialogues can be short corrections or a trail of

---

[229]Jordan, James. Personal Interview. 01 Apr. 2012.

questions and answers. The kind and length of the exchanges vary depending on the particular problem at hand.

If indeed Tudor was a seeker of Truth as the Répétiteurs shared with me, then what truths do his characters reveal? How do the dancers get to the Tudor Truth? How do the dancers navigate the interplay of circumstances and consequences played out by their characters on stage? The dialogue between the Répétiteurs and the dancers confront these issues. The dialogue gives context to the character, technical support to the performance of the difficult Tudor choreography, and directions for the complex mapping of the Tudor narrative. The answers ultimately lie in the experience of dancing and performing the Tudor steps.

## Truthfulness in Performance – "To act or not to act"

The Répétiteurs ease the dancers into a form of acting in which there is no exaggerated, over-reaching gestures. Here again, the acting of the dancers' references Tudor's Stanislavsky method of sense memory or non-acting acting rather than methods from previous generations of acting styles that were broader, exaggerated, and not from a method drawing the inner feelings out to convey emotional content. Also, Répétiteur Amanda McKerrow states that there is a lack of "ego dominance"[230] in the pursuit of the Tudor character. The ego of the dancer must become subservient to the Tudor character. She expands on the concept:

> When the ego is in charge it doesn't work, and that's when I run into my biggest problems with directors and casting is when they want a certain someone in the role and there's this image... of the ego. It's just like this impossible barrier to get

---

[230]McKerrow, Amanda. Personal Interview 19 Dec. 2011.

*through and, sometimes, actually, it is impossible.... So, it's a lack of approaching their work from an ego-based placed. Because there's ego in there and all that, but when the ego is dominant it's just not good.*[231]

Répétiteur Donald Mahler compares dancing a Tudor character to the acting of the silent films era whereby the actors had to convey much of the intended scene through body language. Let me be clear, his comparison solely focuses on the actor's reliance on body language not the over-dramatic exaggerated acting methodology of the silent film actors. Mahler also utilizes film references when coaching certain characters. He explains that in the film Separate Tables, "Deborah Kerr is a down trodden spinster put down by her mother, very similar to the character of Hagar in *Pillar of Fire*."[232] For the role of the mistress in *Jardin aux Lilas*, Mahler refers the dancer to the character of Belle Whatling in *Gone with the Wind*.[233] Similarly, Kirk Peterson aligns the acting with that of the Swedish film maker, Ingmar Bergman.[234] By contrast, Sally Bliss questions if the process is even acting at all, but clarifies that if it is, then it is definitely not bad acting or "artificial" in any way.[235]

Performance studies theorist Richard Schechner suggests that in drama, it is the actor's special task to move through transformations as temporary rearrangements of their body/mind.[236] Schechner suggests, "In all cases rehearsal is a way of selecting

---

[231] Ibid.

[232] Mahler, Donald. Personal Interview 6 Dec. 2011.

[233] Ibid.

[234] Peterson, Kirk. Personal Interview. 6 Dec. 2011.

[235] Bliss, Sally. Personal Interview 13 Dec. 2011.

[236] Schechner, *Essays on Performance Theory*, p. 123.

from the possible actions those actions to be performed, of simplifying these to make them as clear as possible in regard to both the matrix from which they have been taken and the audience to which they are meant to communicate."[237] The Répétiteurs take great care and time with each dancer to allow him or her opportunities to delve into his or her character's specific and detailed kinetic language and to complete the transformation into the simply beauty of a Tudor gesture.

Contrary to Répétiteurs Donald Mahler and Kirk Peterson, Répétiteur Amanda McKerrow focuses her analysis of character development on the movement and the sensations of the movement to monitor whatever "character" emerges without relying on any form of acting. Whatever Tudor established as inclinations or gestures or presentations of the steps, all the information the dancers require to achieve full embodiment of their characters is contained in the steps. McKerrow clarifies: "...he [Tudor] captured everything... everything is in those movements."[238] After the dancer's body has had a complete dosage of the character's movement during the restaging process, the dancer's muscle memory acts as a permanent reservoir for the dancer to tap into whenever necessary. The path to transformation therefore is "in the movements" comments Amanda McKerrow "and if you take the time to make the effort to do it just the way he [Tudor] wanted it to be done, I think it's all there."[239] Sally Bliss, executor of the Tudor will and Trustee of the Tudor Trust, shares that the process is very complex, fitting the complexity of the Tudor characters. She explains:

---

[237]Ibid., p. 135.

[238]McKerrow, Amanda. Personal Interview 19 Dec. 2011.

[239]Ibid.

*It's like [rubbing your stomach and patting your head], you've got to get the steps in order to get the quality, and if you don't have the steps you're not going to have the quality. They are totally interfaced. And you can't just do the steps and not what you are trying to portray, you've got to do both together.*[240]

The outcome for the dancer is an emersion into the structured influences of movement, gesture, and lifts which convey all the required qualities about the character to the dancer. Whatever the point of entry, to act or not to act, the ever-vigilant observations of the Répétiteurs help to sculpt the dancer's performance through a more truthful, integrated, inside-out, holistic awareness, and sensitivity regarding every element in the ballet.

## The Worlds of the Tudor Ballets

When the curtain rises on a Tudor ballet the audience is drawn into a specific and distinct world. The Tudor characters exist then distinctly in these worlds. Even his *Romeo and Juliet* are distinct from the Shakespearean characters. According to twentieth-century arts theorist Nelson Goodman, the worlds we create to live in, to create in, are compiled from other worlds through a system of choices. The choices come through a series of actions and those actions include composition, the formations and deformations of elements in the worlds.[241] Similarly, Tudor took actions that helped him create the worlds of his ballets. The Tudor worlds exist through his kinetic logic, truthfulness in performance, and his musicality. Also, his specific theatrical devises, the specific inclusions of costumes, set, and lighting unify the

---

[240]Bliss, Sally. Personal Interview 13 Dec. 2011.

[241]Goodman, *Ways of Worldmaking*, pp. 7-17.

world as a specific place and time. His characters also move in a specific way because of the cultural world in which they exist. In the end, through a series of specific actions, Tudor's creative world intersected with the worlds of his ballets and the worlds of his dancers.

The world of Tudor's creative process included a group of dancers who were intelligent, open, and musical. His world of creative process included both professional ballet companies and the Juilliard School. He explored. He infused ballet choreography with innovations both artistically and technically. These were his choices. Dancers learned to function, to dance Tudor's world of classes and rehearsals. Actually, he required his dancers to act, to think, and to dance through a specific set of rules and motivations.

Pierre Bourdieu, twentieth-century philosopher, offers a theory of habitus through which we can understand the underlying fusions and intersections of worlds. Bourdieu suggests the concept of habitus to describe the "structuring structures" of forces acting on individuals. Also, he describes habitus as a "product of history which produces individual and collective histories." Bourdieu further suggests that the habitus defines a form of practice, the "modus operandi' of the habitus."[242] I would argue that each Tudor ballet exists as a habitus–a structuring structure–producing a collective history which informs the actions or the modus operandi of the resident characters. Furthermore, I would argue that the Tudor characters by their actions, modus operandi, define the world, or habitus, of the ballet. The world of the Tudor ballet and the characters are mutually definitive and contextual.

---

[242]Bourdieu, *Logic of Practice*, pp. 53-54.

Some examples of Tudor's concept of habitus and modus operandi include:

The Edwardian lilac garden on a moonlit night for Caroline in *Jardin aux Lilas*;[243]

The European village and ritual grounds of the grieving woman in the fourth song of *Dark Elegies*;[244]

The old and slightly seedy bar of the ladies of the evening in *The Judgment of Paris*[245]

We know these worlds by the recognizing the characters within them: how they look, what they wear. We know the Tudor characters by recognizing the worlds in which they live: we can see them, smell them, and almost taste them. For example, we can almost smell the grease paint make-up of the ballerinas in *Gala Performance*,[246] the death and destruction of war in *Echoing of Trumpets*,[247] and the French wines and perfumes in *Offenbach in the Underworld*.[248] Tudor didn't design the curve of a step, or the curve of a hat, or the curve of a set that didn't support the worlds of his narratives.

Just as we, the audience, recognize the Tudor world in performance, the dancers also sense how they exist within the world created in rehearsal and in performance. As Maxine Sheets-Johnstone describes, the dance is a form perpetually experienced by the dancer where its "past has been created, its present is being

---

[243]see Appendix D

[244]see Appendix F

[245]see Appendix E

[246]see Appendix Q

[247]see Appendix J

[248]see Appendix P

created, its future awaits creation."[249] As such, the Répétiteurs press the dancers to understand and experience, to partake of all the available senses to inform their performances, to create fully complex and believable worlds in their dancing. Like Tudor, the Répétiteurs continually ask the dancers questions probing their knowledge of their character. They ask: Who are you in the ballet? What are you doing at this moment in the ballet? They ask the dancers what they were doing right before making an entrance. The questioning only aims to deepen the dancers' understanding of their individual characters and the worlds which they create around them. In other words, the Répétiteurs' modus operandi is to bring the dancer as the character into the habitus of the ballet in order to develop new world spaces. The dancer should be able to see the moonlight, smell the grease paint, or taste the wine even while dancing in practice clothes in the studio.

The Répétiteurs encourage a continued questioning and searching for answers that will lead the dancers down the paths to their truthful interpretations of their roles. Sally Bliss shares a story about two young students from the Jacqueline Kennedy Onassis school of American Ballet Theatre who were going to perform a small section of Tudor's *Little Improvisations*[250] during the Tudor Centennial celebrations at Juilliard. She explains how the students worked so hard learning the exact way to hold the imaginary baby and then captured the characters in rehearsal. "They really took that baby, they made the baby, folded it over, put it into their arms and coddled it and danced with it all the way through, then suddenly they drop the cloth; ends; and the baby is gone. Then they look at each other," described Sally Bliss.

---

[249]Sheets-Johnstone, *The Phenomenology of Dance*, p. 22.

[250]See Appendix S

Unfortunately, when it came to the actual performance, the students' desire to perform overtook Sally Bliss's detailed instructions and coaching. She added "When those two came to the performance, they only did the steps. They forgot to be real."[251] I would add that they forgot to be truthful. For these young students, the world of the two young friends playing together in an attic on a rainy day dissipated with the pressures of the performance. They no longer could smell the rain, see the attic, or feel the baby as they had in rehearsal.

Appie Peterson, dance major at the University of Missouri-Kansas City, describes how her costume in *Dark Elegies* also informed her work in the ballet:

> It was that our pointe shoes were brown and didn't have ribbons.... So it just made it more that we are just people. We don't have... shiny ribbons or shiny pointe shoes and tutus... we're just people.[252]

## Unique Musicality – To Count or Not to Count

Tudor was a musician. He often played for the Rambert Company as an accompanist. Muriel Topaz, former Tudor dancer and author, pens:

> In the archives of the Rambert Dance Company there is a score of Claude Debussy's L'Apres-midi d'un faune with penciled cues in Tudor's hand.... On the front cover of the score is a note from Rambert admonishing Tudor to rewrite the cues in ink.[253]

---

[251] Bliss, Sally. Personal Interview 13 Dec. 2011.

[252] Peterson, Appie. Personal Interview 22 Apr. 2012.

[253] Topaz, *Undimmed Lustre*, p. 24.

Unlike Ashton who was a very musical choreographer but could not read a score, Tudor's knowledge of music came from being able to decipher what he felt were the composer's original intentions directly from the scores. In addition, Tudor was inspired by diverse music and composers in a very specific way. Each piece of music was chosen specifically to create the world in which the dance narrative might live. To underscore his range of musical interests, his scores include: Girolamo Frescobaldi (Cross-Garter'd 1931, Appendix T), Sergei Prokofiev (*Lysistrata* 1932, Appendix U), Gustav Holst (*The Planets* Appendix O), Ernest Chausson (*Jardin aux Lilas* Appendix D), Gustav Mahler (*Dark Elegies* Appendix F), Kurt Weill (*Judgment of Paris* Appendix O), Arnold Schoenberg (*Pillar of Fire* Appendix A), Sergei Prokofiev (*Gala Performance* Appendix Q), Frederick Delius (*The Tragedy of Romeo and Juliet* Appendix B), William Schuman (*Undertow* Appendix H), Jacques Offenbach (*Offenbach in the Underworld* Appendix P), Antonio Soler (*Fandango* Appendix I) , Bohuslav Martinu (*Echoing of Trumpets* Appendix J), Charles Koechlin (*Shadowplay* Appendix K), Leos Janacek (*Sunflowers* Appendix N), Johann Pachelbel (*Continuo* Appendix L), Robert Schumann (*Little Improvisations* Appendix S) and Antonin Dvorak (*The Leaves are Fading* Appendix C).

During my observations and during the interviews, each of the Répétiteurs made several references to Tudor's specific use of music in relationship to learning the choreography, to understanding the movement in relationship to the narrative or the dancers' characters, and to performing with a sense of beginning and end to the ballet. Below is a list of comments from the Répétiteurs about Tudor's musicality:

Mahler: "I think it's perfectly musical, and perfectly logical, and perfectly doable...."[254]

McKerrow: "The movements of it [Tudor's ballet] completely capture the music and what I think he was trying to say...."[255]

Jordan "...the actual time of the step within the musical phrase.... That's most important...."[256]

Peterson: "...the tiniest divergence from [the] musical phrase can change the meaning...."[257]

In addition, the student/participants all commented on their experience in learning Tudor's unique musicality in *Dark Elegies*. Some of their comments include:

AP: He [James] explained [that] he [Tudor]was very specific with timing... with the syncopation, the little beats underneath that most people don't catch onto; that is very intricate, the musicality that happens during *Dark Elegies*....[258]

MS: He [Kirk] is very musical....and he came in and knew everyone's part, and every count, and he was very detailed....[259]

JH: "I really liked dancing to live music. I come from a musical background, and so to have that added energy to the piece, it really helps, I think. It really allows you to really live in the moment and not get stuck in certain patterning that you've been use to rehearsing...."[260]

---

[254]Mahler, Donald. Phone Interview. 27 Jan. 2012, p. 12.

[255]McKerrow, Amanda. Personal Interview 19 Dec. 2011.

[256]Jordan, James. Personal Interview. 01 Apr. 2012.

[257]Peterson, Kirk. Personal Interview. 6 Dec. 2011.

[258]Peterson, Appie. Personal Interview 22 Apr. 2012.

[259]Schmitz, Matt. Personal Interview. 15 Mar. 2012.

[260]Hasam Joshua. Personal Interview. 3 Mar. 2012.

As executor of the Tudor will and Trustee of the Tudor Trust, Sally Bliss acknowledges her concern over the preservation of Tudor's subtle musicality at a future time when the ballets move into the public domain. However, she feels that this problem might be alleviated by the use of Labanotation which she feels has an innate musicality built into its system of recording action on the stage. She states: "But because Labanotation is musical there is always a notator who can make sure that these ballets are musical because it's so easy not to be."[261]

As I mentioned in the Prologue, Tudor often hummed or sang the choreography during my rehearsals of *Pillar of Fire* and *The Leaves are Fading*. Also, I learned much of the choreography of *The Leaves are Fading* as lyrics to the Dvorak score. I'm fortunate; I am musical, and yet I found the Tudor musicality extremely challenging. I also remember being on stage as Hagar and making a concerted effort to keep hearing the music in spite of my nerves, and my fears. To this day, I can hear with my body and feel in the music the opening cords of *Pillar of Fire*, or the deeply moving phrases when Hagar is trying to speak to someone, anyone for help, or the highlighted phrasing of the music just before and after the moment of the lift that seems to signal a turning point in her life.

And then there is the Dvorak score to *Leaves are Fading*. The music appears to be the correct balance between light and weight, flowing and bounded dynamics, as was the ballet. There are tremendous mood shifts within each pas de deux which supports Tudor's ebb and flow of emotion. *The Leaves are Fading* does not contain the dramatic weight of *Pillar of Fire*, but appears fully appropriate to the emotions for which Tudor expressed in that specific ballet. For me as dancer, the experience of dancing in just

---

[261]Bliss, Sally. Personal Interview 18 April 2012.

these two ballets was an education in music, but more im-
portantly, an education based in experience with and through the
art. It was about feeling the power of the music, even in its most
subtle moments, to connect to human emotions.

Unfortunately, Tudor's musicality is often too subtle for the
average or non-musical dancer to hear. The Répétiteurs often re-
sort to counting the music rather than setting the work as chore-
ographed or hummed by Tudor. Even with this help, dancers still
find Tudor's sense of the musicality within the musical score a
challenge. As an illustration of this dilemma, Répétiteur Donald
Mahler shares a story about two dancers in one of the German
companies who never heard their entrance music. They just
couldn't hear the phrases which cued their entrances. He finally
suggested that they "wait 'til the [count of] ten and then [enter].'"
But, he quickly added, that to have his instruction prove helpful,
it meant that "they were on the music [to begin with] to start the
count of one to get to the count of ten."[262]

Sally Bliss does not remember counting during the majority
of her time with Tudor, but she does consider that there might
have been some counting during the Echoing of Trumpets rehears-
als during one group section.[263] She agrees, however, with the Ré-
pétiteurs' choice to count during the restaging process saving
time and putting less stress on the dancers and the Répétiteurs.
Amanda McKerrow does not ask the dancers to count, but to
make note of certain "numerical landmarks" in the music. She
analyzes her choice:

> In the beginning, they don't know the music, the dancers.
> They're not familiar [with it]; they just need to get to know it.

---

262Mahler, Donald. Personal Interview. 13 Feb. 2010.

263Bliss, Sally. Personal Interview 13 Dec. 2011.

*So, we [Amanda and her husband John Gardner] give them
numerical landmarks for musical accents, but we always give
a talk in the beginning "this is for now, we encourage you...
we tell the story about Mr. Tudor, in my experience, he didn't
let us count and I use the opening section of Leaves are Fading
as a perfect example."* [264]

Of the three essential Tudor elements, his musicality is the
most challenging for the dancers to grasp as it underscores the
other two elements of kinetic innovations and truthfulness in per-
formance.

## Deconstructing the Process

I was able to observe each Répétiteur during his or her re-
staging process as each presented the de-constructed master
work to the dancers. I observed first-hand the dailiness[265] of the
process of presenting the three essential Tudor elements to the
dancers: kinetically logical movement, truthfulness in perfor-
mance, and unique musicality. The process involved the teaching
of each section of the ballet, layering the work with details and
specifics, and guiding the casts through the, at times, awkward,
but ultimately rewarding experience of learning, dancing, and
performing a Tudor ballet. For the Répétiteur, the step-by-step
process was challenging.

I also observed that there was another element to the process.
Each of the Répétiteurs recounted stories about their experience
with Tudor or told stories of other Tudor dancers' experiences
with Tudor. The Répétiteurs seemed to have a collection of stories
at the ready to share at any time during the restaging process.

---

264McKerrow, Amanda. Personal Interview 19 Dec. 2011.

265Fernandez, *Transforming Feminist Practice*, p. 52.

These included: the rehearsal in the studio, the coffee break, sitting in the theatre waiting for the technical crew to fix the lighting cue, or backstage during pauses in the technical rehearsals. They shared the stories with whoever was in the rehearsals: dancers, guests, designers, photographers, anyone. I began to realize that the telling of the stories is a part of a collective narrative tradition within the restaging of the Tudor ballets. The Répétiteurs share what they know about Tudor through their teaching of his kinetically logical movements, truthfulness in performance, and unique musicality; however, what brought Tudor into the process was the stories.

Originally, Tudor and the dancers he worked with created experiences that became the stories. The original stories were joined by the stories of subsequent casts of dancers with whom Tudor worked. My story of working with Tudor and his changing my name is now part of the collected narrative shared by the Répétiteurs. The stories capture the essence of Tudor in the room, in the process of creating or restaging his ballets. He is there. But since his death in 1987, he is only present in the restaging process through the stories. What finally affirms the authenticity of the present-day productions of the Tudor ballets are the stories. The telling of stories brings Tudor into the restaging process and is a quintessential part of the Répétiteurs' restaging process.

Répétiteur Kirk Peterson

# Chapter V
# The Transcendent Tudor

## Building a Collective Narrative

In my prologue, I recounted the story of how I met and worked with Tudor in the American Ballet Theatre. My story is based on historical facts – the rehearsals and the performances did take place – and my memories of those events as well as my perception about Tudor's actions, how he appeared in rehearsals, and what I was asked to dance. The events and my memories as well as my perception of them act as the basis for my Tudor story. I am able to recount the events as an insider, an eyewitness to Tudor history, while acting as a connection to the time and place of that history. My memories reach back to that moment in Tudor history which I lived. In this research, I have attempted to bring this lived history forward, not just to relive it, and not just to remember it, but to bring Tudor, the artist, into the conversation about twenty-first century ballet, choreographic craft, authenticity, restaging, and legacy.

I am prompted by the transformative and educative power of the events held within the story of my working with Tudor. Tudor truly changed my idea of dancing and performing, thereby transforming me as a dancer. My insider's experience with Tudor's restaging and choreographic processes endows my moment of storytelling with what I believe is Tudor's presence. My story and all of the stories shared by other former Tudor dancers are

gathered together by the Tudor Trust to form a collective narrative. This narrative is then recounted and told by the Répétiteurs of the Tudor Trust to create what I call a "transcendent Tudor." He, in a sense, has transcended being placed in one historical moment. Through the Répétiteurs' recounting and telling of stories, Tudor is present in each restaging process and final performance. Therefore, I now call the transcendent Tudor the fourth essential element of the restaging process.

Linda Hutcheon, postmodern theorist, reminds us that, "In many fields, narrative is, and always has been, a valid mode of explanation, and historians have always availed themselves of its ordering as well as its explanatory powers."[266] Furthermore, David Lowenthal, theorist of history, emphasizes:

> *Indeed, preserving knowledge of the past is one of history's prime raisons d'etre: both oral accounts and archival records have long been kept against the lapse of memory and devouring time. History is less open to alteration than memory: memories continually change to conform with present needs but historical records to some extent resists deformation.*[267]

The Tudor Trust retains the original historical event through the weight of the eyewitness accounts captured within the stories; the event is further balanced against the Trust's substantial collected archive, and the additional personal experiences of Sally Bliss and three of the Répétiteurs: Donald Mahler, Kirk Peterson, and Amanda McKerrow.

The Tudor Trust's collective narrative of stories advances three imperatives:

---

[266]Linda Hutcheon, *The Politics of Postmodernism*. London: Routledge, 1989, p. 67.

[267]David Lowenthal, *The Past is a Foreign Country*, p. 214.

1) The educative substance of Tudor's process;

The stories are the educative conduit through which Tudor speaks to the present-day dancers.

The stories act to expand the knowledge of the present-day dancers concerning Tudor's process and preferences in movement.

The stories contextualize Tudor's process.

2) The historical relevance of Tudor's life and art;

The stories act as history lessons as they place into context names of famous ballet dancers, theatres, producers, other choreographers, and musicians.

The stories contextualize Tudor's historical relevance in twentieth-century ballet history.

3) The relevance of Tudor in the restaging process;

The root of each story is an experiential relationship with Tudor within the choreographic or restaging process.

The root of each story is based on an embodied experience with the Tudor choreography.

The stories also directly align with the teaching of the other three essential elements of his ballets: his kinetic innovations, his desire for a truthfulness of performance, and his unique musicality. The connections between the essential Tudor elements and the stories are fostered by the first-hand, eyewitness accounts of Tudor in rehearsals. The stories within the Tudor Trust's collective narrative interject first-hand, eyewitness remembrances of Tudor often preserved in recounted Tudor phrases and observations. In addition, the individual stories of the Tudor Trust's collective narrative do not only speak to one imperative at a time. Often, each story contains a plethora of information about Tudor.

As a collection, the stories bring to clear relief the multiple dimensions of Tudor's artistry.

The stories often appear in short, referential statements, almost abstractions; they form deconstructions of more in-depth and lengthier discussions, or experiences. They often appear as directions, as an understanding coded into specific terms – Tudor's terms, which pinpoint a shared discovery. As an observer, I was privy to many of these stories during the interview process. And, as I attended rehearsals, I remained alert to any references to other stories I heard or bits of references that seemed to suggest an underlying narrative. Remembering that time is not the ally of the Répétiteur during the restaging process and that a kind of Tudorism coded within the stories were part of the Répétiteurs' tools, I listened for these brief, sometimes abstracted, deconstructions along with the more fully fleshed, eyewitness accounts. The combination of stories and references to stories creates the Tudor Trust's collective narrative, and makes the Répétiteurs the tellers of stories.

## Educative Stories

The collective narratives expand on Tudor's educative role as a guiding force for many in the previous generation of dancers in American Ballet Theatre, and all of the other companies and schools in which he taught and choreographed. He transformed me as a dancer, as he did many other dancers who are quoted in the Chazin-Bennahum, Perlmutter, and Topaz texts. We, who were lucky to have experienced Tudor's genius, realized the opportunity we had. We learned first to think through the most difficult of choreography; second, to question ourselves and our creative process in regards to how and why we move; and third, to dance as real people without affectation, but with attention to detail and specificity.

These qualities are still present in Sally Bliss and the Répétiteurs who worked with Tudor. The qualities are also reinforced through the collective narrative of Tudor. And, through the recounting and retelling of the stories by Sally Bliss and the Répétiteurs, Tudor is there in the studio, or the lobby, or backstage supervising, sharing, challenging, and working with the dancers. Each of his ballets in some form or another requires the presence of the stories because the ballets require, to this day, Tudor's presence.

In particular, the recounted or told stories shared with the present-day casts by the Répétiteurs help to reinforce the traditions of working in a Tudor ballet. The stories help to counterbalance what would appear to be Tudor's absence in the restaging process by emphasizing his problem-solving, decision making process, his concern for detail, his crafting of character-driven gestural motifs, or his use of descriptive terms, imagery, or corrections. By Sally Bliss and the Répétiteurs bringing his remembered words and phrases and actions into the restaging process, they link their process in recreating his ballets to Tudor's. In a sense, the repeated Tudor words and phrases authenticate their process, but only as a way to authenticate the educative nature of Tudor's choreographic process. That said, David Lowenthal warns that:

> Sharing and validating memories sharpens them and promotes their recall…. In the process of knitting our own discontinuous recollection into narratives, we revise personal components to fit the collectively remembered past, and gradually cease to distinguish between them.[268]

---

[268]Ibid., p. 196.

Lowenthal's sense of creating interwoven narratives does come to play in this research. For example, I found that Sally Bliss and the other Répétiteurs relished the infusion of my differing experiences into the collected stories: my stories provided further layers of Tudor within their own collected narrative; they did not choose to distinguish between our stories, but relished the differences. For instance, Sally Bliss often speaks of being terrified of Tudor but also found him funny, as did Kirk Peterson and Donald Mahler. I was always terrified of Tudor until I had rehearsals with other dancers in the room; however, one-on-one, Tudor terrified me. In a differing story, Tudor was a personal friend to Sally Bliss and her family; he was her son's Godfather. Yet, Tudor made me change my name thereby seeming to lose all connections to my family. In addition, Donald Mahler is often heard sharing stories of Tudor based on conversations he had with him; however, I never had conversations with Tudor during any rehearsals. I only spoke directly with him my last day at American Ballet Theatre. And yet another layer of the story is recounted by Amanda McKerrow who shares great remembrances of Tudor as if he and she also conversed, at length, and often. Amanda's story juxtaposed my memory since it was hard for me to converse with Tudor when I was either shaking in my pointe shoes or hiding behind another dancer.

The multiple perspectives represented in these first-hand, eyewitness accounts of personal relationships with Tudor, as well as the other stories within the Tudor Trust's collective narrative, characterize Tudor as more than a one-dimensional figure. This includes the stories, at least the ones that I have heard, which I characterize as the "fireside," "over dinner," or "having coffee" stories which often reappear in the restaging process. It seems that once the story is shared between Répétiteurs, each personal

collection of Tudor stories expands; the story then becomes part of that Répétiteurs' arsenal of restaging tools.

After hearing some of the stories, I found myself questioning if any of the original narrator's voice is lost in the continued retelling of the Tudor Trust narratives. On this subject, professor of psychology Jerome Bruner writing on narrative and identity posits that the narrator's point of view, knowledge, or perspective is clear in a narrative[269] but, after the stories are communicated from person to person, "their slant and believability" might be dependent on the circumstances of their telling.[270] There is no way to tell whether the Tudor Trust's collected narratives are slanted by the circumstances surrounding their telling over time; however, when observing the Répétiteurs in rehearsals and watching the dancers become affected by the stories, I sense the stories as real, as coming from an original place.

I also believe that Sally Bliss and the Répétiteurs are selective in the stories they share with the dancers through the restaging process or at other times in various circumstances. I would argue though that the selectivity is specific to the needs of the situation to meet Sally Bliss's and the Répétiteurs' responsibilities within the restaging process. In other words, the stories are never trivial; even a story that seems offhand is told to the dancer to give a sense of Tudor in the past or, as suggested by David Lowenthal, to comprise a consensus "anchored in reality and provide real knowledge of the past."[271] After all, the Répétiteurs and the former Tudor dancers who shared their stories in the Tudor Trust

---

[269]Jerome Bruner, *Making Stories: Law, Literature, Life.* New York: Farrar, Straus and Giroux, 2002, p. 17.

[270]Ibid., p. 24.

[271]Lowenthal, *The Past is a Foreign Country*, p. 215.

collective narrative were privileged to have received the educative nature of Tudor's choreographic and restaging processes. They were and are, after all, eye witnesses and, therefore, each story, no matter how small is important to the whole narrative as Tutor transcends through each tale.

## Timing is Everything

Nothing about the Tudor choreographic process or about the process of restaging his ballets was or is left to chance. Therefore, the selection of the story and when to introduce it into the restaging process is important to understand. Specifically, the Répétiteurs optimize the thrust of the story in order to educate the struggling dancers by sharing insights from another Tudor dancer's perspective. The educative value is gained by contextualizing the present-day dancers' struggle against the former Tudor dancers' struggle of learning the Tudor choreography.

As an example, during one observation session of *Dark Elegies* at Webster University, I was asked by Sally Bliss to share my experiences of Tudor with the students. In order to respond to her request, I had to quickly change from my role as researcher into my role as a former Tudor dancer. I recounted how many times it took me to really understand the gestural motif in the beginning of *Pillar of Fire* underscoring Hagar's sense of confinement, turmoil, loss, and denial. After sharing a part of my story within an appropriate amount of time, I then returned to being a researcher in order to document the next exchange of questions and responses between Sally Bliss and the dancers. According to my observations, my story was used by Sally Bliss at just the right time for her educational needs: at that moment in the rehearsal process, this young dancer needed to hear my story of struggle so she could grasp her own struggle as expected, the norm in a Tudor

rehearsal. I brought Tudor to this young dancer; he, again, was in the room with us through my story.

By my sharing my experience of dancing for Tudor, the dancers were being told in various subtle and not so subtle ways, that this is how Tudor worked, and this is how we work, and this is how you will work, if you are to dance a Tudor ballet. I am also sure I could have referenced any part of my total experience from working with Tudor to directly aid the dancers' process. But, Sally Bliss's invitation to be a storyteller led me in the direction she wanted at just the right time she needed to engage the educative nature of the storytelling within the restaging process.

## History in Narrative

Through observations of my participants in various restaging situations, I have noted that the timing of recounted stories often gives weight to the historical context of Tudor's place in ballet history. The Répétiteurs, as historians recounting events from the past, however, can be selective in the contextualizing of the stories. Linda Hutcheon suggests that, "Historical meaning may thus be seen today as unstable, contextual, relational, and provisional, but postmodernism argues that, in fact, it has always been so.[272] Along the same line of thinking as Hutcheon, Chris Husbands, historian and theorist, cautions: "Skillful historians can exploit the most unpromising and complex evidence in order to offer accounts of the past but there is almost no historical evidence which can be taken at 'face value.'"[273] In light of Husbands's and

---

[272]Hutcheon, *The Politics of Postmodernism*, p. 67.

[273]Chris Husbands, *What is History Teach? Language, Ideas and Meaning in Learning about the Past*. Buckingham: Open University Press, 1996, p. 4.

Hutcheon's concerns about the truthfulness of contextualized history, I found the fact that the Tudor Trust's collective narrative as told from numerous points of view and from first-hand eye witness accounts, lends a relational stability to the "face value" of each story even though each is told through the context of the narrator.

To also offset the Trust's concern for legitimizing the stories, the former Tudor dancers, who have offered their stories to the Trust, were known by Sally Bliss and/or one or more of the Répétiteurs. They might have worked together in rehearsals with Tudor. Or their stories relate information that, whether negative or positive in perspective, act as additional information, seemingly possible, and potentially probable. The Répétiteurs with Sally Bliss then decide which of these stories seem most appropriate and necessary for the collective narrative to ring true. In this process of selection, the stories' "truthfulness" has in some form or another passed through a process of verification. No doubt there is a privileging of knowledge, as suggested by Alexandra Carter, writer of history and dance history, through the mere selectivity exhibited by the Répétiteurs and Sally Bliss.[274] However, what counters any disbelief in the value of the stories is that they recount the experiences of the insider, the eyewitness. What appears to be important for the Tudor Trust is the educative value of its historical perspectives contained within the collective narrative.

---

[274]Carter, Alexandra. ed. *Rethinking Dance History: A Reader*. London: Routledge, 2004, p. 10.

## Historical Narratives

In his article "Transforming Dance History: The Lost History of Rehearsal," Stuart Hodes theorizes that the core of dance history lies within the exchanges between the dancers and the choreographers as they make dances and are a significant part of dance history.[275] In the studio the creative collaborations, exchanges, or transactions[276] between choreographer as teacher, and dancer as student, are meaningful and significant to ballet history. Often these precious, creative, historically significant transactions are only captured within the remembered constructions of the dancers' first-hand experience: Their experience shared within their stories. Hutcheon reminds us:

> "...narrative is still the quintessential way we represent knowledge.... In many fields, narrative is, and always has been, a valid mode of explanation, and historians have always availed themselves of its ordering as well as its explanatory powers."[277]

Similar to Hodes's description of significant transactions being captured within the memory of the dancer's experience, Sally Bliss and three of the Répétiteurs have had significantly important historical transactions with Tudor. Their perspectives may be fluid and personal, but the historical anchoring of events

---

[275]Stuart Hodes, "Transforming Dance History: The Lost History of Rehearsals."

[276]David Michael Dees, *Teaching as Transactional Performance Artistry: A Hermeneutic and Phenomenological Investigation into the Aesthetic Qualities of Teacher/Student Transactions through the Performing Arts Traditions of Theatre, Dance, and Music.* Diss. Ken State University, 2000. Dissertations 7 Theses: Full Text, ProQuest, Web. 1 August 2010, pp. 12-13

[277]Hutcheon, *The Politics of Postmodernism*, p. 67.

is not imaginary and the real, rich details come to life through their stories. In the stories, the Tudor historiography depicts Tudor in action, in rehearsal, in his creative process as an artist; they bring the transcendent Tudor into the present.

Additional theorists have written in regards to the connections between story, narrative, stories of historical events, and the events that make up history. Alun Munslow, historical philosopher, reminds us that: "as a form of knowledge history is – plainly and palpably – a narrative representation."[278] Then, Carter again pens that: "The writing of history is the writing of stories about the past. These are narratives, which imply a traditional narrative structure" and quoting Husbands, Carter defines for us that: "The structure is a way of 'using story to give shape to experiences as a way of understanding them.'"[279] In addition, Hayden White, theorist of historical philosophy, offers a thought on the validity of any perspective or constructed reality of history through narrative when he states: "whilst events actually happened, their traces or 'facts' are constructed and history reconstructed from(some of) the facts."[280] For my research, the historical narratives of the Tudor Trust's collected stories represent the also historically relevant experiences, or experienced realities, of the former Tudor dancers. In much the same fashion, taken as a whole, the recounting and the retelling of the stories offer the Répétiteurs opportunities to rediscover additional historically significant connections between the former Tudor dancers and the new Tudor dancers. These connections help to further an understanding

[278]Jenkins, Keith. *Re-thinking History*. London: Routledge, 1991, preface.

[279]Carter, Alexandra. ed. *Rethinking Dance History*, p. 11.

[280]Martin, Carol. "After the Event." 4-51 *Jordan* 1997, p. 42.

of the Tudor ballets for the Répétiteurs and the newest Tudor dancers.

If Hayden White is correct in describing history as being reconstructed, then the reconstructed experiential nature of the dancers' stories, although remembrances, should afford merit to the stories as part of an oral history. Indeed, Jenkins argues that "the past and history are not stitched into each other such that only one historical reading of the past is absolutely necessary."[281] Then, perhaps, for the Répétiteurs, the stories may offer an opportunity to stitch together the history of Tudor's process and the dancers' processes to benefit the restaging of present day productions of the ballets. The stories are not told to create an absolute reality, but to give meaning and context from a collective perspective.

In my analysis of the reasoning behind the storytelling of the Répétiteurs, I considered whether or not the events recounted were indeed altered, foreshortened, highlighted, concentrated, or simplified. My analysis followed this connection: Since Tudor abstracted, capsulated, and edited his narratives out of his perceived reality, there might be a correlation between Tudor's ability to distill vital information from a given story and the ability of Sally Bliss and the Répétiteurs to alter, foreshorten, highlight, concentrate, or simplify the important aspects of each recounted or retold story. In other words, perhaps, Tudor was creating dancers who could tell embodied stories as well as oral narratives.

For my participants, the stories are also a part of the Répétiteurs' in-depth, on-going research for the Tudor Trust. As Tudor dancers, the Répétiteurs learned to question the hows and whys

---

[281]Jenkins, Keith. *Re-thinking History*, p. 7.

of what they were learning through the Tudor choreography. This intensity for questioning seems to continue through the Repetiteurs' research of Tudor and the acquisition of stories. Indeed, the Répétiteurs' understanding of Tudor represents a multiple perspective as suggested by the stories they choose to share. This aligns with the post-modern epistemological quandary in which historical knowledge is questioned as to whose facts are relevant and what constitutes a fact.[282] The final question becoming: Is there more to learn?

Sheets-Johnstone reminds us that: "one can always go back to experience, not only in order to validate empirically what is described, but to discover if there is more to be learned in the experience of the things themselves."[283] As a result, the discovered stories' meanings add an additional understanding of the way to exist in the world of Tudor. The stories create the reality of the dancer's praxis in rehearsal with Tudor. Hence, for the Répétiteurs of the Tudor Trust, the meaning of the dancers' experience and the events which produced particular ballets, the ballet's stories and the historical narrative of the ballet, are reciprocally contextual. In effect, the history of existing as a dancer working within the choreographic process of Antony Tudor is documented within a cacophony of multiple perspectives within the collected oral history.

## Experiential History

The selection of a particular story to interject into the restaging process also speaks more importantly about the Répétiteurs

---

[282]Hutcheon, *The Politics of Postmodernism*, p. 71.

[283]Maxine Sheets-Johnstone, *The Roots of Thinking*. Philadelphia: Temple University Press, 1990, p. 19.

choice to include Tudor in the restaging process. The stories and references to Tudor fill in where Tudor should be, needs to be, in the restaging process. The Répétiteurs recounting and retelling of stories keeps Tudor alive. The recounting and retelling of events of meeting Tudor or working with Tudor seems to keep relevant Tudor's unique choreographic gifts. There is an intermingling of stories, theirs and other dancers', as an important experiential, performative archive of historical events which reveals something of Tudor and his ballets that needs to be shared, understood, and valued. If the stories of Tudor are merged with the experience of learning the ballet for the dancer, his kinetic innovations, his truthfulness of the performance, and his musicality[284] become real. After all, Tudor was not an independent variable in the creation of his ballets. He was and is the essential element. He, once again, becomes the transcendent presence.

Sally Bliss and Donald Mahler have stories from working with Tudor early on in his career at the Metropolitan Opera Ballet. Kirk Peterson and Amanda McKerrow have stories from working with Tudor in American Ballet Theater. These four Répétiteurs often share their experiences of embodying a new role or moving into an established role of another dancer, as with Amanda working with Tudor on the role in *The Leaves are Fading*[285] created on/for and with Gelsey Kirkland. These personal remembrances are accounts of Tudor's creative force in action, first-hand, and often in a one-on-one relationship. The Répétiteurs convey a personal experience with Tudor within the details and presentation of the stories. James Jordan as Répétiteur in-training does not have the personal experience of having worked

---

[284]See Chapter IV.

[285]see Appendix C

with Tudor but did perform in his *Lilac Garden*[286] and *Gala Performance*[287] with the Kansas City Ballet restaged by dance notator Airi Hynninen. Like the other Répétiteurs, he also collects and archives stories told to him or discovered through his research. Each of the Répétiteurs shared stories brings to light an important element of Tudor's cumulative creative process. The Antony Tudor Ballet Trust's collective narrative represents an aggregate of an experiential history.

## Embodied Relevance to the Collected Narrative

Each Tudor ballet also has its own story or, as mentioned in the Prologue, an afterlife in narrative. These narratives, each ballet's story, are often constructed through the individual perspective of each dancer in the cast; the stories reflect each dancer's experience with Tudor. Sheets-Johnstone observes, "Human knowledge is securely tethered to its experiential moorings"[288] and the "tactile-kinesthetic body is a body that is always in touch, always resounding with an intimate and immediate knowledge of the world about it."[289] In dance, and my own experience in ballet, this tacit-kinetic, experiential knowledge for dancers refers to their embodied knowledge. For those who have danced the Tudor ballets, the embodied knowledge is a shared knowledge.

As discussed in the previous chapter, the new cast members of the Tudor ballets move through an extensive transformation in technique and artistry as a result of the restaging process. Each dancer's embodied knowledge becomes the concept of the body

---

[286]see Appendix D

[287]see Appendix Q

[288]Sheets-Johnstone, *The Roots of Thinking*, p. 13.

[289]Ibid., p. 16.

as an organizing center which aligns with Bourdieu's concept of habitus as discussed earlier whereby the "habitus is not simply a state of mind, it is also a bodily state of being. The body is a repository of ingrained and durable dispositions."[290] Moreover, Helen Thompson writes that "the body is the site of incorporated history" and sites, as an example, the curved spines of the Kabylian women which demonstrate the pull of their work toward the ground.[291]

The connection between corporeality and narrative is evident in Tudor's ballet narratives. The success of his ballets is rooted in his ability to tell stories through the corporeality of his characters. The dancers, therefore, will have an embodied memory of their particular character and the process of transformation which created that embodied memory. Daniel Punday, theorist on narrative and corporeality, writes that:

*...it is impossible to tell a story without drawing on human bodies and thus entangling corporeality within the narrative, those bodies must always be shaped into meaningful textual objects by specific choices made by the text. Concern for how the body is endowed with meaning within a narrative will usually touch on systems of meaning that extend far beyond the text itself.*[292]

---

[290]Bourdieu quoted in Stephan Wainwright and Bryan S. Turner. "'Just Crumbling to Bits'? An Exploration of the Body, Ageing, Injury and Career in classical Ballet Dancers." *Sociology* 40:237 (2006): pp. 237-255 p. 241.

[291]Thompson quoted in Ibid., p. 241.

[292]Daniel Punday, *Narrative Bodies: Toward a Corporeal Narratology.* New York: Palgrave MacMillan, 2003, p. 57.

With the aforementioned ideas of how embodied experiences shape the text or movement and how movement or text shape the embodied experience, we find the former Tudor dancers well situated to repeat, reflect, and re-evaluate the historical relevance of their related stories of embodying the Tudor characters, of embodying his narratives. The corporeal memories of the dancers are rooted in multiple events which transformed their bodies while influencing their cognitive awareness of moving. Therefore, I would argue that the Tudor Trust's collective narrative represents an embodied historical narrative.

## Shared Narratives

During the interviews, Sally Bliss and the Répétiteurs shared with me several of the stories that are part of their tools in imparting knowledge during the restaging process. The following stories reference the multi-dimensional person of Tudor and his choreographic and restaging processes.

## Sally Bliss's stories

During our first interview for my research, Sally Bliss told of meeting Tudor for the first time. She had heard great things about Tudor from other Canadian dancers and was looking forward to taking his class. She recounts the following tale:

> First of all, I'm taking a class in the old Metropolitan Opera, my first class and it's Tudor, and I am there trying to hide in the back, I think. All of a sudden, this beautiful English voice says "Hey, you, Maple Leaf forever, come here." .... He made me cower to the front.... But, I don't think I ever got over being scared of him. But, I also thought his classes were the hardest classes I'd taken in my entire life.... No matter how hard you tried you never felt you had done a good class.... With Tudor,

*it was like he was just teasing us... you'd think "I can do this,"*
*and then he would switch you so you'd be going ass back-*
*wards, and inside out and turn, and you'd be going full speed*
*in one direction and then he'd make you turn upstage or turn*
*and go again downstage, impossible. But what I learned was*
*phenomenal. I was hooked.*[293]

Sally Bliss also recounts learning her role in *Echoing of Trum-*
*pets*. Tudor had created this wonderful pas de deux for her char-
acter and the character's husband who had just been murdered.
The woman moves the lifeless body of her husband through a se-
ries of almost macabre embraces, embraces that are clearly one-
sided, as she is fully engulfed in denial and ultimate grief. Tudor
demonstrated what he wanted for Ms. Bliss. She remembers:
"When he would show us what he wanted and he danced the
woman; he was the woman. So, me as the dancer learning that
part, I would try to immolate him... it was very, very difficult, but
I sure... knew what he wanted, and it was what I worked for."[294]
The story highlights Tudor's ability to dance the characters he
created in very specific, detailed, and challenging terms.

In response to my query regarding Tudor's choice to use a
full range of ballet techniques along with his kinetic innovations,
Sally Bliss related witnessing Tudor struggle to create the perfect
choreography for *Concerning Oracles*.[295] As she and other dancers
entered the room she recounts that Tudor "was going like this
[demonstrates banging his head]... because in this one part where
there are three brides he couldn't figure out what he couldn't
make work, and he banged his head [against the mirror]. Oh, that

---

[293]Bliss, Sally. Personal Interview 18 Apr. 2012.

[294]Ibid.

[295]see Appendix R

was such an evening."[296] She shares: "The one thing about Tudor that is very interesting is that he rarely copied or repeated himself. That makes him unique... and when he did [repeat himself] he really hated himself... what really is important... is except for the depth of feeling in his ballets, each one was different from the others."[297] Further, she shares: "Tudor in trying so hard not to repeat himself was always creating unusual step/combinations never seen before or since. These combinations are only in his ballets." She also quoted American choreographer Eliot Feld who stated during the celebration of Tudor's Centennial at Julliard: "Tudor didn't just choreography an arabesque, he invented it."[298]

Tudor was an original. To that end, Tudor's process at times seemed arduous and time consuming to the dancers. The struggle for Tudor was to describe through movement each character's participation in his narrative: how each character created conflict or tension within the human situation revealed in the ballet. Tudor fleshed out his characters through specific backstories as context for his movement creations. Understanding the Tudor images and backstories is paramount for the dancers' success in the roles.

## Donald Mahler's story

The Tudor dancers often share stories about Tudor's use of images that also lend weight to the complexity of his characters. Donald Mahler offered a story told to him by Sallie Wilson. Mahler explained that, "Sallie told me that Tudor would say for instance, the elder sister [in *Pillar of Fire*] was the kind of lady that

---

[296]Bliss, Sally. Personal Interview 25 Jan. 2010.

[297]Bliss, Sally. Personal Interview 13 Dec. 2011.

[298]Bliss, Sally. Phone Interview. 30 Jan. 2013.

took her gloves off and wrapped them in tissue paper and put them in a drawer."[299]

Donald Mahler acknowledged that often the stories told to him provide the key through which the Repetiteur unlocks the mysteries of a Tudor ballet or character. He shares this story:

> *For example Roni Mahler... she watched the rehearsal [of Dark Elegies] and she offered up a very valuable piece of information to me which was that there's a place in the fourth song where the woman expresses pain by doing a double movement of her hands to her waist in pain, pain, and I had always been doing it like "oh it hurts, something hurts," and she said no Tudor had said to her that you don't feel the pain, but that you remember the pain, and that gave me the clue to the whole ballet, because the whole ballet is about remembering.[300]*

I heard Mahler using this reference numerous times to aid our student performing the fourth song during his restaging of *Dark Elegies* at Washington University in St. Louis during the Performing Arts Department's first Tudor residency. Four years later, I heard the same reference from James Jordan during the department's second Tudor residency for restaging *Dark Elegies*.

## Kirk Peterson's story

Kirk Peterson shared that Tudor was known for saying "just do the steps" and even though Tudor meant it, Peterson observed "there is more to the steps than just doing them... it's not true, it's not possible, you can't just do the steps and no more, because it's

---

[299]Mahler, Donald. Personal Interview. 13 Feb. 2010.
[300]Ibid.

not just a step ballet, none of his ballets are step ballets."[301] As a researcher, it is interesting to see how language and experience can be interpreted differently in this story.

## Amanda McKerrow's story

Amanda McKerrow described her first experience with Tudor learning the innocence step in *Pillar of Fire*:

*Such a difficult step, the rond de jambe, rond verse and he pulled me from the back of the room and made me do it over, and over, and over. I was getting really frustrated. I said something under my breath to myself. He said 'what was that?' And I was too immature to think of a better answer or something clever. I said 'it's just so awkward.' And he looked at me and said 'Now you are getting it; go back to the back of the room.'*[302]

## James Jordan's story

The use of the oral narrative continues through the second-generation Repetiteur James Jordan. He shared how Tudor would often make use of sense imagery to ask or tell the dancer something about the dancer's character. He offered this example of Tudor asking dancer Janet Reed, "Are you walking on moss or are you walking on dried leaves?"[303] and again Tudor using "the imagery of a red carpet to bring up the spine and to get that feeling and imagery of the color and the texture of velvet and the royalty that he was trying to bring into her particular... comedic

---

[301]Peterson, Kirk. Personal Interview. 6 Dec. 2011.

[302]McKerrow, Amanda. Personal Interview 19 Dec. 2011.

[303]Jordan, James. Personal Interview. 06 Feb. 2010.

role [in Gala Performance]."[304] Following in Tudor's footsteps, Jordan utilizes these images and develops his own when motivating dancers to understand their roles. One in particular that I heard Jordan use and then heard student dancer Appie Peterson reference, is the image of a broken wing when describing the dancer's arm gesture in the fourth song of *Dark Elegies*.[305] Jordan later clarified for me that he had learned that particular image of the broken wing from Donald Mahler.

## Tudor in the Restaging Process

James Jordan, second-generation Répétiteur-in-training, also recounts how the stories from the collective narrative are important in anchoring his understanding of the facts as presented through the first-hand, eyewitness accounts of the first and second generation Tudor dancers. During Jordan's second interview with me for this project, he reiterated that Tudor incorporated "imagery and references in his work, in his coaching" of his ballets.[306] Jordan went on to describe the abundance of ideas and techniques referenced in the stories about Tudor as "a rainbow of angles and stories and interpretations," "a rich treasure," a "rich tapestry," and a "whole pot of soup of information."[307] He also added the following recent entry into the Tudor Trust collective narrative told to him by Donald Mahler. It seems that while Donald Mahler was staging Lilac Garden in San Francisco, former Tudor dancer Betsy Erikson when visiting the rehearsal, shared her experiences when dancing in Lilac Garden. Jordan continues

---

[304]Jordan, James. Personal Interview. 01 Apr. 2012.

[305]Peterson, Appie. Personal Interview 22 Apr. 2012.

[306]Jordan, James. Personal Interview. 01 Apr. 2012.

[307]Ibid.

Mahler's story by recounting: "Betsy gets up and demonstrates and tells this story about... [how] Tudor had her do this, and Donald's never heard of that [movement] before but he certainly doesn't question that Tudor did that [movement], and that's another piece of the puzzle of being a stager, of evaluating the information and making an educated decision about what your version is going to be."[308]

## Future Storytelling

Soon a generation of Répétiteurs who have had no direct experience with Tudor or his first or second-generation dancers will be the only people left to tell the stories. Sally Bliss and the Trust are aware of the need to document the original stories in differing formats so the recounting done by the first and second generation Tudor dancers are archived and not lost. Then the re-telling by the third-generation dancers with no actual contact with Tudor will at least have the archive to color their own stories. The documenting will ensure that even though the stories are being retold, the original versions or re-countings will still live within the re-telling. The tellers of stories in future generations will then have the responsibility for determining their own methods for assuring the Trust can provide "truthfulness" to the narratives. For the Tudor Trust, the stories are important because they coalesce with the other forms of research, documentation, and archives important and relevant to the Tudor legacy. Also, for the future Tudor dancers the path to understanding the roles they perform may lie somewhere in the stories and their interpretations of the stories. However, the stories remain the path to Tudor.

---

[308]Ibid., p. 9.

## My Restaging Stories

Sally Bliss and the Répétiteurs infer that they are always checking in with "what Tudor would have done" or asking "what would Tudor say at this moment" in order to authenticate the newest production of a Tudor ballet. Let me share some of my observations made during the restaging rehearsals I attended.

During the Performing Arts Department at Washington University in St. Louis's first Tudor residency, I had the pleasure of watching Sally Bliss coach our two dancers in Tudor's *Little Improvisations*.[309] She often referenced Tudor, demonstrated, and continually educated the dancers in the craft of dancing Tudor's ballets. More recently, I watched as she coached dancers during a technical rehearsal in the theatre for the Webster University production of *Dark Elegies*. Even while sitting in the theatre, she directed the lighting designer, the stage manager, and the dancers through her efficient, ever-vigilant, Tudor-like eye for detail, continuity, and specificity. As I videoed Sally Bliss, I remember thinking just how much of Tudor was sitting there in the seat between us.

During my observations of the Webster University residencies with Kirk Peterson, I noted that he shared so many pieces of information about Tudor with the dancers of the dance department that I thought that he might be working off a script of some kind. Instead, as anyone who talks with Kirk Peterson will discover, it is his vast experience with Tudor that underlies this running knowledge. He is a student of Tudor having been "hooked" as a young dancer and budding choreographer in American Ballet Theatre, and later as a principal dancer with the company. During one rehearsal, Peterson spoke to Webster University

---

[309]See Appendix S

dancers about Tudor's having been a Zen Buddhist. He directed the dancers in the opening section of *Dark Elegies* to have "baby Buddha" hands, softly folded in front of their bodies. He commented: "one could not help but see the influences of Tudor's interest in Buddha and Japan in *Dark Elegies*."[310] And I observed and wrote in my memos, "One could not help but see Tudor's presence through Peterson in the rehearsal."[311]

As part of my research, I traveled to Indiana University's dance department to observe and video Donald Mahler as he restaged Tudor's *Lilac Garden*.[312] During the second session one day, while working with the dancers performing the roles of Caroline and the Cadet, he mentioned to them that if they wanted to know about Tudor then they should understand plié – the bending of the knees – and Tudor's use of the back. He emphasized over and over again the use of the plié while making the dancers repeat the particular problematic aspect of the Tudor choreography. Later, while sitting on the bench in the front of the room, Donald Mahler continued to speak to the dancers about Tudor's use of the back while demonstrating the Tudor expressive opening of the chest with the arms held quietly to the side.[313] And as I watched and videoed him I thought, "And there is Tudor."

In addition, during the restaging rehearsals I attended in the school for classical and contemporary dance at Texas Christian University, I heard Amanda McKerrow restating Tudor's preference for weight in the plié. She advised, "think more modern dance than classical ballet" and then added "plié, more weight"

[310]Peterson, Kirk. Personal Interview. 6 Dec. 2011.

[311] Ibid.

[312]see Appendix D

[313]Mahler, Donald. Personal Interview. 05 Dec. 2011.

(I noted that this was the same use of plié that Donald Mahler had commented on almost a year before at Indiana University.

And finally, I remember noting during a restaging rehearsal in the dance department at the University of Missouri-Kansas City that James Jordan asked one of the dancers to run "with your chest.... Have more urgency!" and then he demonstrated the same use of the back and chest that Donald Mahler had demonstrated a year before at Indiana University.[314] Again, I found myself observing the use of the back and arms that was and is so reminiscent of Tudor. However, this time I was seeing the knowledge and embodiment of a Répétiteur who had never worked with Tudor. Tudor's presence, the transcendent Tudor, was present, teaching, and coaching even through this second-generation Répétiteur.

## Summary

Whether the collective narrative is recounted or told, accompanied, supplemented, or supported through demonstration, Sally Bliss and the Répétiteurs tell the story of Tudor. Ultimately, the Tudor past is well known and presented through the collective narrative of the Répétiteurs of the Tudor Trust: they are the tellers of the Tudor stories, and that Tudor, as a transcendent presence, remains an essential element within the restaging process of the Tudor ballets.

For the Tudor Trust and the Répétiteurs sharing the stories is relevant to the restaging process, and part of the history of Antony Tudor. However, when interviewed, my dance/student research participants who had worked on *Dark Elegies* with Donald Mahler, Kirk Peterson, James Jordan, and Sally Bliss; or *Continuo*

---

[314]Mahler, Donald. Personal Interview. 13 Feb. 2010.

with Donald Mahler and Sally Bliss; or *Jardin aux Lilacs* with Amanda McKerrow and Sally Bliss, could not remember any of the stories told by the Répétiteurs during the rehearsals.

I questioned in my field notes: What is the disconnect for the dancers between hearing the story and remembering the story? Through further analysis of the interviews with the dancers, I noted that each recounted being influenced when hearing the stories; the point of the story was relevant to their struggle in rehearsal. The story somehow helped each dancer's process during a time when each was having difficulties with a particular step. Each remembered the effect of the story on his or her understanding of his or her role, and how to better dance the role. This led me to believe that the stories and the references to Tudor's process and preferences in movement and movement qualities are educative for the dancers as dancers rather than as historians.

Although the dancers are interested in the subtle contextual information within the stories, the information they are immediately seeking is anything that supports and helps their performance of the Tudor ballet. Rather than remembering the stories, the dancers chose to apply the understanding of the why and how of Tudor's choreography garnered from each story. They all assured me, however, that they now know more about Tudor having gone through the restaging process of learning, dancing, and performing his ballets.

# Conclusion

During the process of my research and the development of this book, the Tudor Trust, as I anticipated, moved into a second phase of leadership. I say I anticipated this transition only because during several "aside" moments while interviewing Sally Bliss and then later in spending time with her and her husband, Jim Connett, Sally shared her goals for the future of the Trust, and for herself. I sensed that Sally had seen the future development and longevity of the Trust but, in some fashion, without her. These asides were not shared as longing desires for a future retirement, but rather well-considered overviews of facts, the current climate of the ballet world, and other predictable concerns about who would lead. Sally's critical eye for detail, continuity, and quality, quite mirroring Tudor's own, was merely taking stock of just how far the Trust had come under her leadership and where it needed to proceed.

Sally Bliss established and set in motion a Trust worthy of Tudor's genius. The details of her process, as enumerated in this text, sustains the Trust's well-defined purpose, resolve, and devotion to the Tudor legacy and the Tudor ballets. By and through her leadership, the Trust is steadfast in the selection of the best qualified Répétiteurs who are tasked with the responsibility of restaging the ballets. Much like Tudor's entry into the world of twentieth century ballet choreography, Sally forged a Trust whose Répétiteurs worked through a sense of history, of context, and of narrative to band together as a group of individuals whose sole purpose was the restaging of the Tudor ballets. She allowed

for individual process, encouraged the particular inclusions of unique and timely personal tales of working for Tudor, and was ever present. She made her presence felt in writing letters, making calls, or speaking with directors of companies and chairs of dance departments to share the potential wealth of knowledge waiting for their audiences or their students through the restaging and performance of a Tudor ballet.

When I analyzed the amount of data I had brought together to finally understand the repeated threads which revealed the basis of Tudor's artistic DNA, the essential elements of his works, I realized that even though each person I interviewed had a unique Tudor journey, they all agreed that his kinetic innovations, truthfulness in performance, and his unique musicality was the scaffolding that supported each and every Tudor ballet. These elements had to be retained and sustained in each restaging in order for that restaging to truly be a Tudor ballet.

And yes, the storytelling, the great narratives shared by the Sally and the Répétiteurs to casts of dancers are also reflective of Sally Bliss. Sally has a wealth of stories about Tudor having worked with him, for many years in her lengthy dance career, creating several leading roles. Tudor was also her sons' Godfather. Therefore, Tudor lives within these stories. His master craftmanship as a choreographer, unique amongst his peers, is best perceived by watching his ballets, even better in dancing his ballets. And, that is the best reason to have future dancers in companies and dance departments dance his ballets. The dancers become insiders to the Tudor genius. They embody his process; they embody his DNA, they are allowed to dance in history.

The Trust is cobbled together through legal documents, and contracts, through choreography and stories. And now, Amanda McKerrow will lead the Trust into the future. Sally did not anticipate the amount of work the transition process would take, or

the patience. When I asked Sally about the transition process, she emailed me her thoughts:

*"For something that seemed a pure and simple solution, I have never gone through something as complicated and conflated as legally turning over the trusteeship from... Sally Brayley Bliss to Amanda McKerrow... It took over two years of lawyers, legalese, and just plain patience. Finally, it is complete, and now Amanda McKerrow is the sole Trustee of the Antony Tudor Ballet Trust."*

Sally is now Trustee Emeritus. Having guided the Trust since 1987, she remains a valuable resource. Sally believes that at this time in history when Tudor's reputation and his ballets are slipping into being an afterthought, Amanda will bring new twenty-first century ideas and concepts to the Trust for preserving the Tudor ballets and his legacy.

She continued a bit more self-reflective:

*"It is time for me to retire. I was in my fifties when Tudor died and I took over the Trusteeship of the Trust in 1987. I turned eighty in 2017. At this time in the history of Ballet, Tudor has almost been forgotten. This won't last long because of my confidence in Amanda, the next generation with twenty-first century new ideas and Excitement regarding Tudor's great ballets. Along with George Balanchine, Jerome Robbins, and Frederick Ashton and last but not least Antony Tudor. Tudor's great masterpieces must not be lost. Amanda, I'm certain will make sure he lives on forever."*

Amanda is excited to take on this challenge and will act to raise Tudor's profile again and prevent the Tudor ballets from disappearing. And for those Tudor lovers amongst, we wish Amanda great success.

# Acknowledgements

I would like to gratefully acknowledge the many individuals who have contributed to the realization of this book. I want to thank Sally Bliss, executor of the Tudor will and trustee emeritus of the Antony Tudor Ballet Trust for allowing me full access to the Trust and to the Répétiteurs of the Trust who participated in my research. The research could not have been completed without her continued interest and support of this project.

I am also grateful to Dr. Janet Brown and Betty Skinner for their continued encouragement and guidance during my initial efforts to create a manuscript worthy of the topic. In particular, I want to thank my sister, Karen Brewington, for her continued support and encouragement throughout my doctoral studies. All scholars should be fortunate enough to have sisters like Karen. To Karen, I could not have done this without you.

# Appendixes

## APPENDIX A – PILLAR OF FIRE

*Pillar of Fire*: Hagar, whose elder sister is a spinster, foresees the same fate for herself. When the man she unrequitedly loves seems to show preference for her younger sister, Hagar in distraction gives herself one she does not love. The resulting crisis, however, unites her with the man she really loves. The ballet is set in the period around 1900 because it was then that Schoenberg composed the music.

Music: Arnold Schoenberg; *Verklarte Nacht*

Premiere: New York; Metropolitan Opera House, April 8, 1942; American Ballet Theatre

*Courtesy of the Antony Tudor Ballet Trust*

# APPENDIX B – THE TRAGEDY OF ROMEO AND JULIET

*The Tragedy of Romeo and Juliet*: Tudor's interpretation of the ill-fated love story by William Shakespeare remains the only ballet version of *Romeo and Juliet* presented in one act. One of the most shocking memories of *Romeo and Juliet* is the fact that Tudor could not finish this forty-five minute epic by the date of the premiere. A finished version was presented four days after the premiere.

Of note is the story of how the costumes and sets were designed: "I originally wanted sets and costumes by Salvador Dali because I had conceived the décor in terms of Fra Angelico and Dali handles those notions very well. However, Dali's ideas did not harmonize with mine," Tudor stated.

Eugene Berman eventually was brought on and he designed the scenery and costumes by drawing inspiration from Renaissance paintings, notably by Botticelli. The designs were a success with both the audience and critics.

Music: Frederick Delius; A Walk to Paradise Garden from A Village, Romeo and Juliet; Eventyr; Over the Hills and Far Away; Brigg Fair; Prelude to Irmelin, orchestrated by Antal Dorati.

Premiere: (Incomplete) New York; Metropolitan Opera House; April 10, 1943; American Ballet Theatre.

*Courtesy of the Antony Tudor Ballet Trust*

# APPENDIX C – THE LEAVES
# ARE FADING

*The Leaves are Fading*: The setting is a leafy glad in late summer. A woman enters and in a place obviously familiar to her, reflects on her happy memories of times past. Groups of young people appear and portray...her nostalgic thoughts in dance. The light of day darkens, the leaves are fading and the woman departs with her memories reborn.

Music: Antonin Dvorak from string quartet "Cypresses" and other chamber music for strings.

Premiere: New York State Theatre; July 17, 1975; American Ballet Theatre.

*Courtesy of the Antony Tudor Ballet Trust*

# APPENDIX D – JARDIN AUX LILAS

*Lilac Garden (Jardin aux lilas)*: The bittersweet them is set in the gracious Eduardian era. A young woman betrothed to a man she does not want to marry, mirrors the society in which power and position are uppermost. The ballet is so musically constructed that it would seem Ernest Chausson indeed wrote it for the ballet. Dame Marie Rambert, in whose ballet company *Lilac Garden* was created said of the ballet: "The interplay of feelings between these characters was revealed in beautiful dance movements and groupings, with subtle changes of expression, which made each situation clear without any recourse to mime or gesture."

Music: Ernest Chausson; "Poeme for violin and orchestra Opus 28."

Premiere: London- Mercury Theatre; January 26, 1936; Ballet Rambert.

*Courtesy of the Antony Tudor Ballet Trust*

# APPENDIX E – JUDGMENT OF PARIS

*Judgment of Paris* was a takeoff on the antique myth of the same name. Tudor chose to limit almost all references to godlike Olympian characters by shifting his setting to a cheap hotel of the night.

The scene open on a poorly lit dive; an air of deadly boredom hangs over the appalling place. Lounging at a table are two bedraggled female entertainers, one of them reading a newspaper; at the second table is another broken dancer and a waiter who exudes an air of purpose and solidity. Suddenly there is a flurry of activity as a customer enters. Upon seeing their potential prey, the lady dancers in their old high heels and fishnet stockings discover a certain amount of inspiration and like wound-up toys begin to vamp back and forth, executing old chorus line dance steps. The customer gazes at these three wrecks preparing to show their stuff and asks the waiter for a bottle of wine. It seems that the customer, a latter-day Paris, will be the judge of a surreal beauty context, although unlike Paris, he is a bit tipsy and has no interest in any of these scary women.

Music: Kurt Weill selections from "Die Dreigroschenoper" (Three Penny Opera).

Premiere: England; Westminster Theatre; June 15, 1938.

*Courtesy of the Antony Tudor Ballet Trust*

# APPENDIX F – DARK ELEGIES

*Dark Elegies* is danced to the song Cycle Kindertotenlider ("Songs on the Death of children") by Gustav Mahler (1860-1911). This is a work consisting of five songs to lyrics by Friederich Ruckert.

Tudor described this work as his favorite ballet. And many consider it to be his greatest. From tender moments of quiet devastation to careering bursts of rage, Tudor's "ballet requiem," set to Mahler's absorbing Kindertotenlieder, expresses the raw emotion of a tight-knit community faced with the inexplicable loss of their beloved children.

Premiere: London; Duchess Theatre; February 19, 1937; Ballet Rambert.

*Courtesy of the Antony Tudor Ballet Trust*

## APPENDIX G – DIM LUSTRE

A whiff of perfume, the touch of a hand, a stolen kiss release whirls of memories which take the rememberers back briefly to other moments and leave them not exactly as they were before.

The ballet opens on a lush red backdrop rich in Viennese ballroom motifs and chandeliers, against which five orange and red waltzing couples, all looking very much alike, float and whirl through their predetermined steps and patterns. The Gentleman with Her kiss her on the shoulder, triggering a transformation. The lights go down, the music stops; the lights return to reveal the lady facing her double and moving exactly like her. In fact the stage seems to be divided horizontally by a huge mirror. How easily and quickly her mind takes her back to her youth when another young man, It Was Spring, kissed her on the shoulder. These momentary flashbacks are interrupted by the ballroom scene when the other dancing couples interpose themselves both spatially and psychically, tugging these day-night dreamers back to the present.

Music: Richard Strauss, "Burleske for Piano and Orchestra."

Premiere: New York; Metropolitan Opera House; October 20, 1943; Ballet Theatre.

*Courtesy of the Antony Tudor Ballet Trust*

# APPENDIX H – UNDERTOW

*Undertow*: The original program notes were too lengthy for Tudor's liking, thus ten years later, in 1956, the program notes shrank considerably to include just the following.

The ballet concerns itself with the emotional development of a transgressor. The choreographic action depicts a series of related happenings, beginning with his babyhood when he is neglected by his mother. The frustrations engendered by this episode are heightened during his boyhood by his sordid experiences in the lower reaches of a large city, and only resolve themselves in his murder of a lascivious woman.

Music: William Schuman; commissioned score.

Premiere: New York; metropolitan Opera House; April 10, 1945; American Ballet Theatre.

*Courtesy of the Antony Tudor Ballet Trust*

# APPENDIX I – FANDANGO

*Fandango*: A public square in the South of Spain, with general overall lighting. The five girls meet in the square and immediately start vying for attention. Each one thinks that she is better than the others and tries to prove it. This rivalry or competition is serious without becoming vicious and even playful at times. Everything is done for and at the other girls. The dancers are not conscious of the audience.

Music: Antonio Soler.

Premiere: Town Hall; New York; March 26, 1963.

*Courtesy of the Antony Tudor Ballet Trust*

# APPENDIX J – ECHOING OF TRUMPETS

*Echoing of Trumpets*: This ballet was created to the memory of the Czechoslovakian village of Lidice, which was destroyed in 1942 by Nazis who brutally attacked the inhabitants of a defenseless village. Tudor felt it could be any place, any time during a war.

*Courtesy of the Antony Tudor Ballet Trust*

# APPENDIX K – SHADOWPLAY

*Shadowplay* does not resemble any of Tudor's other ballets and reinforces his own dictum that he never liked to repeat himself. Though there is no synopsis of the ballet, the program for *Shadowplay* explained that Tudor chose the main structure of his ballet from Koechlin's "Les Bandar-Log" (1939), which is based on Rudyard Kipling's *The Jungle Book* (1894).

The theme of the ballet is growing up, or "a man's progression to a state of nirvana beyond the distractions and irritations of the world. The young boy is beset by the menaces of the jungle (the world) and its creatures of the trees and of the air. He is confronted by a male figure (Lord of the Jungle or his earthly self). He is successively charmed and threatened by the celestial (a chaste goddess or seductress). In the end, he achieves his peace (manhood) through an act of will (or the sexual act)." (Cohen, Tudor and the Royal Ballet).

Music: Charles Koechlin, "Les Bandar Log Opus 176," sections from "La Course de Printemps Opus 95."

Premiere: Royal Opera House; Covent Garden; January 25, 1967; Royal Ballet.

*Courtesy of the Antony Tudor Ballet Trust*

# APPENDIX L – CONTINUO

*Continuo* is a non-programmatic "classical ballet...It is one long lyrical out-pouring. The movement flow never stops. The 'steps' should be linked with freedom and abandon." This quality of linkage characterizes Tudor's movement style and is often the most prominent feature noted by critics.

Music: Johann Pachelbel Canon in D.

U.S. Premiere: Private viewing New York; the Juilliard School; May 27, 1971.

*Courtesy of the Antony Tudor Ballet Trust*

# APPENDIX M – CEREUS

*Cereus* was inspired by a student party that Tudor attended, where, apparently, he was shocked not only by the promiscuity but also by the cruelty of these young people when one person was ignored or left out of the group's. Many of Tudor's ballets hinge on the ways men and women discover partners in love. With *Cereus*, the naked and casual sensuality of modern American youth is explored to an upbeat and jazzy score.

Seven young people make modern jazz moves, and from the odd number it is assumed that one person will be left out. Three couples dance together, while a single male watches, looking quizzical. He follows what they do. The spinning of girls going from one partner to another creates the image of separate planets twirling in their own orbits, bouncing, off other bodies, and young people choosing mates with a chaotic and frenetic energy.

Music: Geoffrey Gray; *L'Inconsequenze* (1968; revised 1970).

Premiere: Private viewing New York; The Juilliard School; May 27, 1971.

*Courtesy of the Antony Tudor Ballet Trust*

# APPENDIX N – SUNFLOWERS

*Sunflowers*: "The ballet's name directly evokes sunflowers which always keep their heads turned toward the sun, and bloom in the heart of summer. The four ladies of the ballet are friends of long acquaintanceship having known each other for almost as long as they can remember and every summer they seem to have been brought together at this particular bit of countryside, for here they regathered in what seems to be the corner of a hayfield with an old weather beaten log fence separating it from the country lane in the background and down which the two men have strolled onto the scene. They are also old acquaintances and have wandered by wondering if the girls are still around."

Music: Leos Janacek: "*String Quartet #1.*"

Premiere: New York; The Juilliard School; Private viewing; May 27, 1971; Juilliard Dance Ensemble.

*Courtesy of the Antony Tudor Ballet Trust*

## APPENDIX O – THE PLANETS

In *The Planets*, Tudor compose the parts (Venus, Mars, Neptune and later, Mercury), not only to reflect the music, but also to create the atmosphere and lyrical movement that reflected different planets' meanings. The moods of each section of the music were strongly contrasted, and Tudor matched them by adopting different choreographic styles.

Music: Gustav Holst; *The Planets*.

Premiere: London; Mercury Theatre; October 28, 1934; Ballet Club (Rambert).

*Courtesy of the Antony Tudor Ballet Trust*

# APPENDIX P – OFFENBACH IN THE UNDERWORLD

*Offenbach in the Underworld*: One of the great originals of modern dance forms, Tudor is seen as a principal trans-former of ballet into a modern art. His work usually considered as modern "psychological" expression of austerity, elegance and nobility. *Offenbach in the Underworld*, a humorous story about the flirtatious interactions among celebrities at an 1870s French café, is filled with colorful characters and costumes. It culminates with a sultry and exhilarating chorus line of high kicking known as the "can-can."

Music: Jacques Offenbach; *Gaite Parisienne* Orchestrated by Manuel Rosenthal.

Premiere: Philadelphia: Convention Hall; May 8, 1954; Philadelphia Ballet Guild.

*Courtesy of the Antony Tudor Ballet Trust*

# APPENDIX Q – GALA PERFORMANCE

*Gala Performance*: The ballet takes place in a large theatre during the 1800's. The opening scene is backstage where members of a ballet company, complete with ballet master, conductor and wardrobe personnel, are in the throes of last minute preparation for a *Gala Performance* with three very distinguished guests – La Reine de la Danse (from Moscow), La Deesse de la Dance (from Milan) and la Fille de Terpsichore (from Paris). Individually, the guest artistes arrive and their hosts (and the audience!) instantly assess their personalities. In the performance which follows, each guest appears and the Gala concludes on a high note as the "starts" attempt to steal the limelight from each other during their curtain calls.

Music: Serge Prokofiev; 1st movement of "Piano Concerto #3" and Classical Symphony.

Premiere: London; Toynbee Hall Theatre; December 5, 1938.

*Courtesy of the Antony Tudor Ballet Trust*

# APPENDIX R – CONCERNING ORACLES

*Concerning Oracles* is composed of three episodes, both sinister and comic, concerned with the fits of prophecy. In the first episode, an Elizabethan lady thought to be Mary, Queen of Scots, confronts the powerfully symbols of kingdom (an orb), marriage (a chaplet), and death (a skull). The second episode, "Les Mains Gauches," (originally a small ballet performed at Jacob's Pillow in 1951) deals with the rose and the noose as possible choices during a pas de deux. Though the original character of Fate was changed, the atmosphere of hidden horror still pervades the dance. The third episode, "L'Arcane," with its setting of a family outing at a picnic table in nineteenth-century provincial France, was a prophetic comedy in which an imperfect fool becomes involved with Tarot cards, love, war, and marriage.

Music: Jacques Ibert, Suite Elizabethaine, Capriccio, Divertissement, Regard sur un Crystal, Les Mains Gauches, L'Arcane.

Premiere: New York; Metropolitan Opera House; March 27, 1866; Metropolitan Opera Ballet.

*Courtesy of the Antony Tudor Ballet Trust.*

# APPENDIX S – LITTLE IMPROVISATIONS

*Little Improvisations*: The ballet depicts two children playing in an attic on a rainy day.

Music: Robert Schumann; "*Kinderscenen – Opus 15.*"

Premiere: Lee, Massachusetts; Jacob's Pillow Dance Festival; August 28, 1953.

*Courtesy of the Antony Tudor Ballet Trust*

# APPENDIX T – CROSS GARTER'D

The scenario of *Cross-Garter'd*, drawn from Act II, scene v, and Act III, scene iv, of *Twelfth Night* concerns Malvolio, the pompous, conceited steward to the Countess Olivia. His wildest desire would be to marry Olivia. Maria, Olivia's shrewd serving woman, has designs on Sir Toby Belch, Olivia's fat, jolly, hard-drinking cousin. Toby's companion, Sir Andrew Aguecheeck, is a wealthy, skinny, rather feebleminded knight who has come to woo Olivia. And Fabian symbolizes the typical sly, merrymaking Elizabethan servant, the sort of character whom higher-born aristocrats like Toby and Andrew enjoy spending time with.

Music: Girolamo Frescobaldi; Selected organ works.

Premiere: London Mercy Theatre; November 12, 1931; Ballet Club.

*Courtesy of the Antony Tudor Ballet Trust*

# APPENDIX U – LYSISTRATA

*Lysistrata* was suggested to Tudor by Ashley Dukes, who also devised the subtitle, Strike of Wives. Based on the original comedy written in 411 B. C. by Aristophanes, *Lysistrata* present the Athenian women refusing to perform their wifely duties until their husbands forswear war. Before proclaiming her plans, *Lysistrata* has the older women seize the Acropolis in Athens in order to control the treasure. The Spartan men, unable to endure prolonged celibacy, are the first to petition for peace, on any terms. Then, *Lysistrata*, in order to hasten the war's end, has a nude girl exposed to the two armies. Thereupon the Athenians and Spartans, goaded by frustration, make peace quickly and depart for home with their wives. With only minuscule program notes and an* incomplete series of photographs surviving, it is difficult to know the complete scenario of Tudor's version of *Lysistrata*.

*Courtesy of the Antony Tudor Ballet Trust*

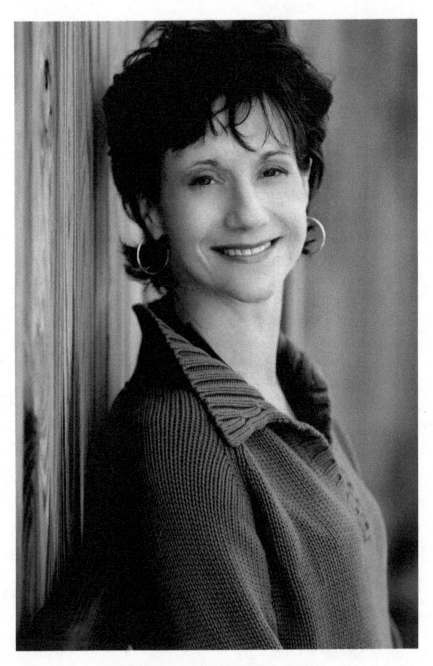

Christine Knoblauch-O'Neal

# About the Author

Christine Knoblauch-O'Neal, Ph.D., Professor of the Practice in the Performing Arts and Director of the new MFA in Dance program for the Performing Arts Department at Washington University in St. Louis, MO. Dr. Knoblauch-O'Neal performed for twenty years with such companies as American Ballet Theater, the National Ballet, Dancers, the Cincinnati Ballet, Dancers, and the Dayton Ballet.

Dr. Knoblauch-O'Neal attended Smith College as an Ada Comstock Scholar graduating with an AB in theater. Her M.A.L.S. thesis from Wesleyan University in Middletown, CT, culminating with performances of *As Is*, a classical ballet, structured improvisation with the Webster Dance Theater at Webster University, St. Louis, MO, was featured in the Summer/Fall 2001 edition of Contact Quarterly.

Her awards include a bronze medal from the International Ballet Competition in Varna, Bulgaria, a State Department medal in recognition of her accomplishment in Varna, the Washington University in St. Louis' ArtSci Faculty award, and, most recently, the 2009 CORPS de Ballet International Service Award. Her research interests include: the restaging of master dance works, storytelling, the physicality of narrative, and the embodying of history.

# Bibliography

Adams, Cindy. *Lee Strasberg: The Imperfect Genius of the Actors Studio.* Garden City: Doubeday & Company, Inc., 1980.

Anderson Jack. "Tudor's 'Dark Elegies,' by Ballet Theatre." *New York Times,* 6 June 1987, http://www.nytimes.com /1987/06/06/ arts/dance-tudor-s-dark-elegies-by-ballet-theater.html?ref=antonytudor 2 Feb. 2011.

Anderson, Jack. "With Movements, Tudor's Short Stories." *New York Times,* 30 Apr. 1992 http://www.nytimes.com/1992/ 04/30/arts/ review-dance-with-movements-tudor-s-short-stories.html?scp=1&sq=Dance/Review%20%22With%20Movements,%20Tudor's %20Short%20Stories%22&st=cse 7 Apr. 2012.

Antony Tudor Ballet Trust http://www.antonytudor.org/ballets/ballets.html.

*Antony Tudor.* Dirs. Viola Aberlé and Gerd Andersson. Stockholm and New York. 1985. DVD. Highstown, 2007.

A Tudor Evening with American Ballet Theatre. Dir. Judy Kinsberg; written by David Vaughn, David Grimm, Danish Radio Symphony, Soren Kirk, Danmarks Radio; 12 Apr. 1990.

Bavarian State Ballet. http://www.bayerische.staatsoper.de/922-ZG9tPWRvbTImZmxhZz0x JmlkPTI4MzcmbD1lbiZ0ZXJtaW49MTE1MzM-~spielplan~bal-lett~veranstaltungen~ vorstellung.html 24 Aug. 2012.

Beaumont, Cyril W. Michel Fokine and His Ballets. London: Dance Books. 1996.

Bliss, Sally. Personal Interview 25 Jan. 2010.

Bliss, Sally. Personal Interview 13 Dec. 2011.

Bliss, Sally. Personal Interview 18 Apr. 2012.

Bliss, Sally. Phone Interview. 30 Jan. 2013.

Bourdieu, Pierre. Logic of Practice. Trans. Richard Nice. Stanford: Stanford University Press, 1990.

Bourdieu, Pierre and Loïc J. D. Wacquant. An Invitation to Reflexive Sociology. Chicago: The University of Chicago Press, 1992.

Bourdieu, Pierre. Outline of a Theory of Practice. Cambridge: Cambridge University Press, 1997.

Brown, Janet. Personal Conversation, 4 Aug 2012.

Bruner, Jerome. Making Stories: Law, Literature, Life. New York: Farrar, Straus and Giroux, 2002.

Buckle, Richard. Nijinsky. New York: Pegasus Books, 2012.

Burke, Peter. Eyewitnessing: The Uses of Images as Historical Evidence. Ithaca: Cornell University Press, 2001.

Butler, Judith. "Performativitiy's Social Magic." Shusterman ed. Bourdieu, pp. 113-128.

Carter, Alexandra. ed. Rethinking Dance History: A Reader. London: Routledge, 2004.

Charmaz, Kathy. *Constructing Grounded Theory: A Practical Guide Through Qualitative Analysis*. Los Angeles: Sage Publications, 2006.

Chazin-Bennahum, Judith. "Shedding Light on Dark Elegies." *Proceedings of the Eleventh Annual Meeting Society of the Dance History Scholars February 1988*, pp. 131-144.

Chazin-Bennahum, Judith. *The Ballets of Antony Tudor: Studies in Psyche and Satire*. New York: Oxford University Press, 1994.

Cohen, Selma Jean. *Next Week, Swan Lake*. Middletown: Wesleyan University Press, 1982.

Creswell, John W. *Qualitative Inquiry and Research Design: Choosing Among Five Traditions*. Thousand Oaks: SAGE Publications, 1998.

Dance Notation Bureau. Phone Interview. 17 Aug. 2012.

Darlington, Yvonne, and Dorothy Scott. *QUALITATIVE RESEARCH IN PRACTICE: STORIES FROM THE FIELD*. Buckingham: Open University Press, 2002.

Dees, David Michael. *Teaching as Transactional Performance Artistry: A Hermeneutic and Phenomenological Investigation into the Aesthetic Qualities of Teacher/Student Transactions through the Performing Arts Traditions of Theatre, Dance, and Music*. Diss. Ken State University, 2000. Dissertations 7 Theses: Full Text, ProQuest, Web. 1 August 2010.

Dewey, John. *Experience and Education*. The Macmillan Company: New York, 1950.

"Dick Cavett." WNET Television Station. Interview with Antony Tudor and Dick Cavett. Daphne Productions. New York, New York. 1998.

Dunning, Jennifer. "Antony Tudor's Teaching Method: 'No, You Fool!'" http://www.nytimes.com/2003/10/26/arts/dance-antony-tudor-s-teaching method-no-you-fool.html?pagewanted=all&src=pm 16 Jan. 2012.

Eisner, Elliot W. *The Enlightened Eye: Qualitative Inquiry and the Enhancement of Educational Practice*. Columbus: Prentice-Hall. 1998.

Ellsworth, Elizabeth. *Places of Learning: Media, Architecture, Pedagogy*. New York: Routledge, 2005.

Fernandez, Leila. *Transforming Feminist Practice: Non-Violence, Social Justice and the Possibilities of a Spiritualized Feminism*. San Francisco: Aunt Lute Books, 2003.

Fuhrer, Margaret. "Story Ballets Make a Comeback." *Pointe*, December 2011/2012.

Gibbons, Elizabeth. *Teaching Dance: The Spectrum of Styles*. Bloomington: Author House: 2007.

Goodman, Nelson. *Ways of Worldmaking*. Indianapolis: Hackett Publishing Company, 1978.

Gove, Philip Babcock. Ed. *Webster's 3rd New International Dictionary of the English Language Unabridged*. Springfield: Merriam-Webster, Inc., 2002.

Guba, Egon G., and Yvonne S. Lincoln. *Effective Evaluation*. San Francisco: Jossey-Bass Publishers, 1981.

Halstead, Normala, Eric Hirsch, and Judith Oakely. eds. *Knowing How to Know: Fieldwork and the Ethnographic Present*. New York: Berghahn Books, 2008.

Hammond, Sandra Noll, and Phillip E. Hammond. "The Internal Logic of Dance: A Weberian Perspective on the History of Ballet." *Journal of Social History*, 12:4 (1979), pp. 591-608.

Hammond, Sandra Noll, and Phillip E. Hammond. "Technique and Autonomy in the Development of Art: A Case Study in Ballet." *Dance Research Journal* 2.12 (1989), pp. 15-24.

Hasam Joshua. Personal Interview. 3 Mar. 2012.

Haskell, Arnold. "The Dancer." ed. Caryl Brahms. *Footnotes to the Ballet.* New York: Henry Holt and Company. 1936.

Hodes, Stuart. "Transforming Dance History: The Lost History of Rehearsals" *Design for Arts in Education.* 91.2 (1989), pp. 10-17.

Homans, Jennifer. *Apollo's Angels.* New York: Random House, 2010.

Hutcheon, Linda. *The Politics of Postmodernism.* London: Routledge, 1989.

Husbands, Chris. *What is History Teach? Language, Ideas and Meaning in Learning about the Past.* Buckingham: Open University Press, 1996.

"In Search of *The Rite of Spring*." The Joffrey Ballet. PBS Television Special. 1 Jan. 1990.

Jenkins, Keith. *Re-thinking History.* London: Routledge, 1991.

Joffrey Ballet. http://joffrey.org/performances/productions/les-pr%C3%A9sages, 24 Aug 2012.

Jordan, James. Personal Interview. 06 Feb. 2010.

Jordan, James. Personal Interview. 27 Dec. 2011.

Jordan, James. Personal Interview. 01 Apr. 2012.

Jordan, Stephanie. ed. *Preservation Politics: Dance Revived, Reconstructed, Remade. Proceedings of the Conference at the University of Surrey Roehampton,* November 8-9, 1997.

Kane, Angela. "Issues of Authenticity and Identity in the Restaging of Paul Taylor's *Airs*." Jordan, *Proceedings,* pp. 72-78.

Knowles, Gary J., and Ardra L. Cole., Eds. *Handbook of the ARTS in Qualitative Research*. Ontario: Sage Publications, 2008.

Lawrence-Lightfoot, Sara and Jessica Hoffmann Davis. *The Art and Science of Portraiture*. San Francisco: Jossey-Bass, 1997.

Lawson, Douglas E., and Arthur E. Lean. *John Dewey and the World View*. Carbondale: Southern Illinois University Press, 1964.

Lidbury, Claire. "The Preservation of the Ballets of Kurt Jooss," in Jordan, *Proceedings*, pp. 89-96.

Lincoln Yvonne S. and Egon G. Guba. *Naturalistic Inquiry*. Beverly Hills: Sage Publications. 1985.

Lofland, John. *Analyzing Social Settings: A Guide to Qualitative Observation and Analysis*. Belmont: Wadsworth Publishing Company, Inc., 1971.

Lowenthal, David. *The Past is a Foreign Country*. Cambridge: Cambridge University Press, 1985.

Mahler, Donald. Personal Interview. 13 Feb. 2010.

Mahler, Donald. Personal Interview. 05 Dec. 2011.

Mahler, Donald. Personal Interview 6 Dec. 2011.

Mahler, Donald. Phone Interview. 27 Jan. 2012.

Malterud, Kristi. "Qualitative Research: Standards, Challenges, and Guidelines." *The Lancelot* 358 (2001), pp. 483-488.

Martin, Carol. "After the Event," pp. 4-51 in Jordan, *Proceedings*.

Massine, Leonide. http://en.wikipedia.org/wiki/L%C3%A9onide_Massine, 6 Apr. 2012.

Mathis, Bonnie. "The Influence of Antony Tudor on a Dance Artist." *Proceedings of the Thirty-first Annual Meeting of the Dance History Scholars, June 12-15, 2008*; "Roundtable on *Tudor Today: A Centennial Glance*," pp. 104-109.

McKerrow, Amanda. Personal Interview 19 Dec. 2011.

Merriam, Sharan B. *Qualitative Research: A Guide to Design and Imple-mentation*. San Francisco: Jossey-Bass, 2009.

Minor-Smith, Gail. *The Life and Times of Eugene Loring's "Billy the Kid": A Study of the Restaging Process*. Diss. Texas Women's University, 2004.

Morse, Janice M. *Qualitative Health Research*. Newbury Park: Sage Publications, 1992.

Mullis, Eric C. Towards an Embodied Aesthetic. Diss. Winthrop University, 1999.

Mullis, Eric C. "Performative Somaesthetics: Principles and Scope." *Journal of Aesthetic Education*, 40.4 (2006), pp. 88-118.

Murphy, Jacqueline Shea. Introduction. *The People Have Never Stopped Dancing*. Minneapolis: University of Minnesota Press, 2007.

Myers, Margaret. "Qualitative Research and the Generalizability Question: Standing Firm with Proteus." *The Qualitative Report* 4.3/4 (2000), pp. 1-9.

Nadel, Myron Howard and Constance Gwen Nadel, eds. *The Dance Experience: Readings in Dance Appreciation*. New York: Praeger Publisher, 1970. Print

Nagatomo, Shegenori. "An Eastern Concept of the Body: Yuasa's Body-Scheme." ed. Maxine Sheets-Johnstone. *Giving the Body Its Due*. Albany: State University of New York Press, 1990, pp. 48-68.

Norton, Leslie. *Leonide and the Twentieth Century Ballet*. Jefferson: McFarland & Co. 2004.

Perlmutter, Donna. *Shadowplay: The Life of Antony Tudor*. New York: Penguin Group, 1991.

Peterson, Appie. Personal Interview 22 Apr. 2012.

Peterson, Kirk. Personal Interview. 5 Dec. 2011.

Peterson, Kirk. Personal Interview. 6 Dec. 2011.

Peterson, Kirk. Phone Interview. 18 Feb. 2012.

Punday, Daniel. *Narrative Bodies: Toward a Corporeal Narratology.* New York: Palgrave MacMillan, 2003.

Rubin, Herbert J., and Irene S. Rubin. *Qualitative Interviewing: The Art of Hearing Data.* 2nd ed. Thousand Oaks: Sage Publications, 2005.

Runco, Mark A. Ed. *Problem Finding, Problem Solving, and Creativity.* Norwood: Ablex Publishing Corporation, 1994.

Schechner, Richard. *Essays on Performance Theory: 1970-1976.* New York: Drama Book Specialists, 1977.

Schechner, Richard. *Between Theatre & Anthropology.* Philadelphia: University of Pennsylvania Press, 1985.

Schmitz, Matt. Personal Interview. 15 Mar. 2012.

Sheets-Johnstone, Maxine. "On Movement and Objects in Motion: The Phenomenology of the Visible in Dance." *Journal of Aesthetic Education* 13.2 (1979), pp. 33-46.

Sheets-Johnstone, Maxine. *The Roots of Thinking.* Philadelphia: Temple University Press, 1990.

Sheets, Maxine. *The Phenomenology of Dance.* Milwaukee: The University of Wisconsin Press, 1996.

Sherman, Jane. "Denishawn Revivals: One Method in the Madness." *Dance Chronicle,* 6.1 (1983), pp. 37-53.

Shusterman, Richard. ed. *Bourdieu: A Critical Reader.* Oxford: Blackwell Publishers, 1999.

Siegel. Marcia B. "Resurfacing." *The Hudson Review.* 44.3 (1991), pp. 447-452.

Siegel, Marcia B. "Retrievals." *The Hudson Review*. 54:3 (2006), pp. 437-444.

Siegel, Marcia B. *Mirrors & Scrims: The Life and Afterlife of Ballet*. Middleton Wesleyan University Press, 2010.

Singleton, Trinette. Personal conversation, 3 Mar. 2005.

Smith, Kevin. 'Howard Gardner and Multiple Intelligences,' *The Encyclopedia of Informal Education*, http://www.infed.org/thinkers/gardner.htm 11 Aug. 2012.

Thomas, Helen. "Reproducing the Dance: In Search of the Aura?" Ed. Stephanie Jordan *Preservation Politics: Dance Revived, Reconstructed, Remade*. London: Dance Books, 2000, pp. 125-131.

Thomas, Helen. "Reconstruction and Dance as Embodied Textual Practice" Alexandra Carter ed. *Rethinking Dance History: A Reader*. Routledge: London, 2004, pp. 32-45.

Tobin, Gerard A. and Cecily M Begley. "Triangulation as a Method of Inquiry." *Journal of Critical Inquiry into Curriculum and Instruction*. 3.3 (2002), pp. 7-11.

Tobin, Gerard A. and Cecily M. Begley. "Methodological Rigour within a Qualitative Framework." *Journal of Advanced Nursing* 48.4 (2004), pp. 288-396.

Topaz, Muriel. "Reconstructing: Living or Dead? Authentic or Phony?" *Jordan Proceedings* 1997, pp. 125-131.

Topaz, Muriel. "Specifics of Style in the Works of Balanchine and Tudor." *Choreography and Dance*: 1 (1988), pp. 1-36.

Topaz, Muriel. *Undimmed Lustre: The Life of Antony Tudor*. Lanham: The Scarecrow Press, Inc. 2002.

Videos from rehearsals of *Dark Elegies*. Dancers in the dance department. Donald Mahler, Répétiteur. Filmed by Judith Chazin-Bennahum. University of New Mexico. January 1998; February 1998.

Wainwright. Stephan. *Bourdieusian Ethnography of the Balletic Body*. Diss. University of London. 2004.

Wainwright, Stephan and Bryan S. Turner. "'Just Crumbling to Bits'? An Exploration of the Body, Ageing, Injury and Career in classical Ballet Dancers." *Sociology* 40:237 (2006), pp. 237-255.

Wolcott, Harry F. *Writing up Qualitative Research*. 3rd ed. Thousand Oaks: Sage Publications, 2009.

Wulff, Helena. "To Know the Dancer: Formations of Fieldwork in the Ballet World." Narmala Halstead, Eric Hirsch, and Judith Okely. *Knowing How to Know*. New York: Berghahn Books, 2008, pp. 75-91.

# Index

234 Revealing the Inner Contours of Human Emotion

# HISTRIA

## BOOKS

 VITA HISTRIA   GAUDIUM

Addison & Highsmith   CENTER FOR Romanian STUDIES

### EXCELLENCE IN PUBLISHING SINCE 1996

#### OTHER RELATED TITLES OF INTEREST

## AVAILABLE AT
## HISTRIABOOKS.COM